THE ART OF
JIM BURNS
HYPERLUMINAL

This book is dedicated to my family. To my wife Sue and my children Elinor, Megan, Gwendolen and Joseph. In particular it's dedicated to my grandchildren Frida, Benjamin, Nancy, Phoebe and Silas. They will be there helping to build the real future—which may or may not resemble anything contained between these covers!

THE ART OF JIM BURNS: HYPERLUMINAL

ISBN: 9781781168448

Published by Titan Books
A division of Titan Publishing Group Ltd.
144 Southwark St.
London
SE1 0UP

First edition: September 2014
10 9 8 7 6 5 4 3 2 1

To receive advance information, news, competitions, and exclusive offers online, please sign up for the Titan newsletter on our website: www.titanbooks.com

Did you enjoy this book? We love to hear from our readers. Please e-mail us at: readerfeedback@titanemail.com or write to Reader Feedback at the above address.

A CIP catalogue record for this title is available from the British Library.

Printed and bound in China.

THE ART OF
JIM BURNS
HYPERLUMINAL

JIM BURNS

FOREWORD BY JOE HALDEMAN

TITAN BOOKS

JIM BURNS — MASTER OF THE FANTASTIC AND THE REAL

BY JOE HALDEMAN

To say that Jim Burns is a master of fantastic realist art does not do justice to his large and mysterious talent. The computer in front of me now has inside it a cybernetic stack of a couple of hundred Jim Burns paintings and drawings, and sorting through them is an exercise in wonder and delight.

The only British winner of the Hugo Award for Best Professional Artist, he won the coveted prize in 1987 and again in 1995 and 2005. He is also a twelve-time winner of the annual British Science Fiction Award for Best Artwork or Best Artist.

Jim does have a professional's necessary mundane artistic talents. His lines are crisp and sure; his colors brilliant or muted as need be. His paintings of women would stop me dead if their subjects were just gathering flowers or shopping at the 7-11. When they depict beautiful women doing things that won't have a name for a thousand years, they are that much more beautiful, and a testament to Jim's inventive imagination as well as his skill as a painter and illustrator.

One of the things he does especially well is a tool, or talent, that we might call "science-fictionalization" —the art of taking an everyday object and transforming it into something wonderful and strange. You often don't see quite how this is done unless you're looking for it. A '58 Chevy that's been morphed into a weapon of war. A shelf with old jars of formalin, some half evaporated, casually holding as mundane specimens monstrous homunculae with wings or too many legs. An artist—herself a stunning beauty—deep in concentration, using a futuristic airbrush to sculpt what seems to be a living creature.

That one, "Homuncularium," is my favorite picture in the book — just as arresting as it was when I first saw it, while relaxing on the fast train between Paris and London. Science fiction was pretty far from my mind, but I picked up a copy of Interzone and was hooked immediately. It contains a stronger narrative — without any words— than most science fiction writers, including yours truly, can manage with thousands.

Science-fictional artists routinely employ this sort of invention, since after all you can't pick up the phone and order a cage full of harpies or a brace of hecatoncheires. (Good thing, too.) But few science fiction artists come close to Jim's convincing imaginings. Technical skill is necessary, as they say, but not sufficient. You have to be a dreamer as well as a weaver.

A lot of artists travel the world in search of material, but Jim is one of the few who have gone up as well as around. He joined the Royal Air Force at age 18, and learned how to fly jets. Fortunately for art and science fiction, he left that world behind in favor of more distant ones. Everyone who picks up this book will find favorites. Here, in addition to the incredible homunculus-crafter, are some of mine:

"Muscle Ship" (p. 134) for its convincing fusion of the organic and the mechanical. SF writers spend thousands of words trying to make this combination both exotic and convincing. Burns does it in one masterful stroke. "Grail Imaging" (p. 134) is similarly effective.

"iRobot" is, I think, the most chilling and evocative picture here, even though it doesn't contain a living human. The battered robot seems to be asking "Why?" of whatever gods allowed his organic companion to meet his grisly fate.

There are lots of fascinating portraits in the book— Jim puts life into wonderful and bizarre frames—the most moving of which is the ancient astronaut in "Schismatrix Plus," his face and body deformed by the rusty machinery that links him to his equally ancient ship, with mysterious alien companions drifting along in the vacuum outside.

This Spread: *There is no Darkness.*
(Joe Haldeman and Jack C. Haldeman) Acrylics. 1983

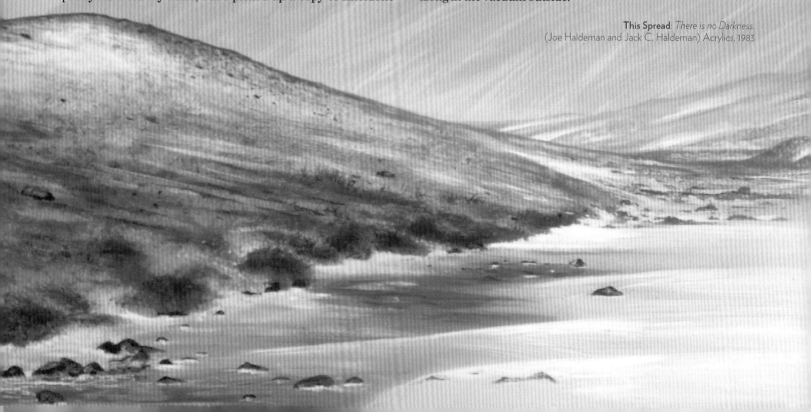

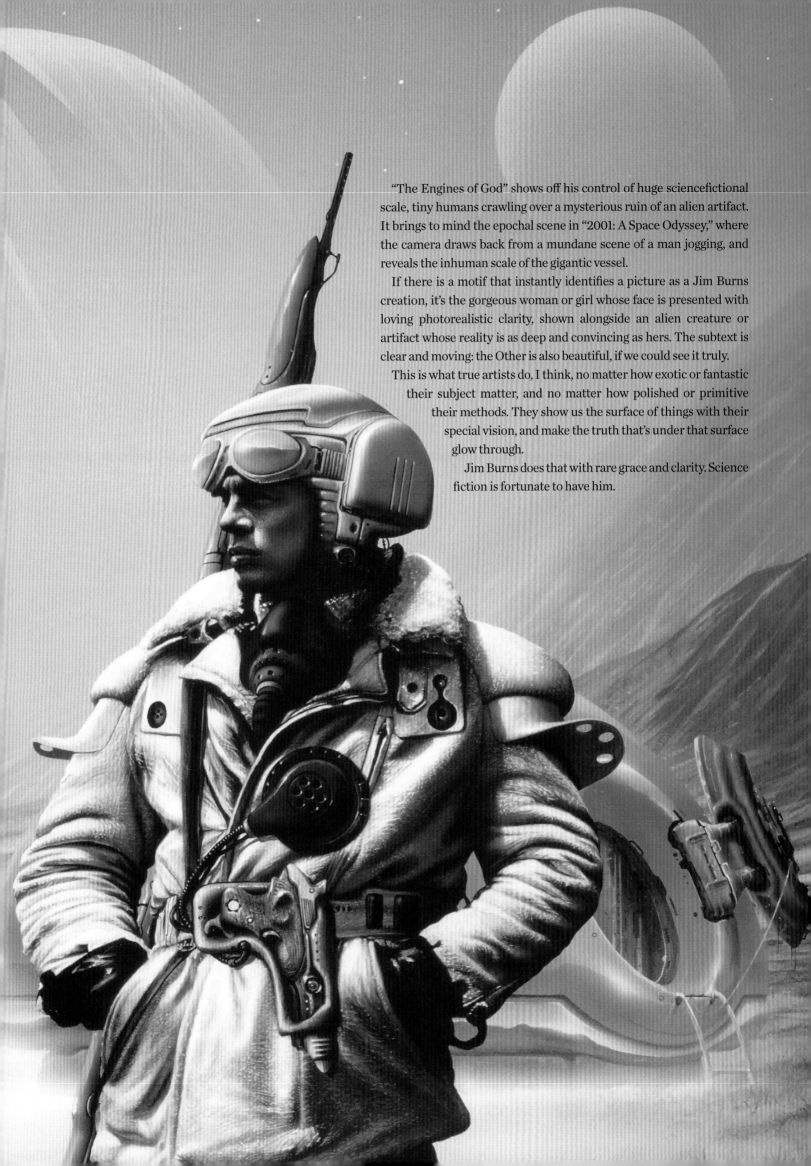

"The Engines of God" shows off his control of huge sciencefictional scale, tiny humans crawling over a mysterious ruin of an alien artifact. It brings to mind the epochal scene in "2001: A Space Odyssey," where the camera draws back from a mundane scene of a man jogging, and reveals the inhuman scale of the gigantic vessel.

If there is a motif that instantly identifies a picture as a Jim Burns creation, it's the gorgeous woman or girl whose face is presented with loving photorealistic clarity, shown alongside an alien creature or artifact whose reality is as deep and convincing as hers. The subtext is clear and moving: the Other is also beautiful, if we could see it truly.

This is what true artists do, I think, no matter how exotic or fantastic their subject matter, and no matter how polished or primitive their methods. They show us the surface of things with their special vision, and make the truth that's under that surface glow through.

Jim Burns does that with rare grace and clarity. Science fiction is fortunate to have him.

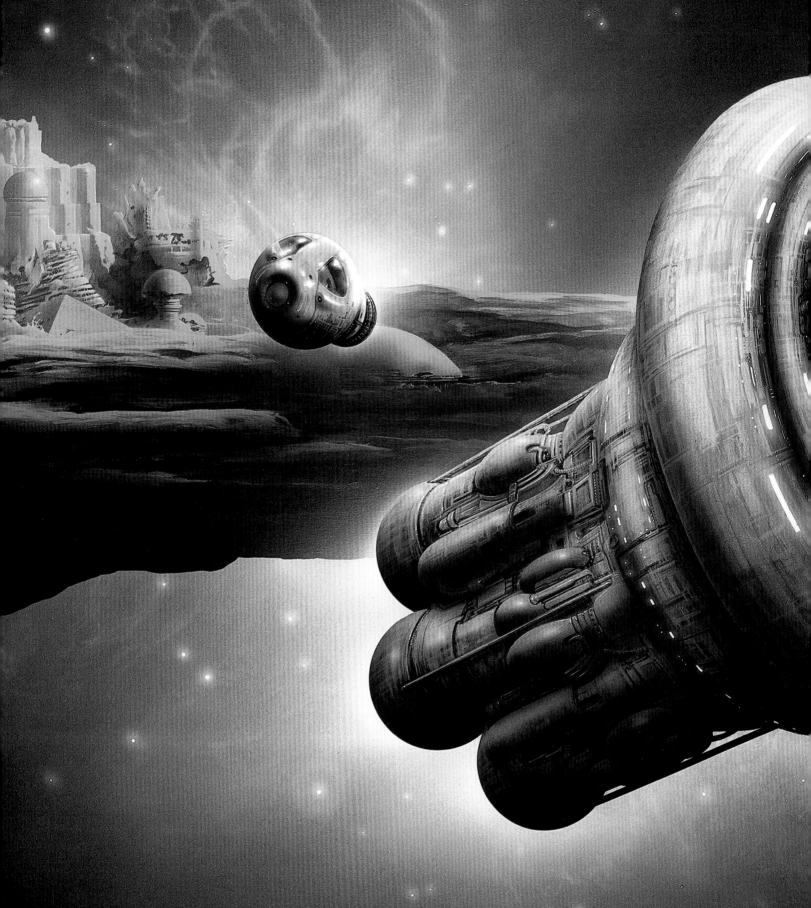

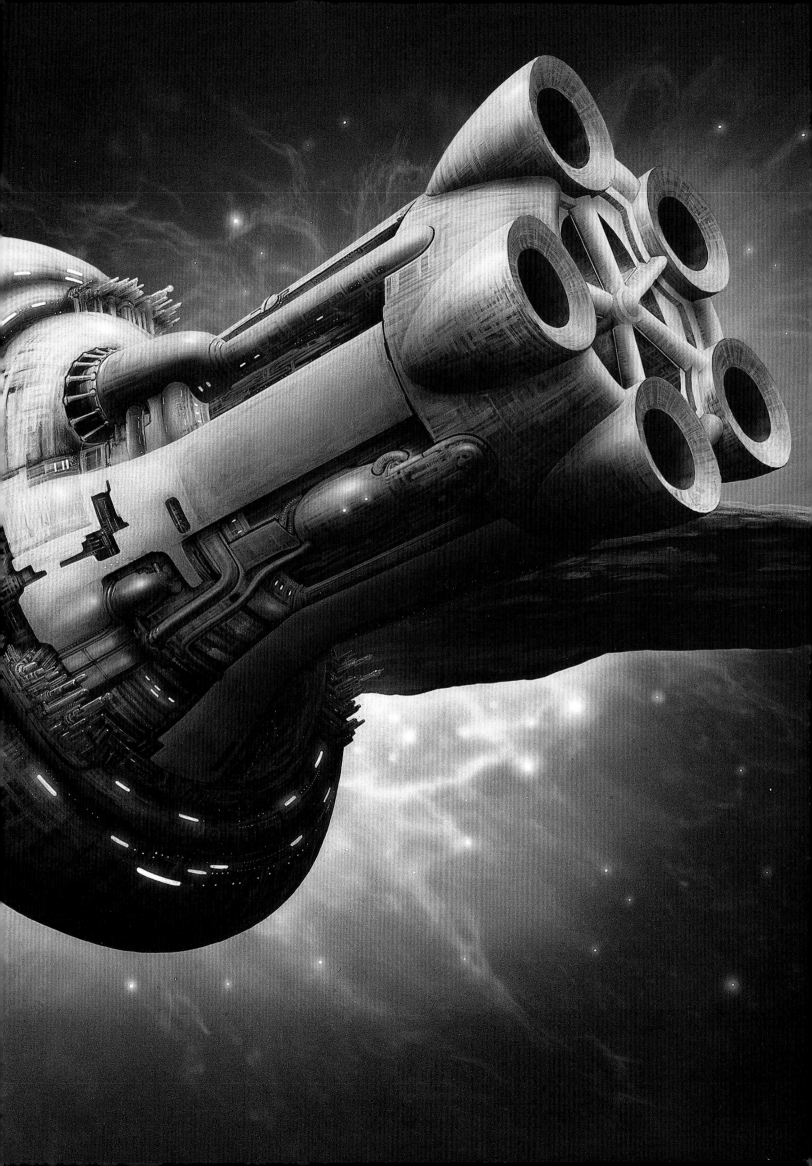

The poet, Rainer Maria Rilke wrote "The only journey is the one within". The one journey that truly matters is the passage of our own lives. We evolve through the stages of our lives from childhood through adulthood and on to the end as a consequence of how events outside us and within us affect and change us.

The creative mind of the writer, musician or artist is fed and nurtured by those events and the imagination is employed to interpret them in the way that is unique to that creative individual.

Where that springboard of creativity comes from, when it becomes evidently part of the 'make-up' of a personality, is a mystery to me. I do know that in my own case the desire to create images on paper seems, in my mind's eye, to have been there forever or at least as far back as my memory will go. I do not recall a time when I wasn't scribbling away. The desire to refine my scribbles into coherent, identifiable *'somethings'* was there, present in me from a very early age. Like many small boys I was totally fascinated by all things mechanical. Or rather—I loved the *look* of machines. I was less interested in their workings than in their individual aesthetics. I didn't, at that time,

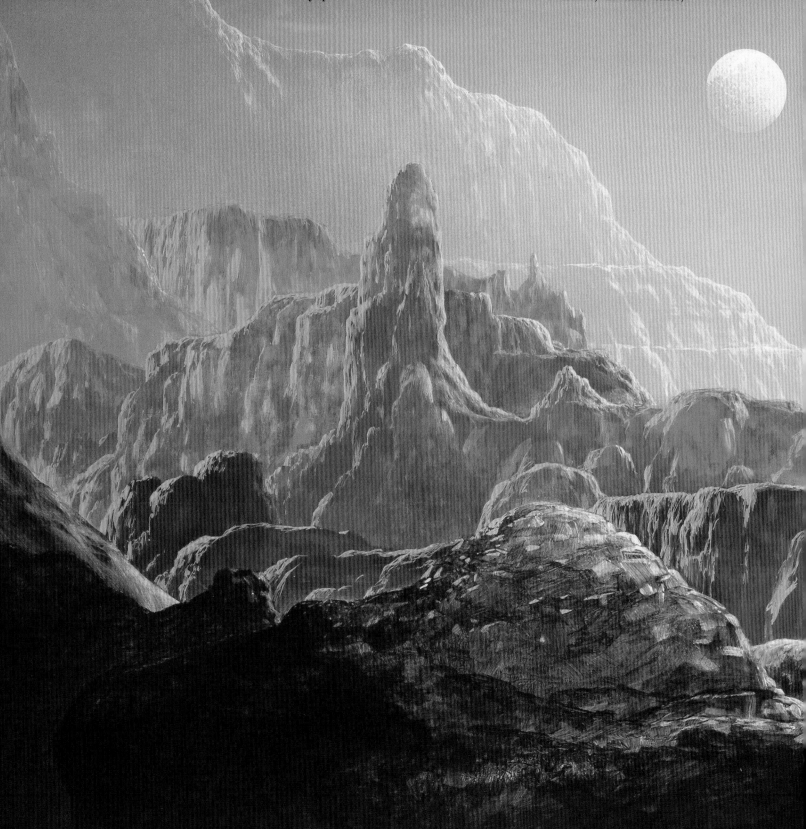

know the word 'aesthetics' but I did know that there was something visually pleasing about the particular curves in a jet fighter's fuselage. I was also intrigued by how one manufacturer's products would differ from another—how a British aircraft would possess some defining virtues that made it different from an American or Russian design. And the chromed grilles and flaring fins in the cars of that time—in particular American cars! Tanks and ships and all things military!

My other *big* interest was the natural world. In a way, it was the same interest. It was physical form, surface detail, and variations in species that most fascinated me so through the 1950s and into the '60s, my drawings and paintings were essentially inhabited by machine contrivances and occasionally weird creatures. I had less confidence with the latter. Nobody can tell me that my machine is 'wrong'. It's how I want it to be! But a dodgy squinty eye or a badly drawn hand or foot, however alien, just looks plain wrong, full-stop!

Around about the age of five, my own journey of the imagination began. And I'm still on that journey.

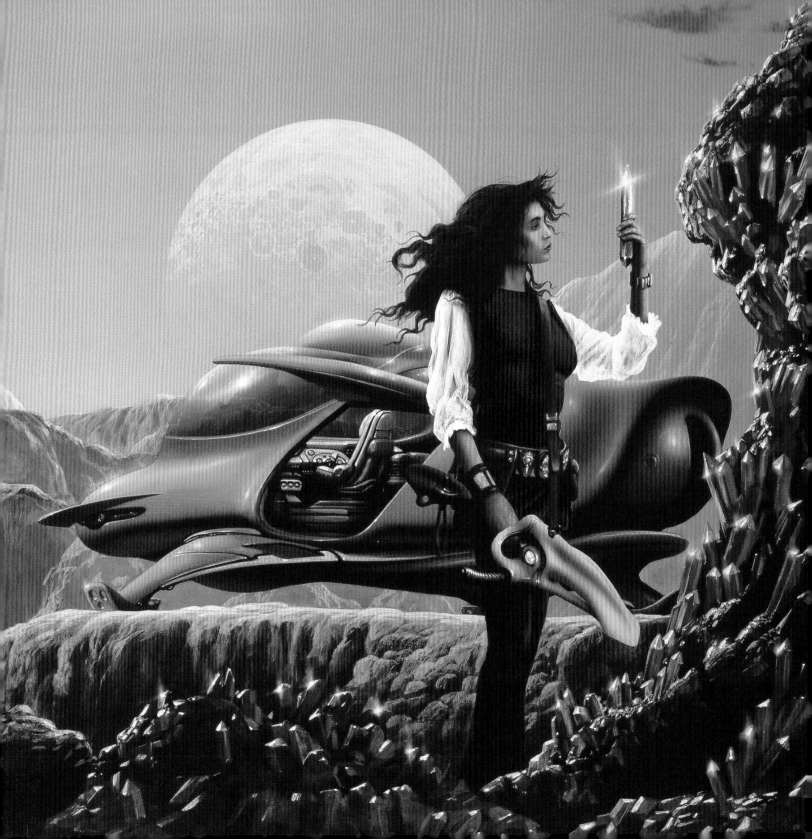

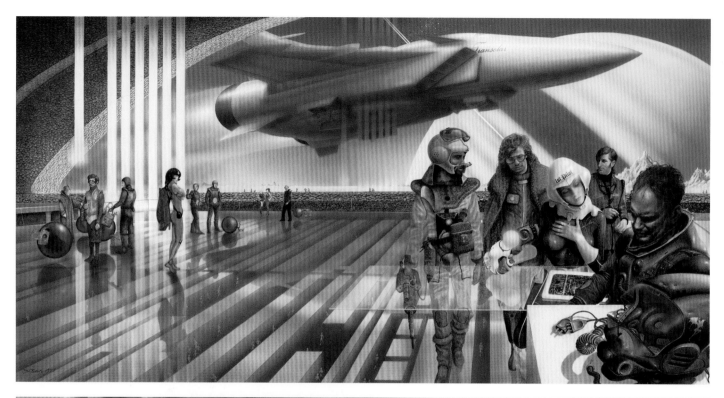

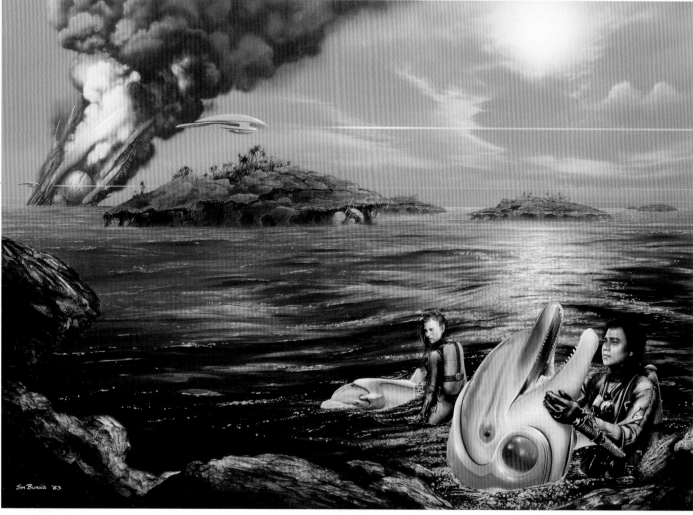

Opening Spread: *Pandora's Star—Book 1 of The Commonwealth Saga* (Peter F. Hamilton) Acrylics. 2003

Previous Spread: *The Crystal Singer* (Anne McCaffrey) Acrylics. 1999

Top: *Sol Transit Complex 7 (Janus)* (Personal) Oils. 1977

Above: *Startide Rising* (David Brin) Acrylics. 1983

Right: *Traverz* (Personal) Digital. 2013

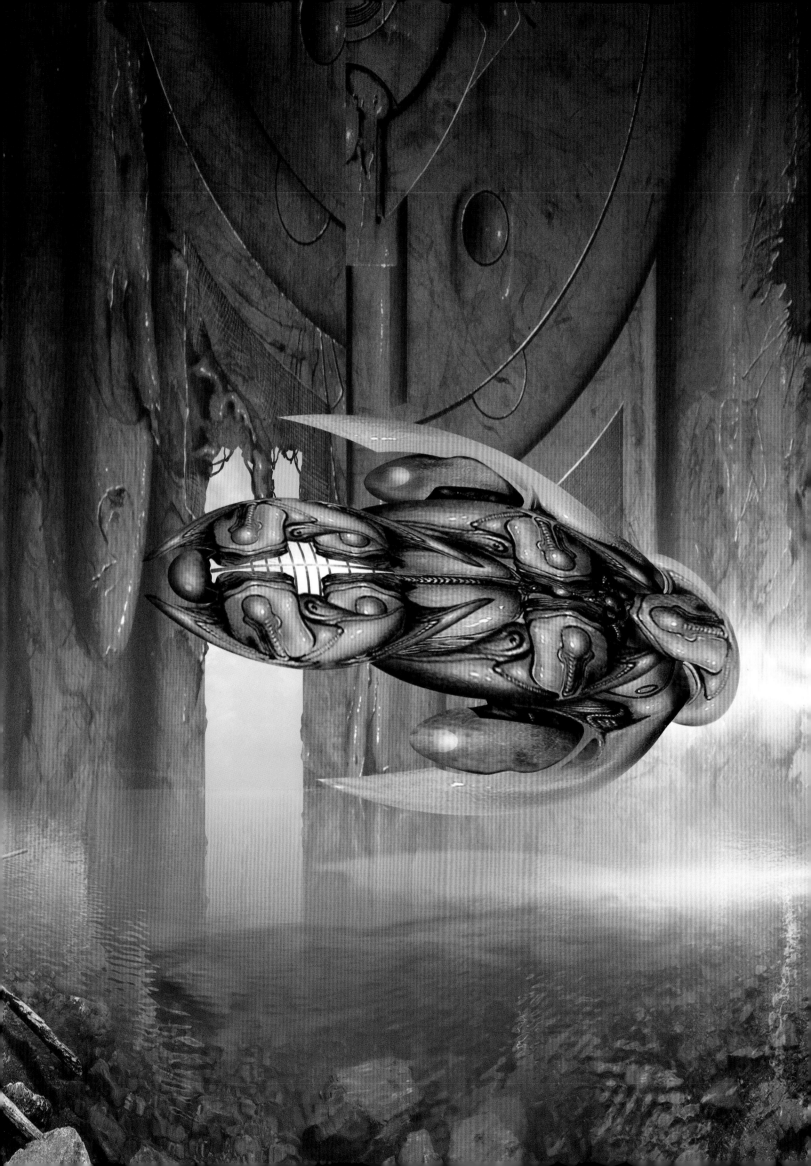

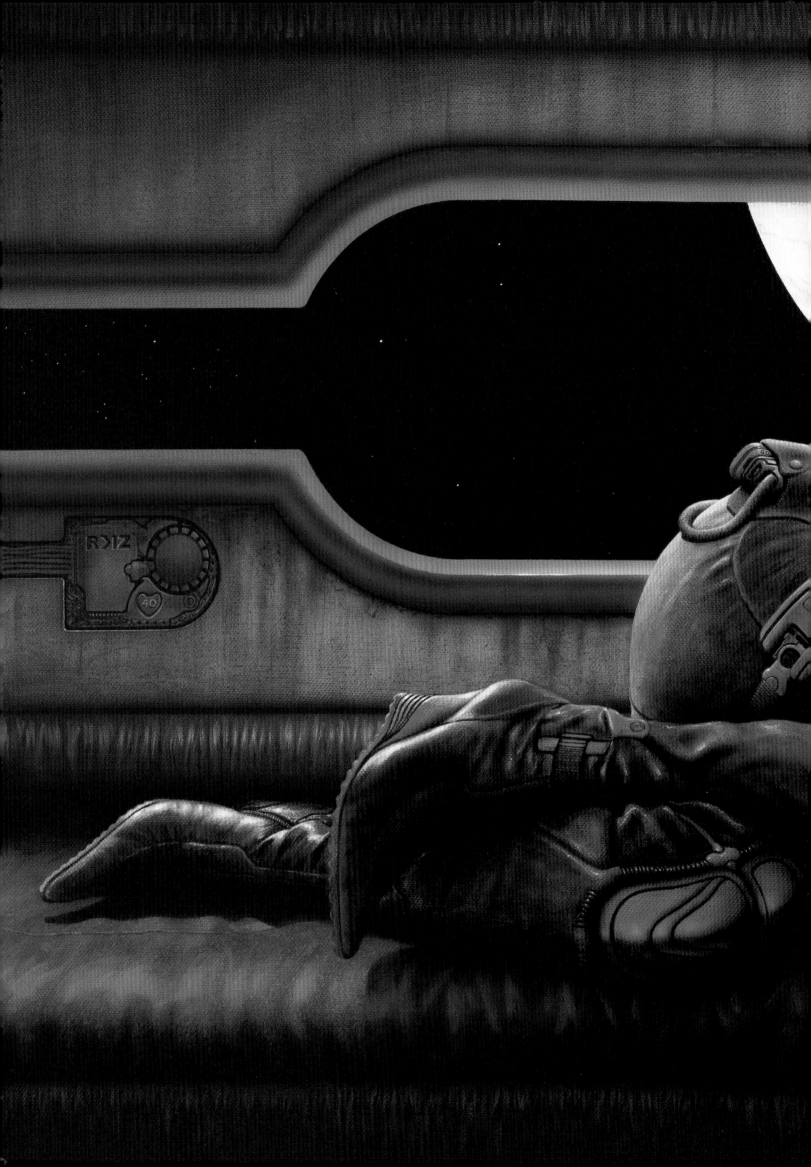

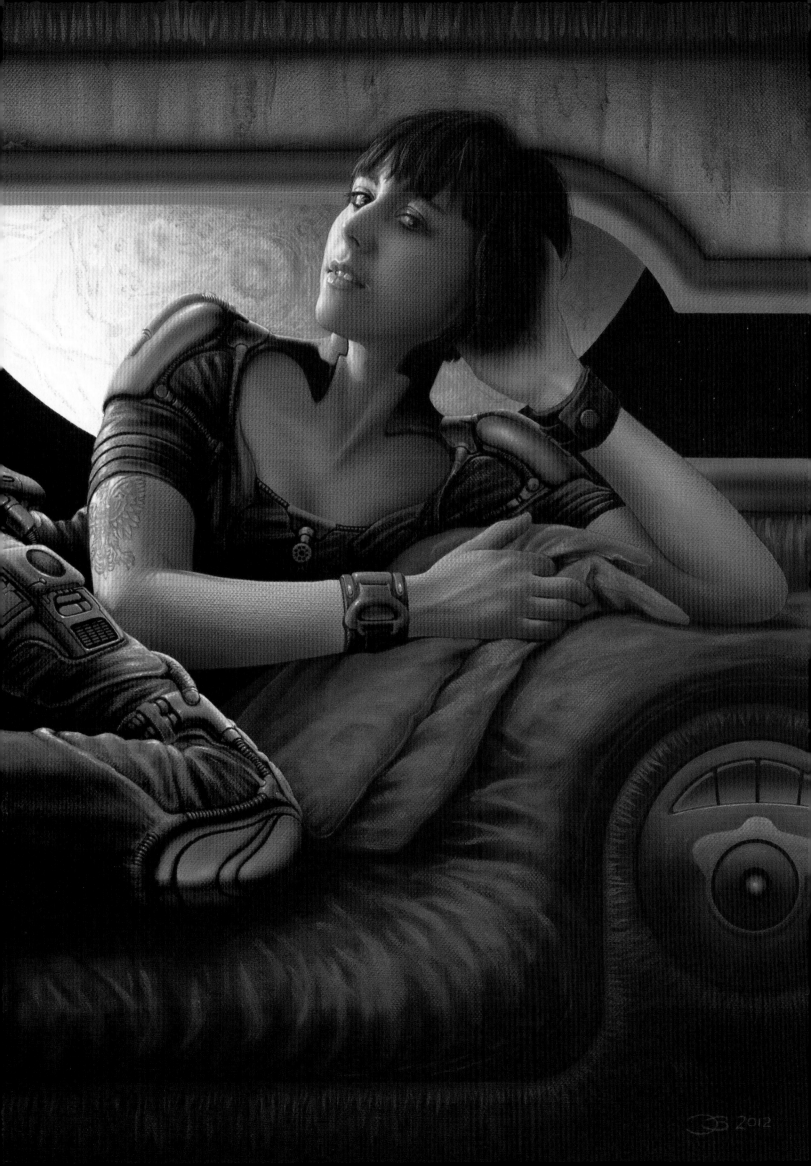

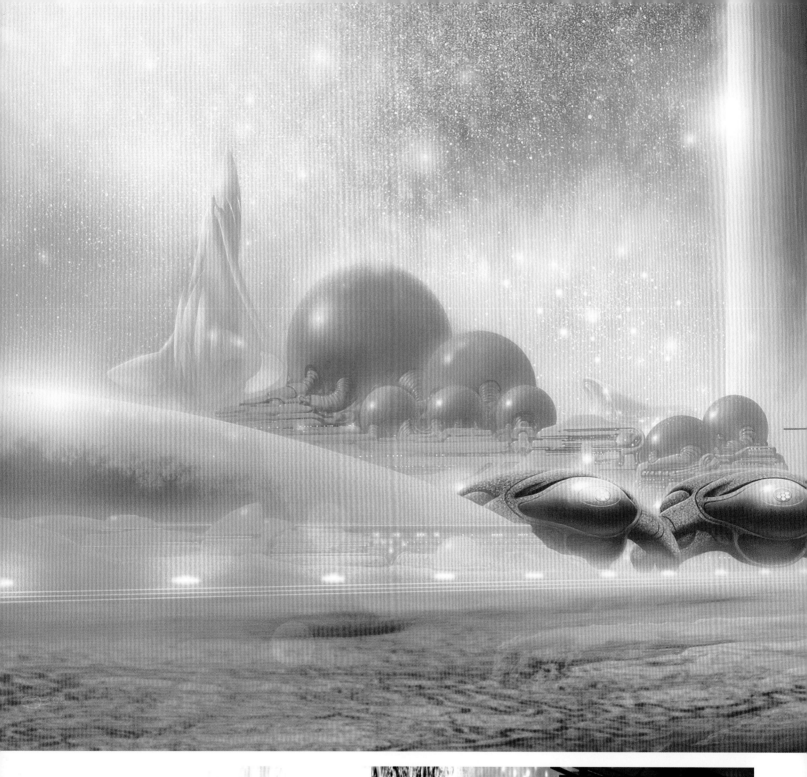

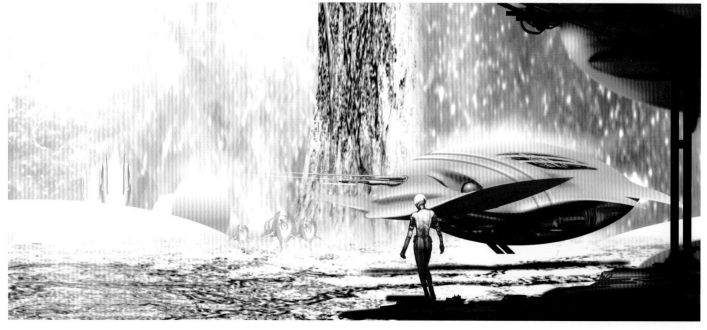

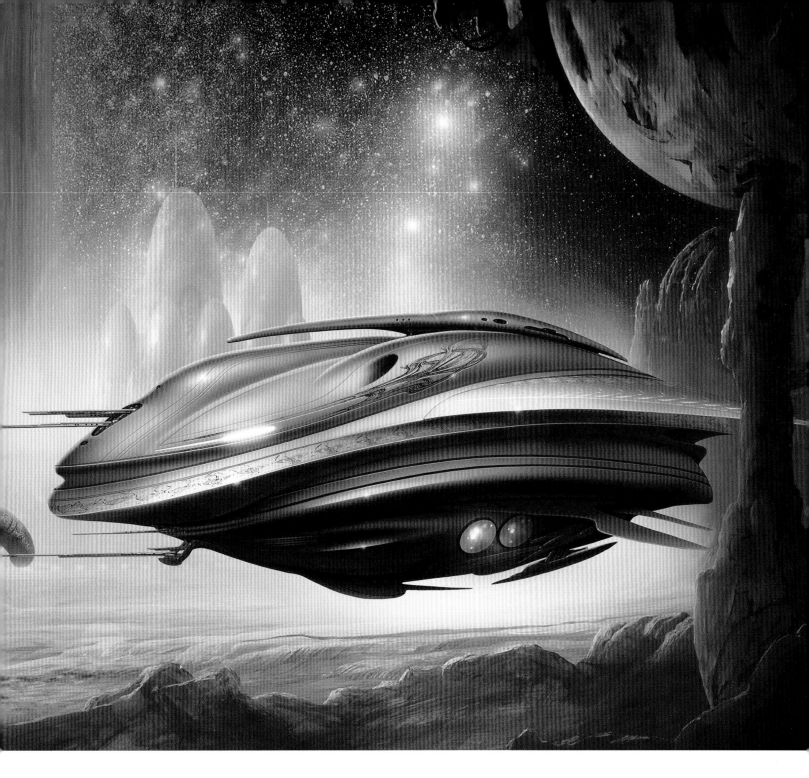

Discovering fellow travellers on my journey was probably crucial in my own imagination's development. As a kid I came across great comic artists like Frank Hampson, Frank Bellamy and Sidney Jordan. I was not alone. There were people out there on precisely my own wavelength! Frank Hampson's Dan Dare character in the *Eagle* comic was probably the single most influential factor in my young life—in more ways than one. The desire to *be* Dan Dare took me off down an interesting and exciting cul de sac. I joined the RAF and trained as a pilot. I flew jet trainers solo so wasn't I on the way to a career that would inevitably lead to Dan Dare-dom? Back then wasn't Britain going to lead the charge into the galaxy?

Well no. I wasn't much of a pilot and came out of the RAF and Britain pretty much opted out of 'The Space Race'. Yuri was in orbit! A hero—but not an English hero! How did that happen? So I went to art college instead. Wiser heads had told me all along it was my natural path but through the journey of life, isn't it sometimes those little side streets that prove the most exciting? I'm glad I investigated that particular no-through-road but I never regretted finding my way back on to the essential highway, the logical direction towards a rewarding life in art.

Above: *The Temporal Void—Book 2 of The Void Trilogy* (Peter F. Hamilton) Mixed acrylics/digital. 2008

Left: *The Temporal Void* Digital sketch

Previous Spread: *Portrait of Izabella Skrzyszewska* (Private commission) Acrylics. 2012

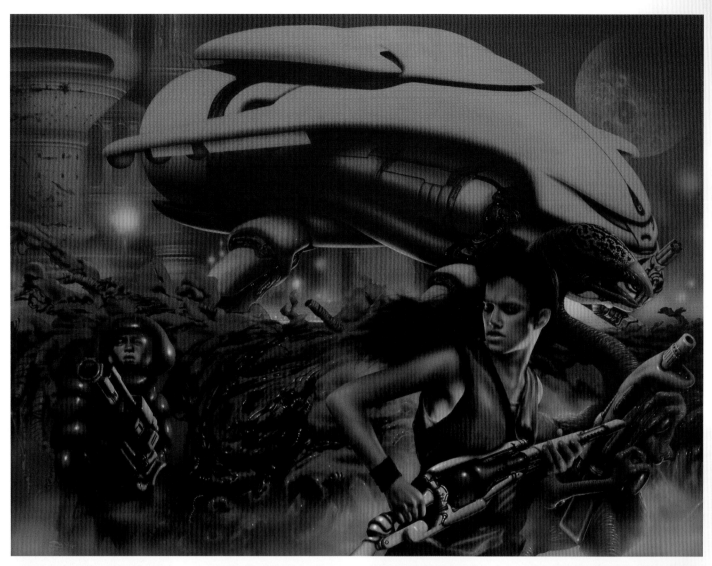

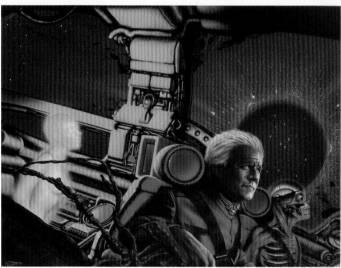

A satisfyingly convoluted and byzantine trilogy by S. Andrew Swann
set on the Anarcho-Capitalist world of Bakunin

Top: *Hostile Takeover 1—Profiteer* Acrylics. 1994

Above Left: *Hostile Takeover 2—Partisan* Acrylics. 1994

Above Right: *Hostile Takeover 3—Revolution* Acrylics. 1995

Opposite: *Resonance—Book 3 of the Ragnarok Trilogy* (John Meaney) Digital. 2013

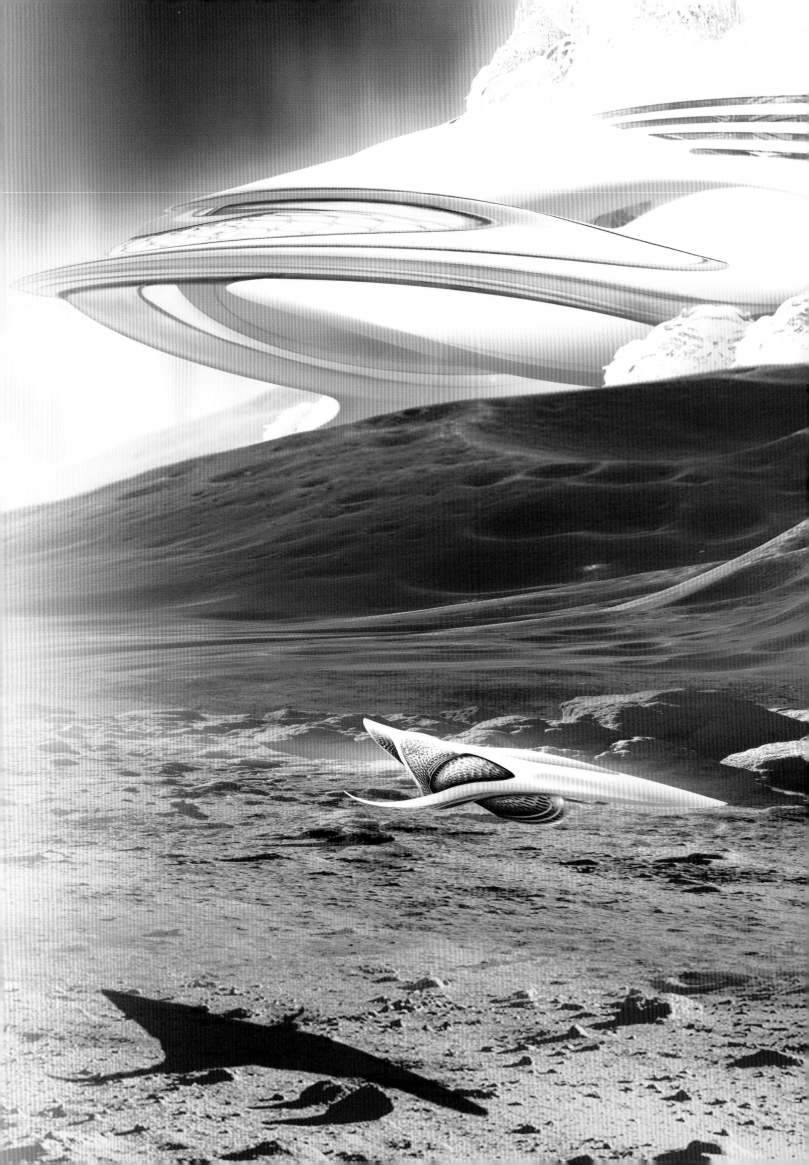

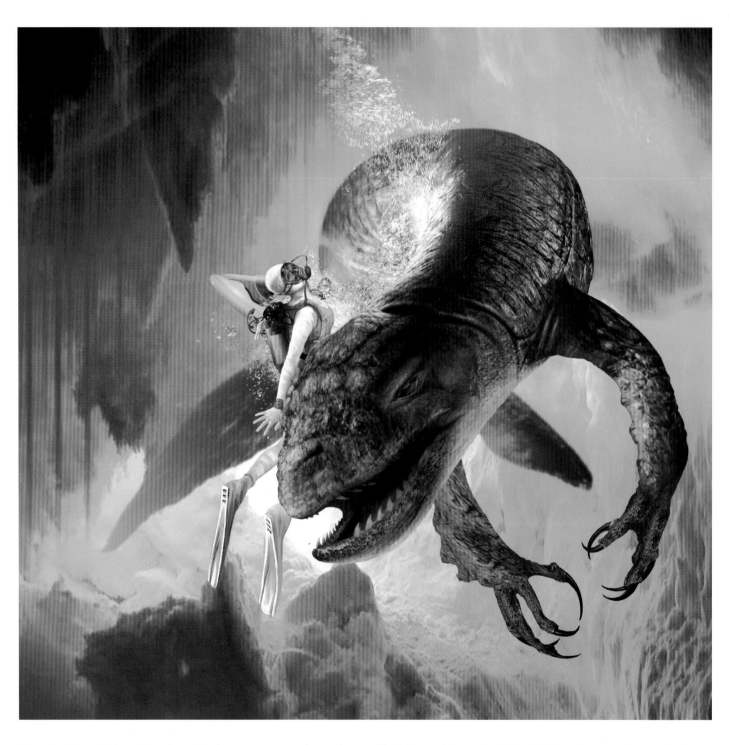

Comic art took me some way down the road but it was discovering the glorious treasure trove of science fiction writing that truly grabbed my imagination. For some years it made up 80-90% of my reading. Here at last I found my natural traveling companions through life. Earliest voyages of discovery through the novels of science fiction blur a little in the memory but Heinlein's evocation in *Red Planet* of a version of a Mars based, to some degree, on the old Schiaparellian 19th Century model—criss-crossed with canals—resonated strongly, sowing a seed of desire to read more. Then I found H. G. Wells. Again it's Mars or rather, invaders from, in *The War Of The Worlds*. Eventually I moved on through my teenage years through Clarke, Asimov—the usual suspects and the bedrock of many a fan's early reading.

In my last year at St Martin's School of Art in London, I was taken on by the Young Artists agency and almost immediately started finding paid work. Being paid for an obsessional hobby is a bit of a gift it has to be said. It's a fortunate man who is able to take a hobby and turn it into a career. You don't necessarily retire from your hobbies—particularly gentle ones like art — so I can't see myself ever laying down the brushes either.

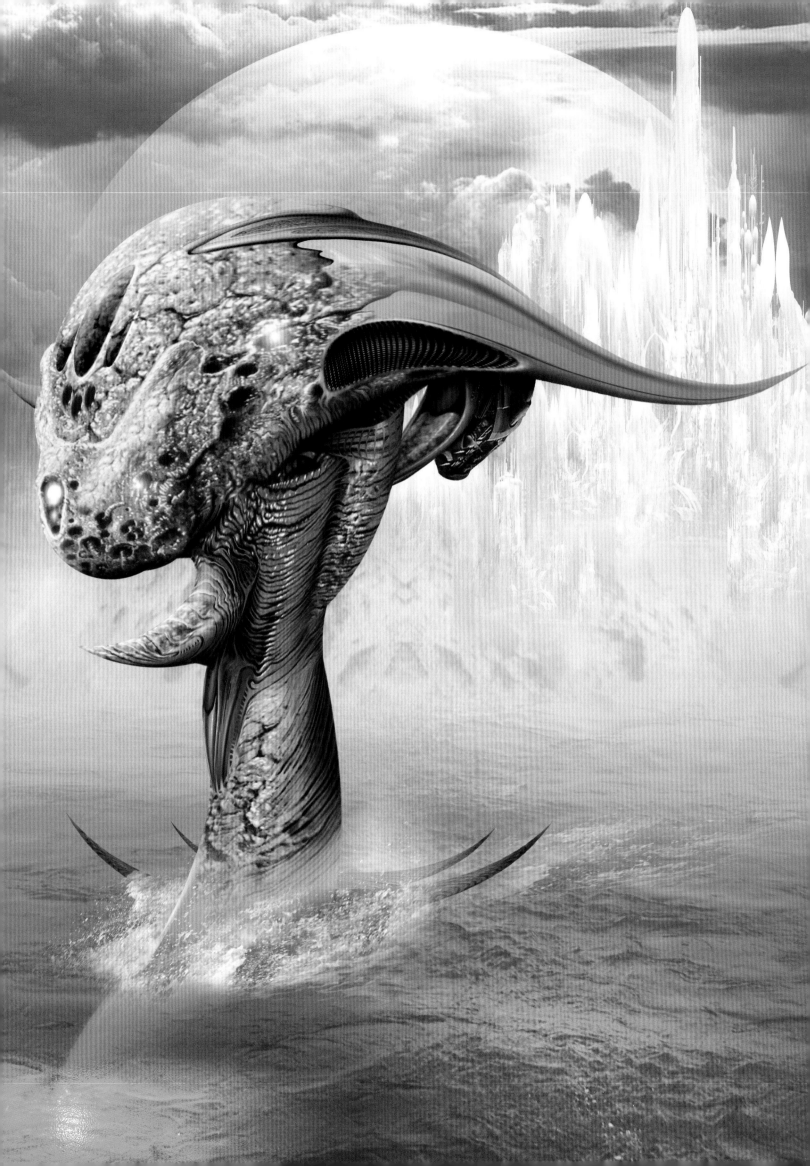

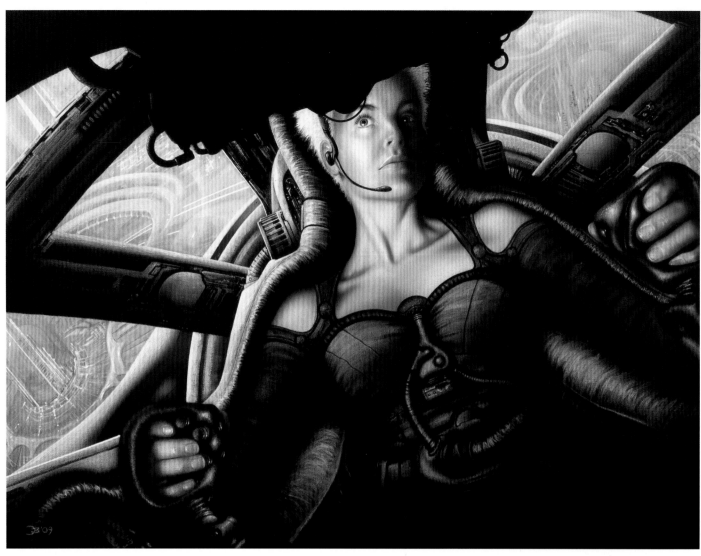

Above: *Fly-By-Wire* (Personal) Acrylics. 2009

Below: *Strafer—detail* (Personal) Digital. 1997.
My very first venture into Photoshop!

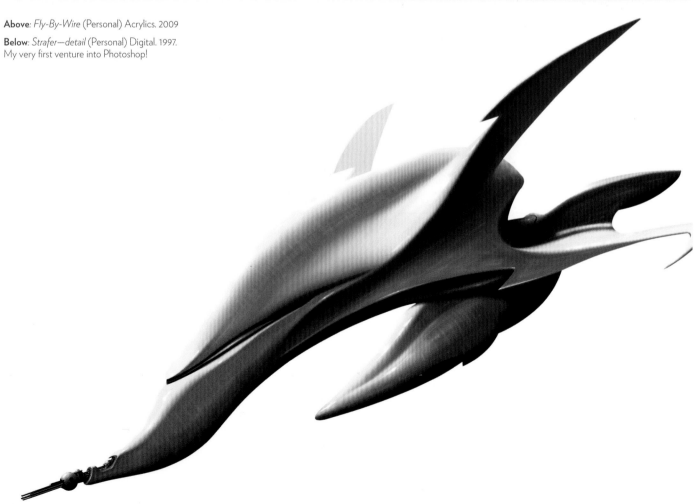

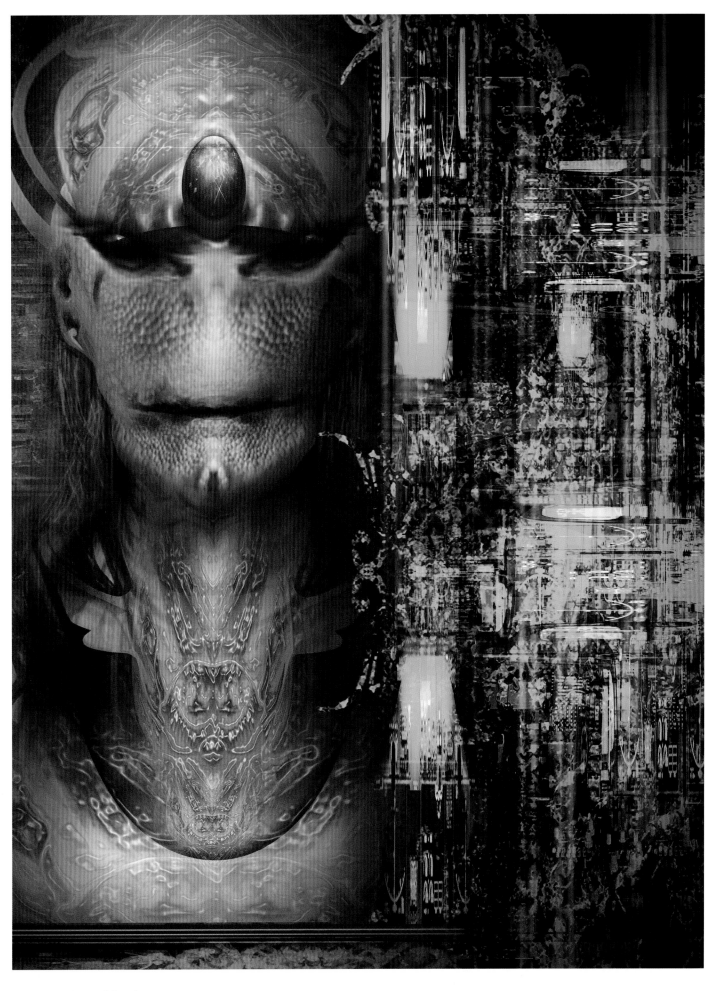

Above: *Xianth* (Personal) Digital. 2014

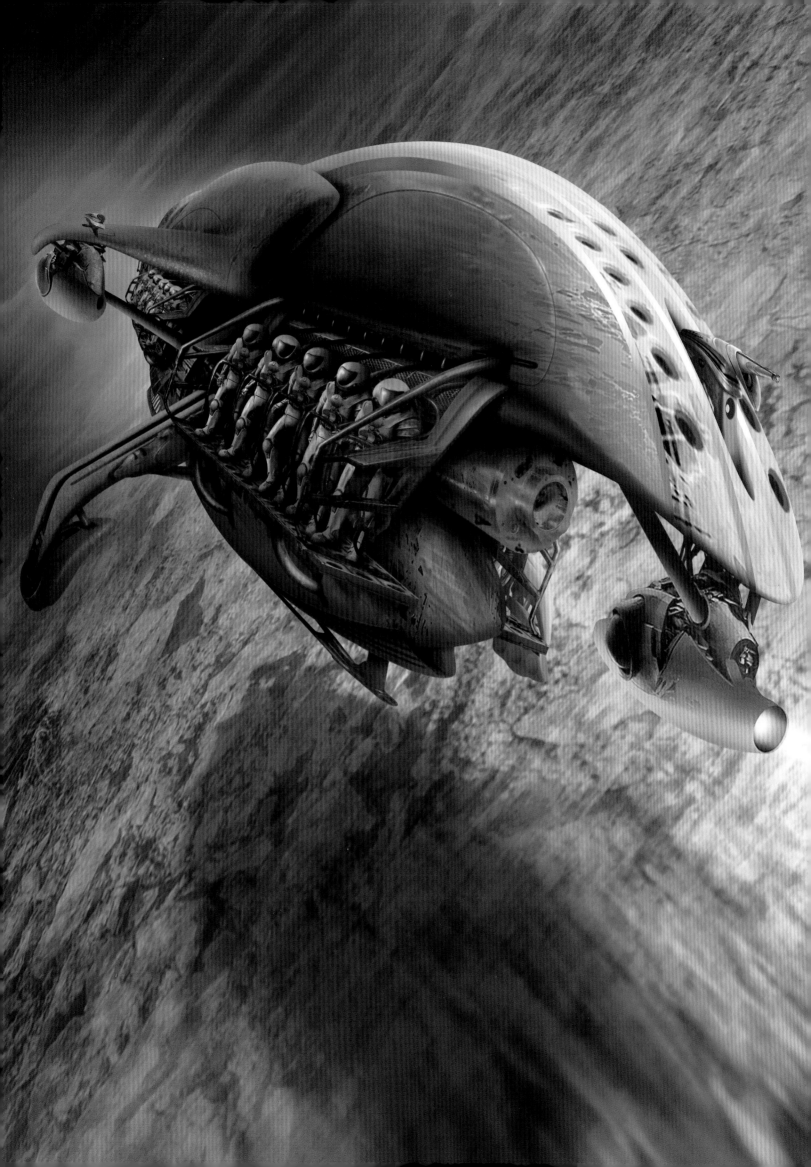

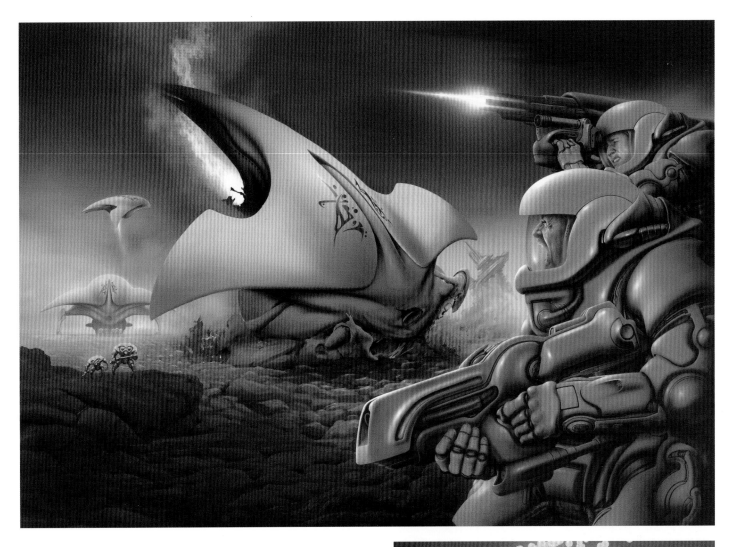

The Forever War (Centipede Press Limited Edition) is one of my favourite science fiction novels and possibly the best 'military science fiction' story ever. Written by Joe Haldeman, who has kindly provided the foreword for this book, it is visionary and poignant—based very much on Haldeman's own experience of war in Vietnam. Unlike most SF novels, I love the way he refuses to ignore the time dilation effects of relativistic travel—which creates much of the sense of poignancy. And his Taurans are a wonderfully imagined extraterrestrial enemy.

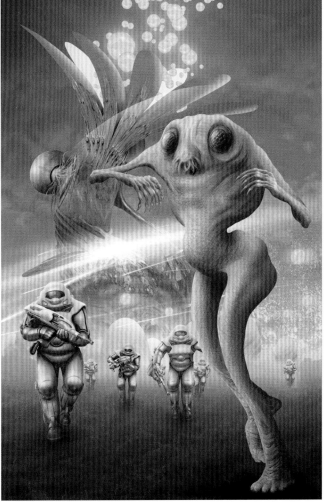

Top: *The Forever War* (Cover). Acrylics. 2011

Right: *Attack on the Tauran Base—detail*
Digital. 2011

Far Right: *Attack on the Tauran Base*
Digital. 2011

Left: *Assault Ship* Digital. 2011

Following Spread: *His Conquering Sword* (Kate Elliott) Acrylics. 1992. Kate bought the original from me on sight at the World Science Fiction convention in San Francisco, 1993. So rewarding an experience!

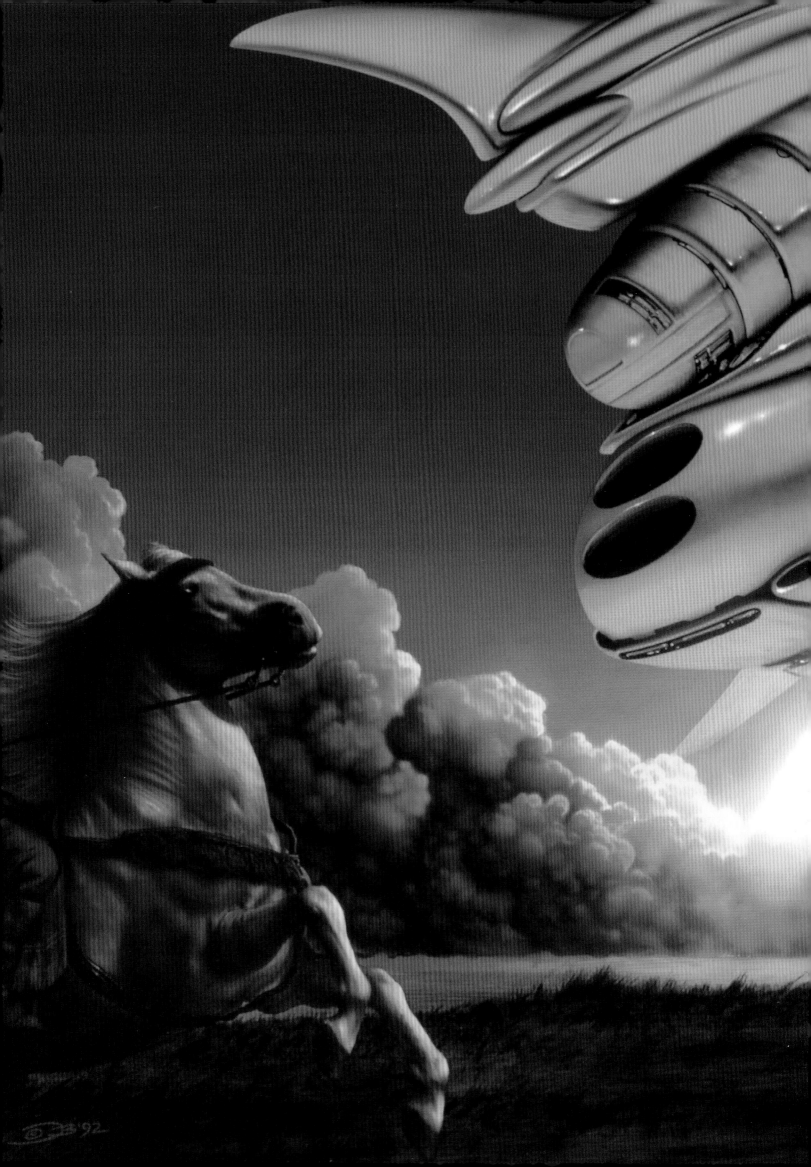

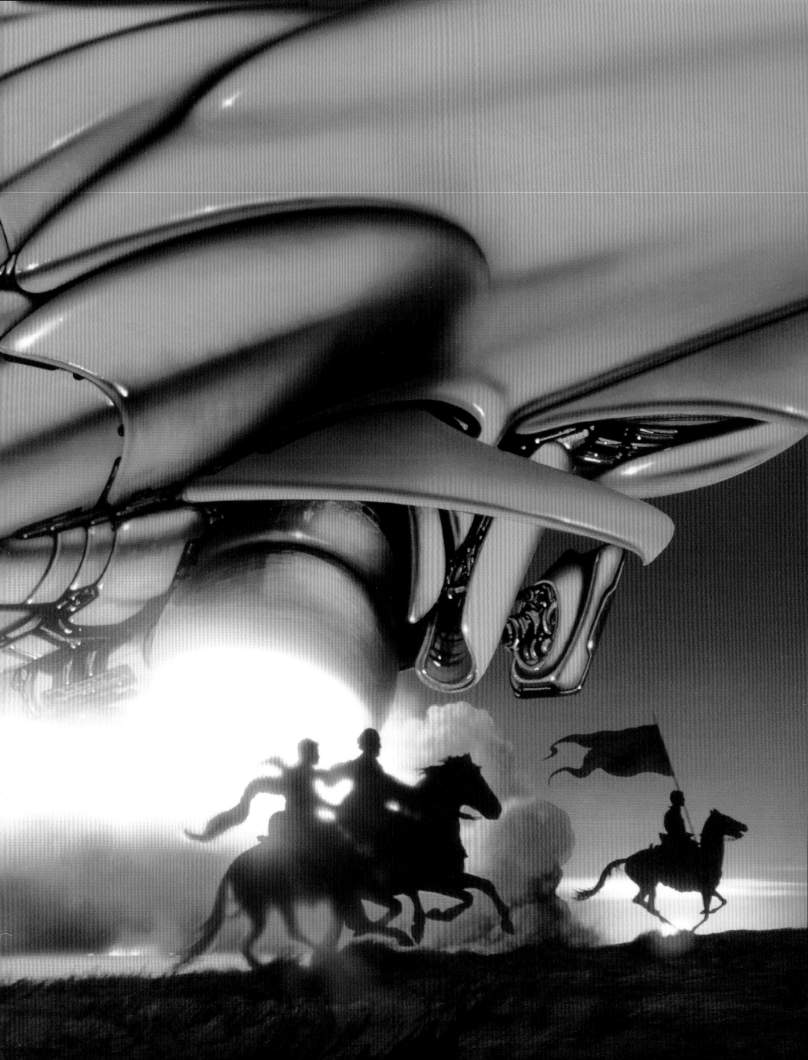

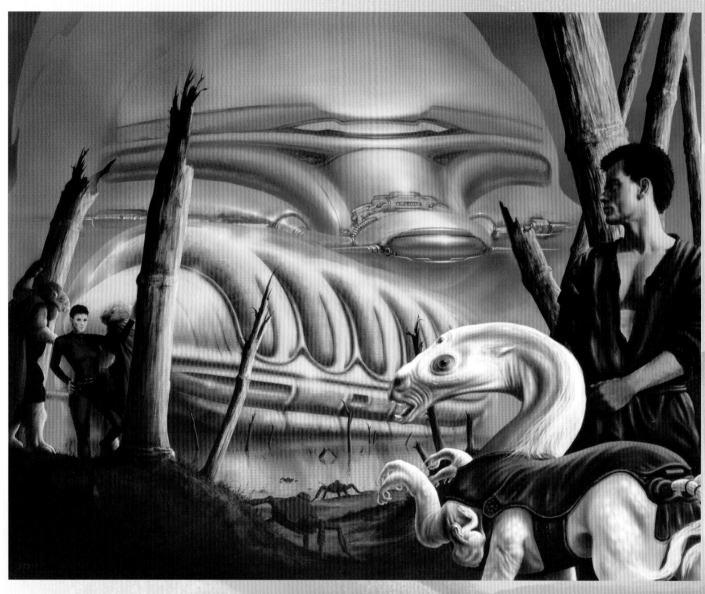

David Brin and I became good chums during his time living in the UK. His hugely entertaining *Uplift* novels, tales of billion-year-old intergalactic civilisations peopled by bizarre, bickering extraterrestrials and the heroic, 'wolfling' species Humanity, are a rich treasure trove of potential visuals. David paid me the compliment of buying the original for 'The River of Time' back in the mid 1980s and which he tells me still resides on his study wall above his desk.

Above: *Infinity's Shore* Acrylics. 1996
Right: *Heavens Reach* Acrylics. 1997
Opposite: *The River of Time* Acrylics. 1986

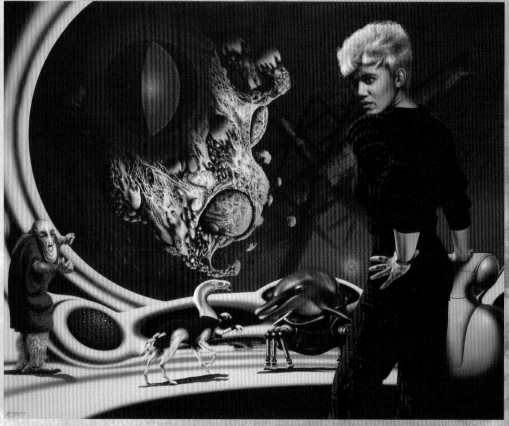

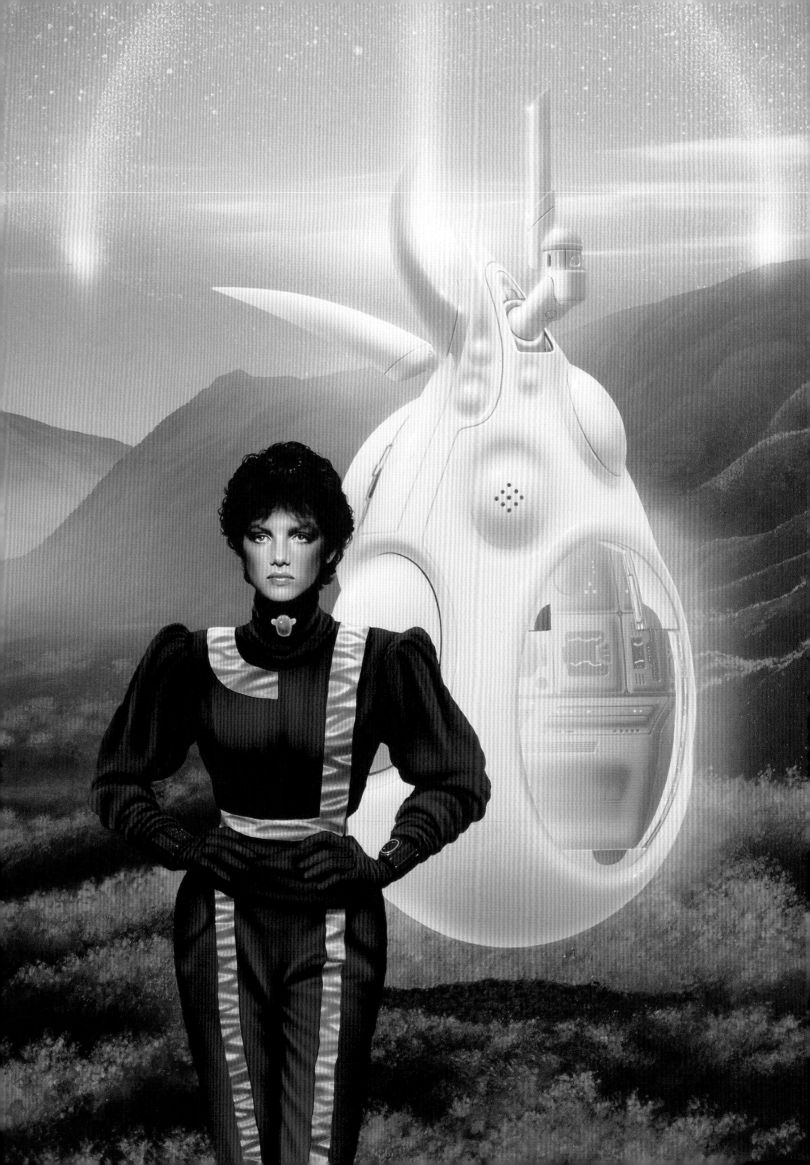

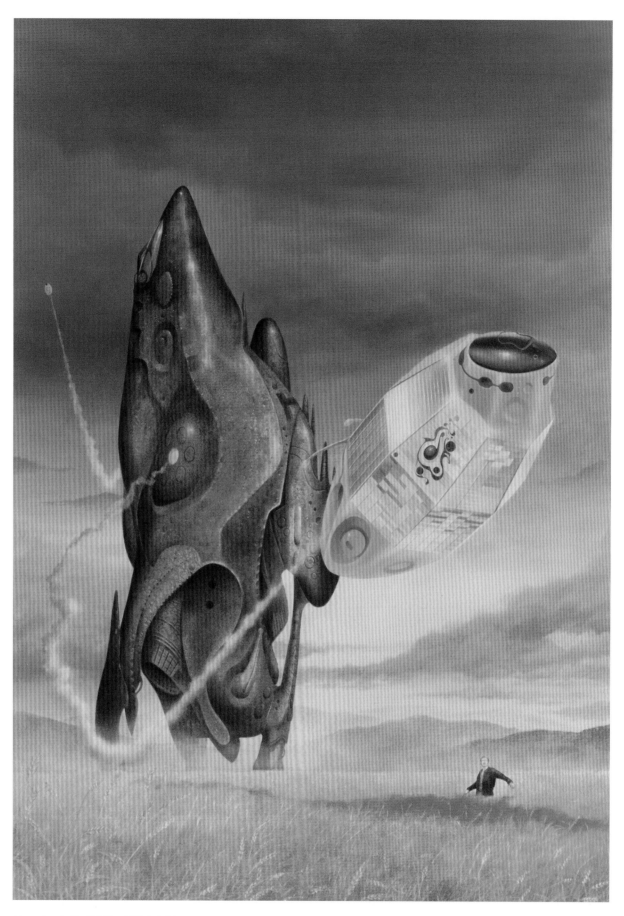

Above: *Let the Fire Fall* (Kate Wilhelm) Oils. 1977

Right: *Plasma Launch* (Personal) Digital. 2011

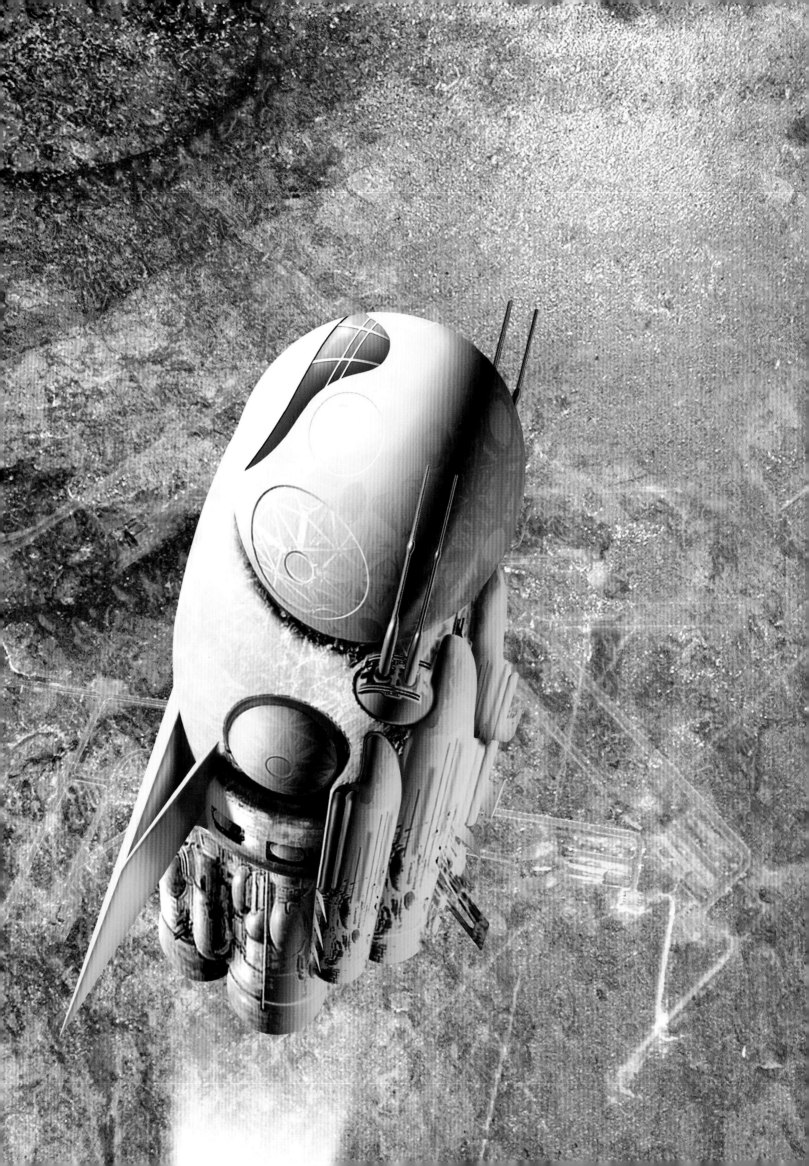

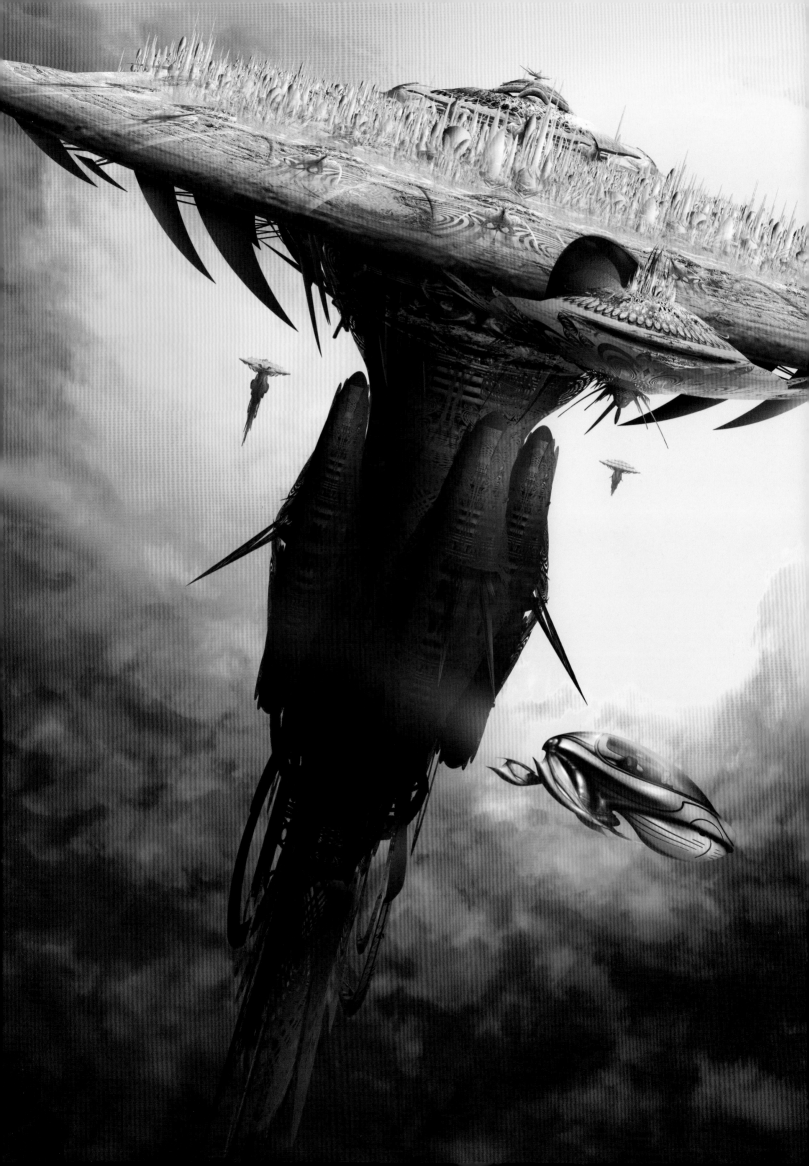

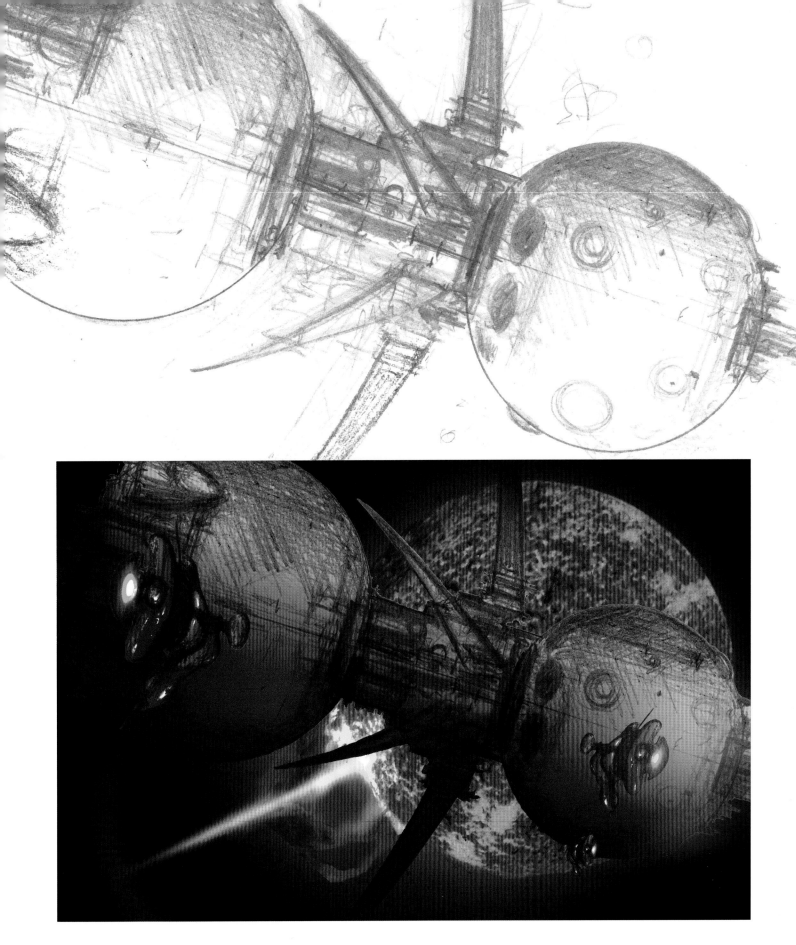

Hitching a ride on the imaginations of good writers has proved to be a mind-expanding journey over the last four decades. Every imagination is different, every evocation of some exotic off-world destination unique. I read a book as if I were watching a film. It unfolds visually in my mind's eye in precisely that way. The skill of the cover artist for these tales of strangeness is in some way to 'freeze-frame' some element or combination of elements in such a way as to convey in a snapshot something of the book's character, plotline and atmosphere.

Top: Moscow-Class ship from *Judas Unchained* Pencil sketch. 2005

Above: *Judas Unchained* Pencil/digital colour sketch. 2005

Opposite: *Transmission—Book 2 of The Ragnarok Trilogy* (John Meaney) Digital. 2011

Following Spread: *Judas Unchained—Book 2 of The Commonwealth Saga* (Peter F. Hamilton) Acrylics. 2005

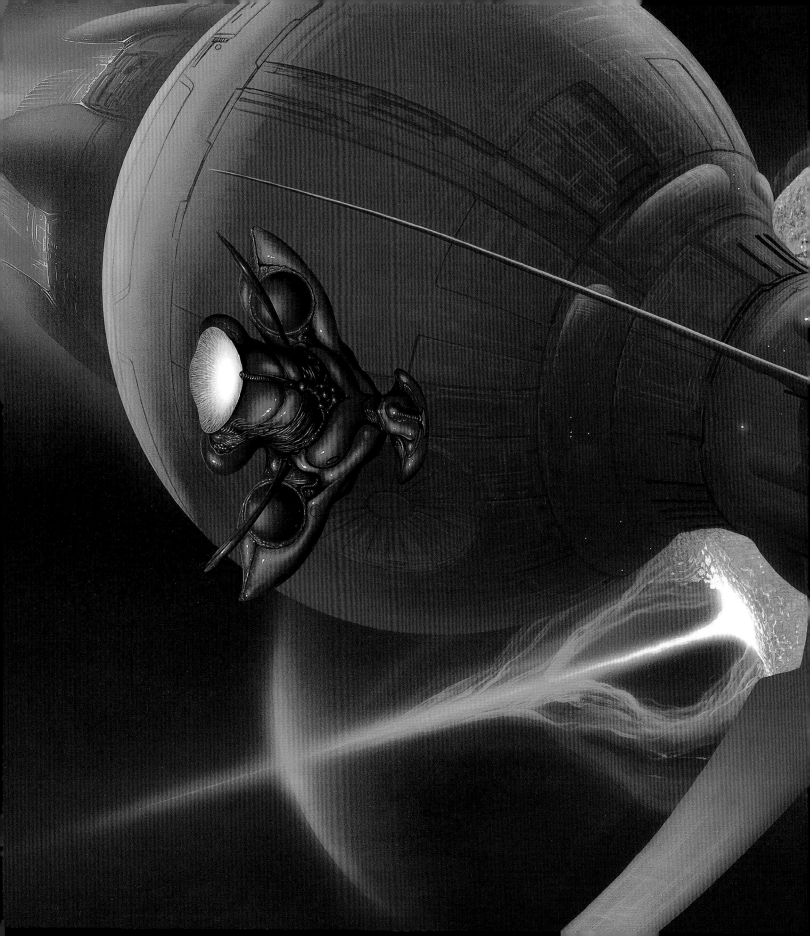

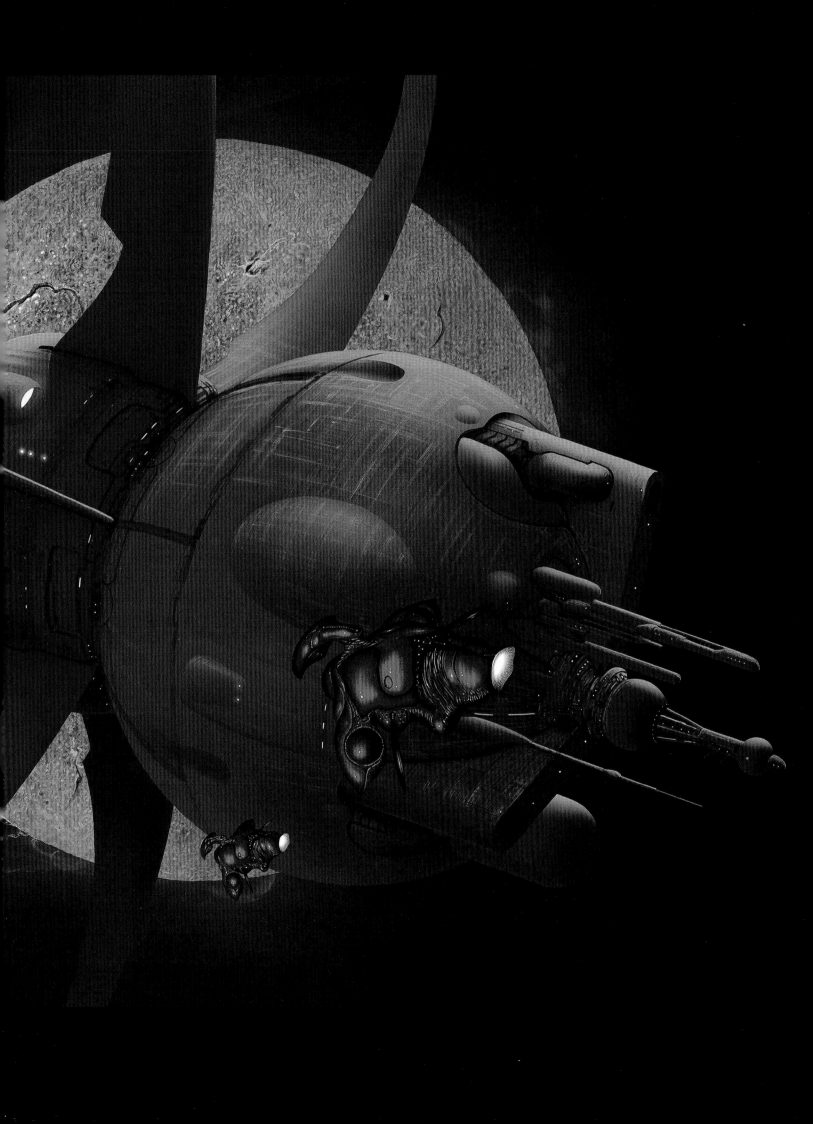

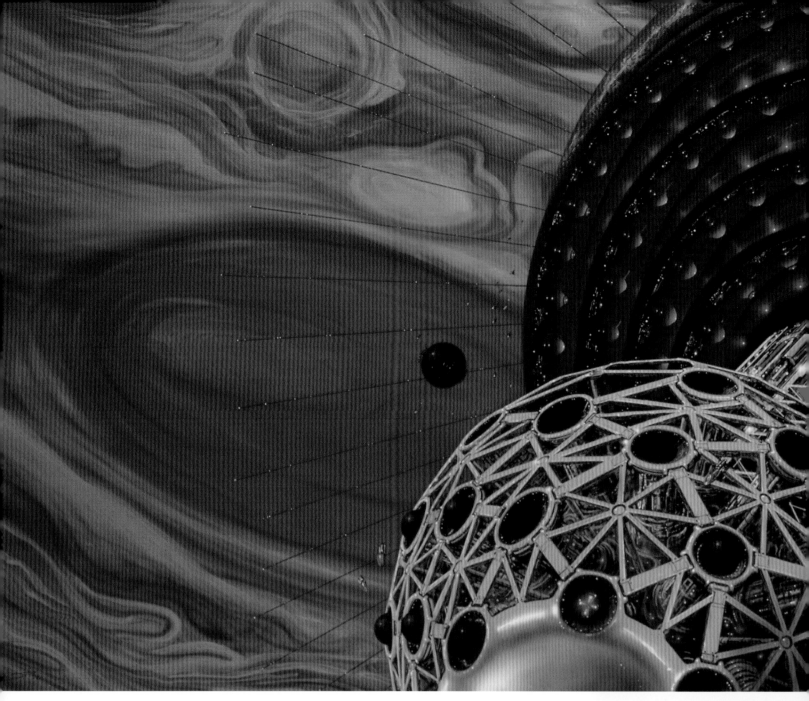

The first science fiction commission I received was in 1972 for a Damon Knight edited anthology called *Towards Infinity*. Technique-wise I was still finding my way. Coloured pencils and a bit of colour-wash aren't the most immediate of media for exciting science fiction stories and I also don't recall actually being given a manuscript to read. The image doesn't feature in this book unfortunately, as I have no good record of it.

My second commission, again in 1972 and again for a collection, this time by an author named Wyman Guin was 'Beyond Bedlam' after the longest story contained within its covers. It took me to a strange schizophrenic future a thousand years hence in which an enforced 'duality of personalities' supposedly nullifies Man's subconscious aggressions but which also means that human passion and art disappear. A very dystopian trip—a variation on Huxley's theme for his classic *Brave New World*.

Above: *The Neutronium Alchemist—Book 2 of The Night's Dawn Trilogy*
(Peter F. Hamilton) Acrylics. 1996

Opposite: *The Fallen Dragon* (Peter F. Hamilton) Acrylics. 2001

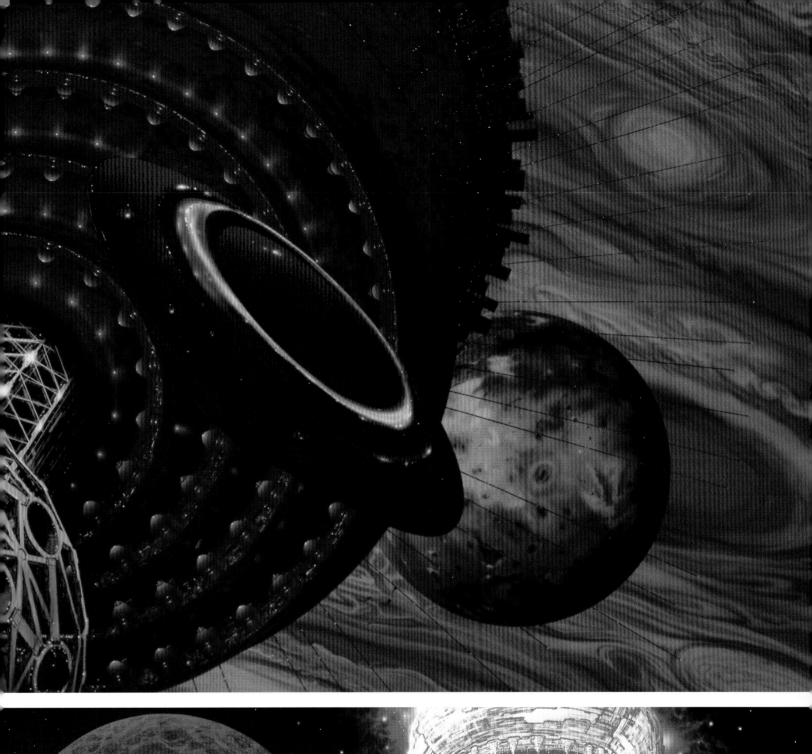
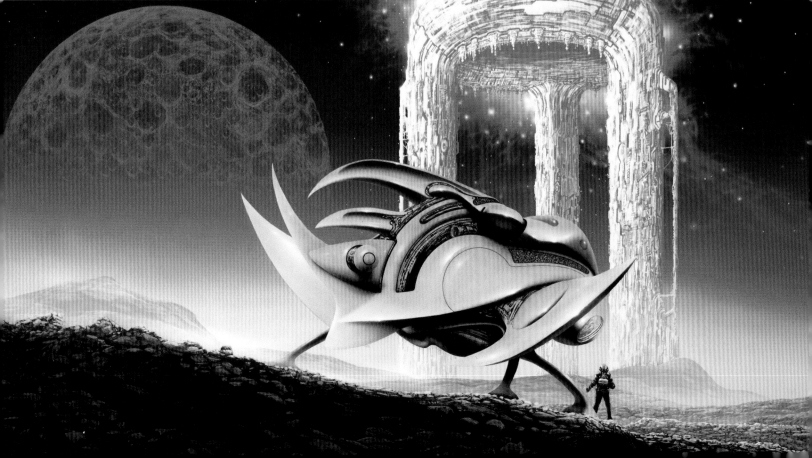

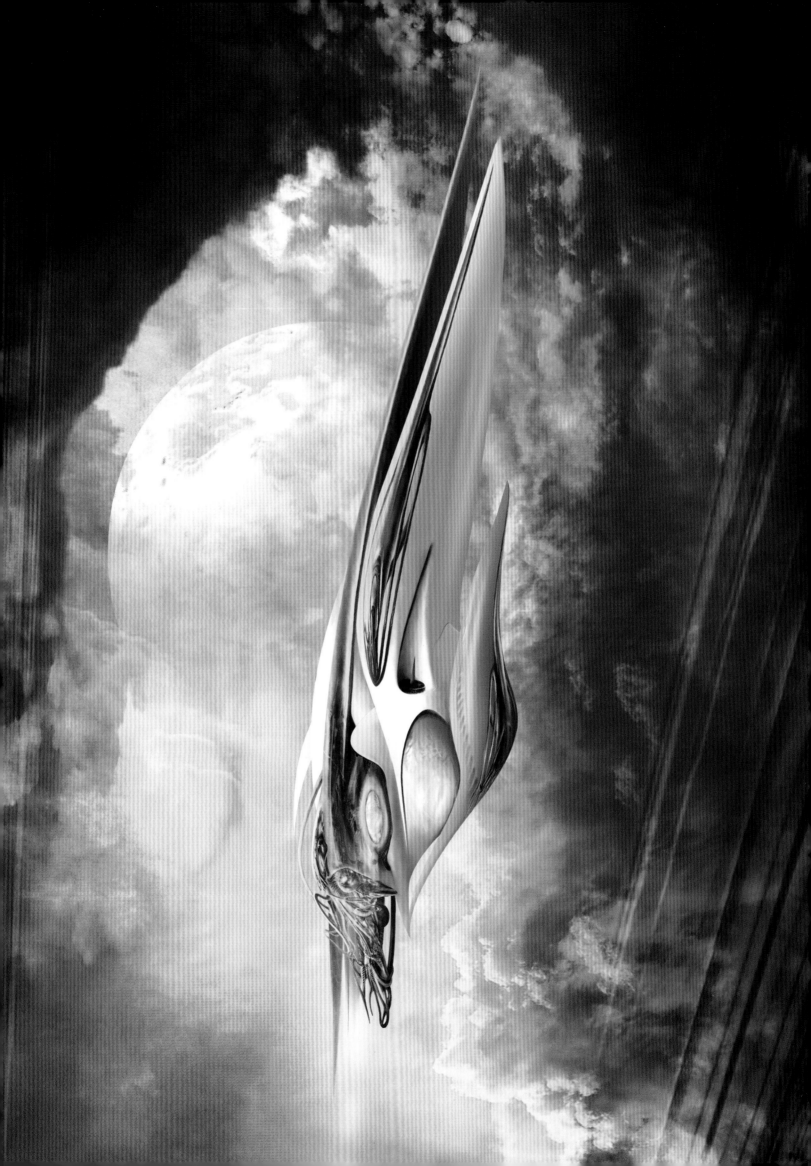

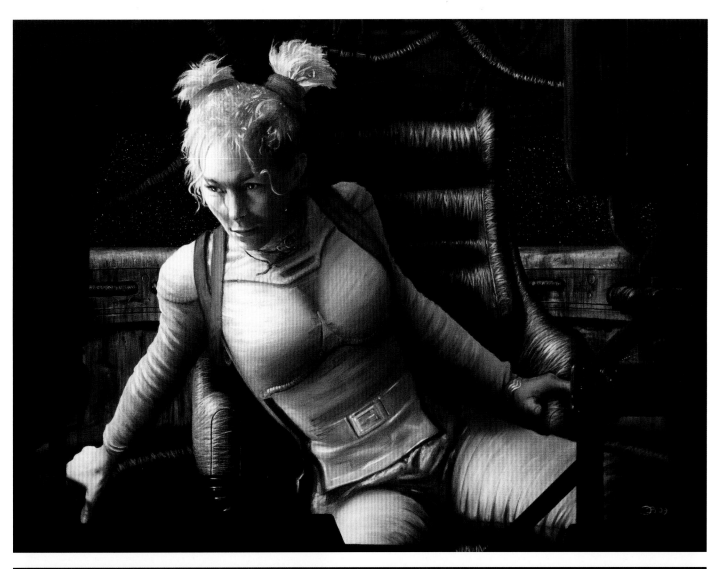

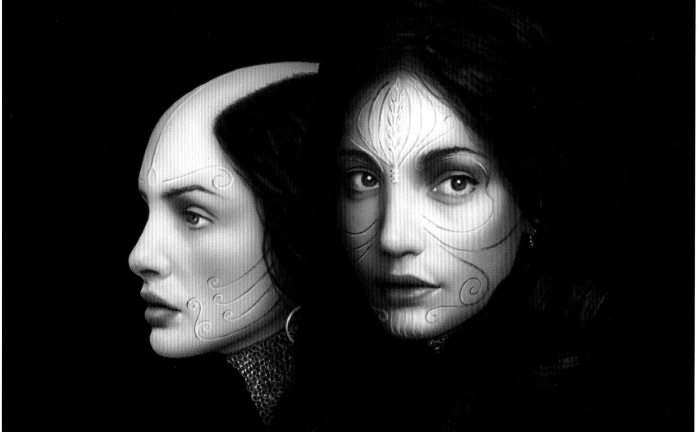

Left: *Tachyonic* (Personal) Digital. 2013

Top: *Pod Shift* (Personal) Acrylics. 2009

Above: *Oolita and Kathein—detail from Courtship Rite*
(Donald Kingsbury) Acrylics. 2006

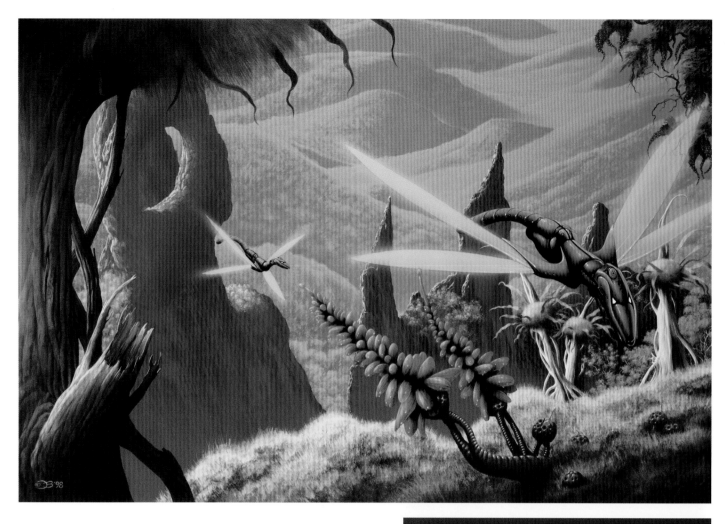

The job I found myself doing meant that over the following years, I discovered writers within the genre I'd never heard of. In short order I became fairly well read—at least within the literary boundaries of science fiction and, occasionally fantasy and horror. Oh, what transports of delight! To find myself, for instance, in the company of that great world-builder and master of the planetary romance, Jack Vance—one week to the planet, Durdane, crossing the continent of Shant alongside young Gastel Etzwane, the next aboard the ship Miraldra's Enchantment on the River Vissel in *Showboat World*. Then onwards to the vast *Big Planet* and then the ever-shifting landscape of *Marune: Alastor 933* a planet locked into the strange celestial physics of a hierarchical quadruple star system. His exotic and complex *The Gray Prince* introduced me to a dense and fascinating world where, after a long period of harmonious co-existence, three human and two alien societies now find themselves at each others' throats.

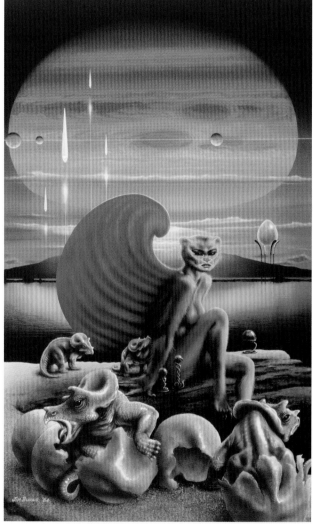

Top: *Bios* (Robert Charles Wilson) Acrylics. 1998

Right: *The Conglomeroid Cocktail Party*
(Robert Silverberg) Acrylics. 1984

Opposite: *Space Opera* (Anthology) Acrylics. 1996

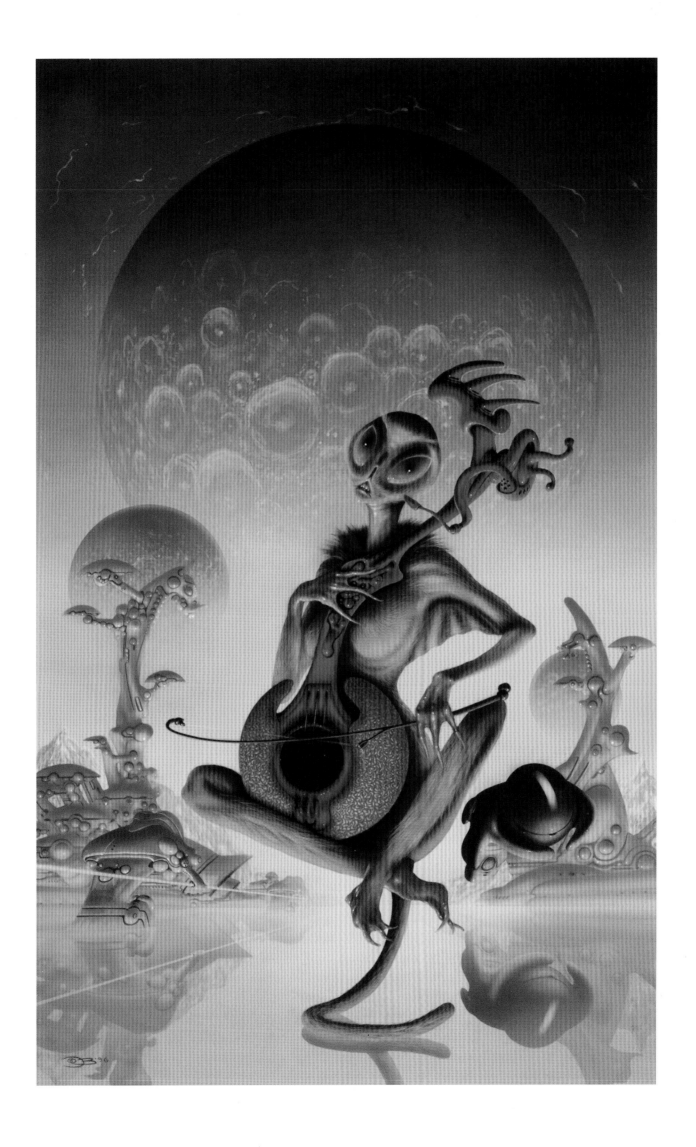

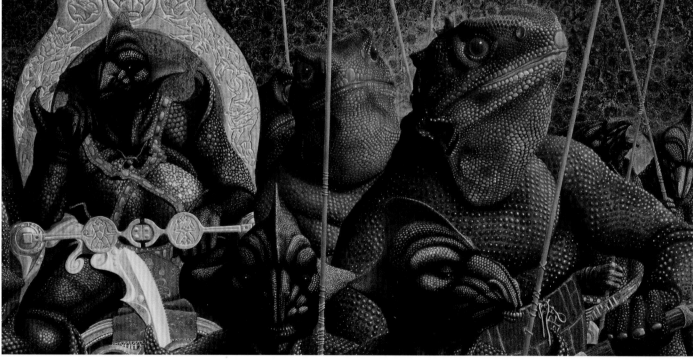

Top: *The U.S.E. Execrable* Oils. 1977-78
Above: *King Kroakr* Oils. 1977-78

Opposite Page
Top: *Styrene Fome* Oils. 1977-78
Middle: *King Ratt of Kroo* Oils. 1977-78
Bottom: *Poo-bombers* Oils. 1977-78

For two years I spent my time hilariously tooling around Harry Harrison's wonderfully comic world of the absurd Strabismus in the company of innocent Private Parrts, top-heavy Styrene Fome and psychotic Colonel Kylling—in our collaborative venture, Planet Story. As 'light' a read as it is, it was a hugely important project for me. Two years of a regular monthly income, the opportunity to truly begin to develop something resembling a personal 'voice'. Getting acquainted with the inimitable Harry Harrison—the first 'pro' writer in the field I got to know personally. At the promotional event for the book at Seacon '79, where I joined Harry for my first signing session and also exhibited all my paintings for the book, I first became aware of the world of convention-going. I had been completely unaware of these gatherings until then and I realised at that moment that in fact I was a member of a very large club of similarly-minded people. I became a 'fan'.

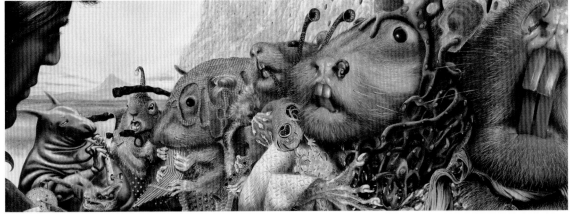

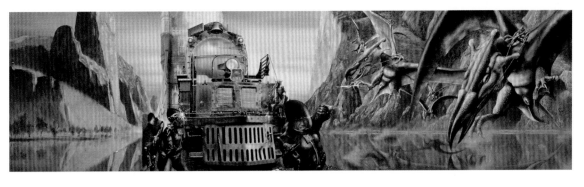

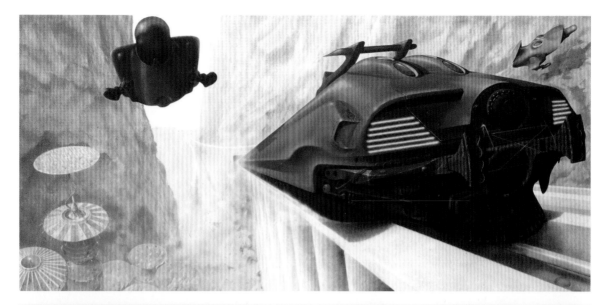

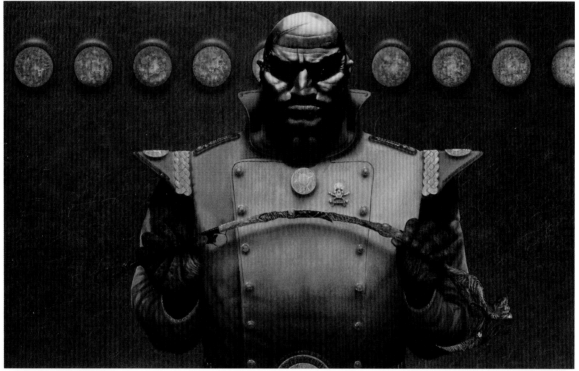

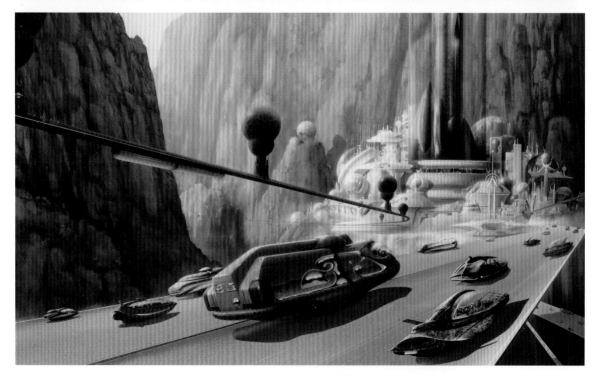

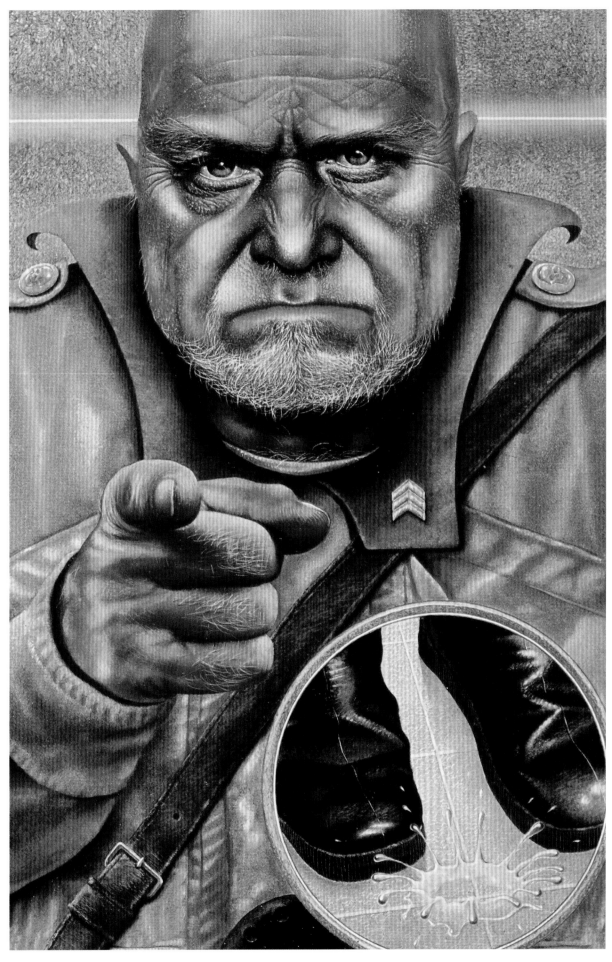

Opposite Page

Top: *Supertrain—sample painting for Planet Story project*
(Personal) Oils. 1977-78

Middle: *Colonel Kylling* Oils. 1977-78

Bottom: *Earthport -Tour of the Universe* (Personal) Oils. 1980

Above: *You do find me attractive, Parrts, don't you?*
Oils. 1977-78

Following spread: *Seasons of Plenty*
(Colin Greenland) Acrylics. 1994

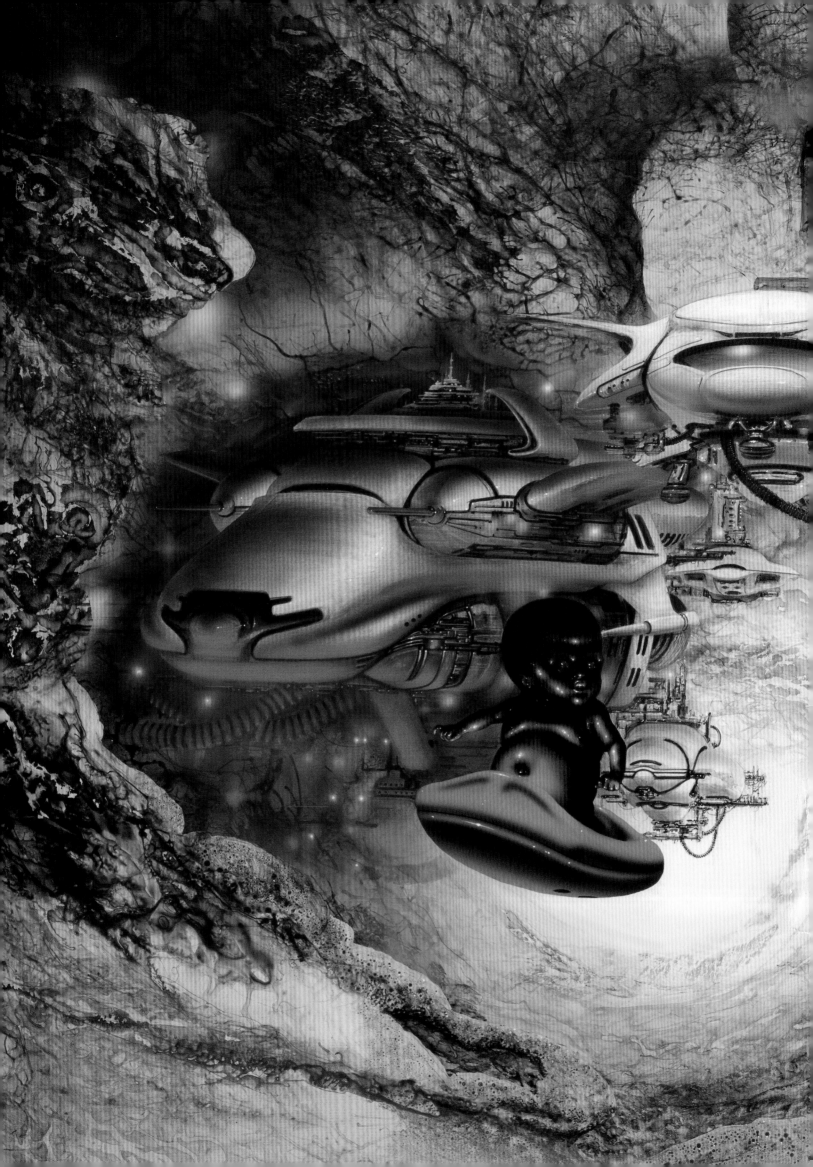

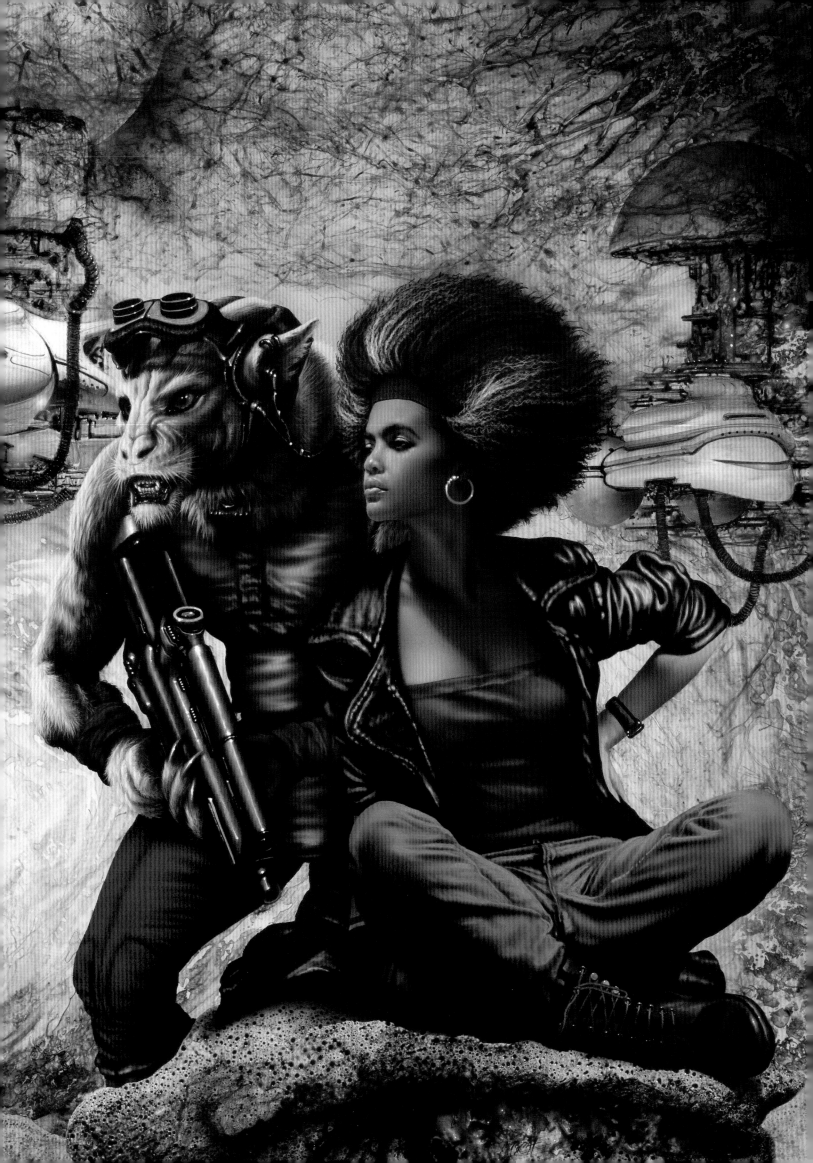

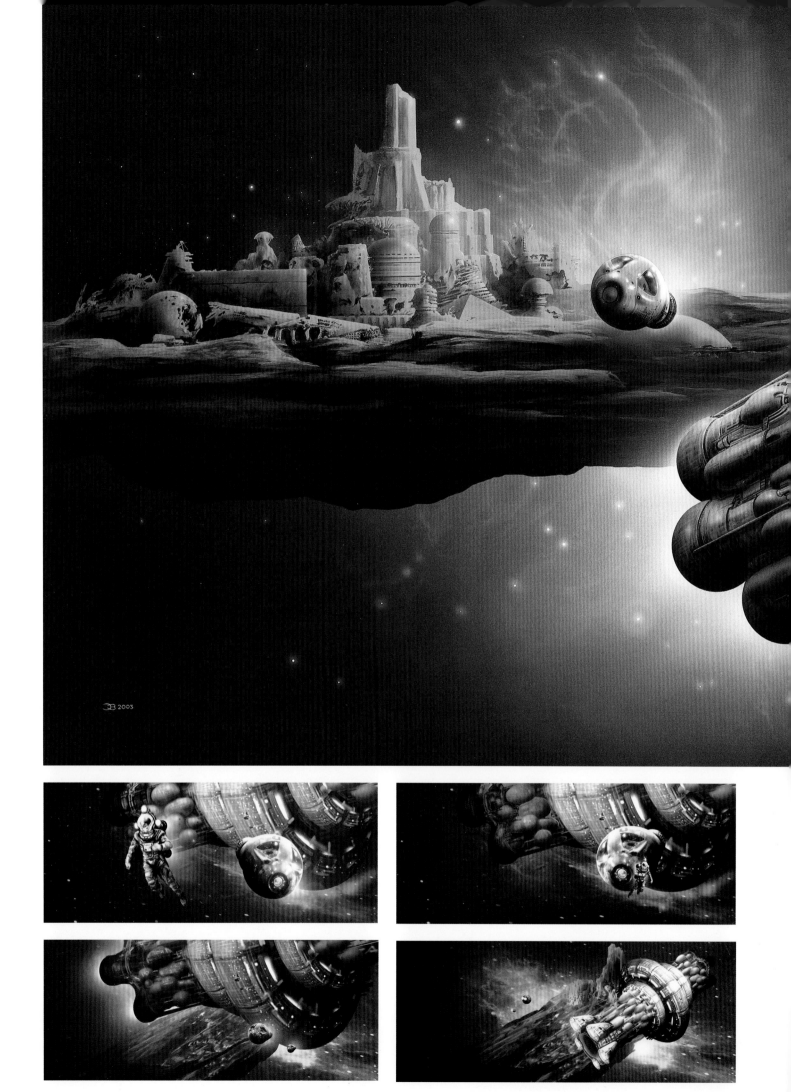

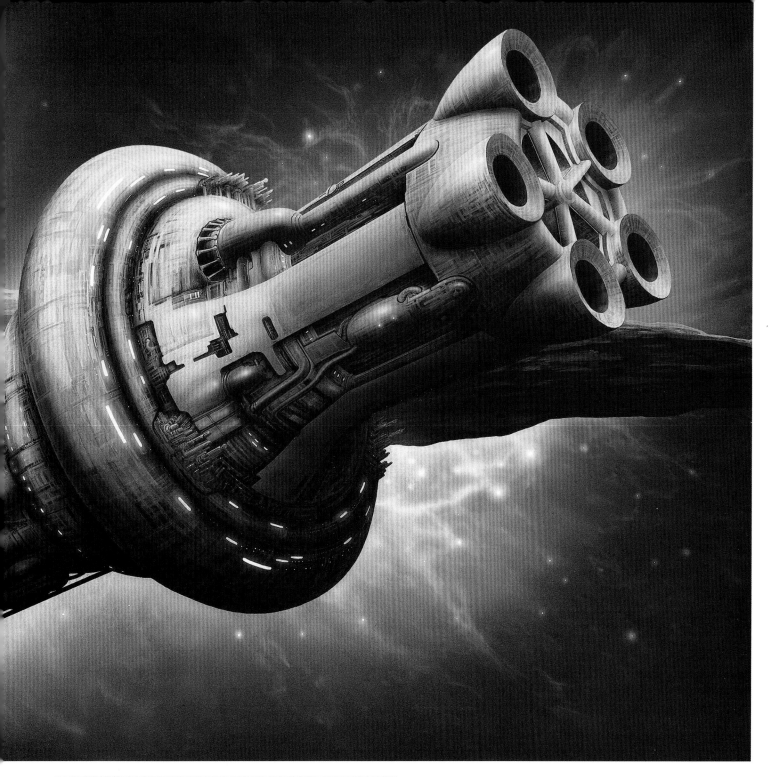

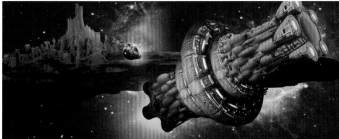

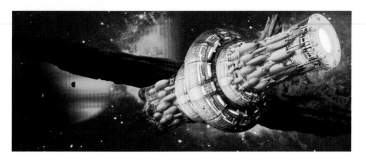

In Kate Wilhelm's *Let The Fire Fall* I would be back on Earth with a tale of an alien baby crash landing in a cornfield and making his way in a fearful and paranoid world. Jack Williamson, the 'Dean of Science Fiction', took me, in *Brother To Demons, Brother To Gods,* to a future peopled by premen, trumen, mumen, stargods and ultimen—the products of genetic tinkering. Later I would revisit Williamson in *Manseed*—a tale of Man's ambitions for his own continued existence by sending seedships containing human DNA out into the universe. Then Williamson's *Lifeburst* revealed a complex alien civilisation living unknown to us in the Oort Cloud.

All these books I illustrated. Many and varied are the themes of science fiction.

Top: *Pandora's Star—Book 1 of The Commonwealth Saga* (Peter F. Hamilton) Acrylics. 2003

Left: *6 digital 'sketches' for Pandora's Star*

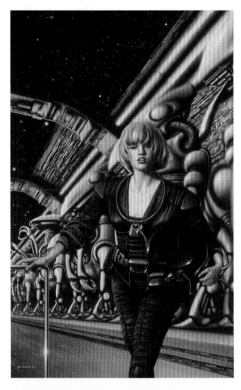
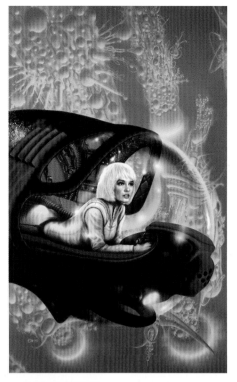
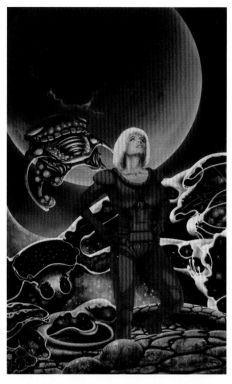
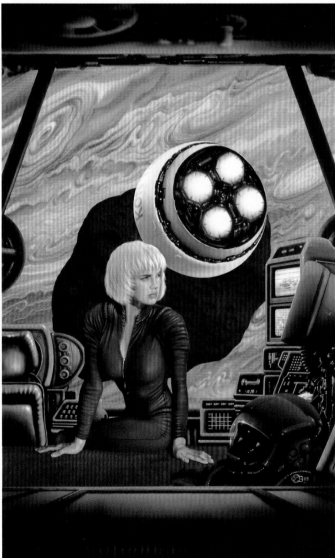
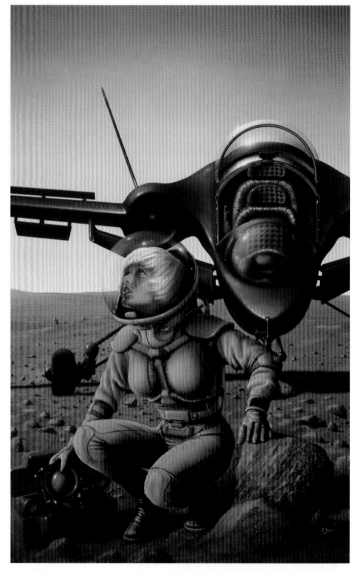

Between 1987 and 1990 I created six covers for a series of books written by Paul Preuss, all based on short stories by Arthur C. Clarke. The stories follow the beautiful, biotech-engineered young woman Sparta on her voyage of self-discovery.

Top Row Left to Right

Volume 1—Breaking Strain

Volume 5—The Diamond Moon

Volume 6—The Shining Ones

Bottom left: *Volume 4—The Medusa Encounter*

Bottom right: *Volume 3—Hide and Seek*

Opposite: *Volume 2—Maelstrom*

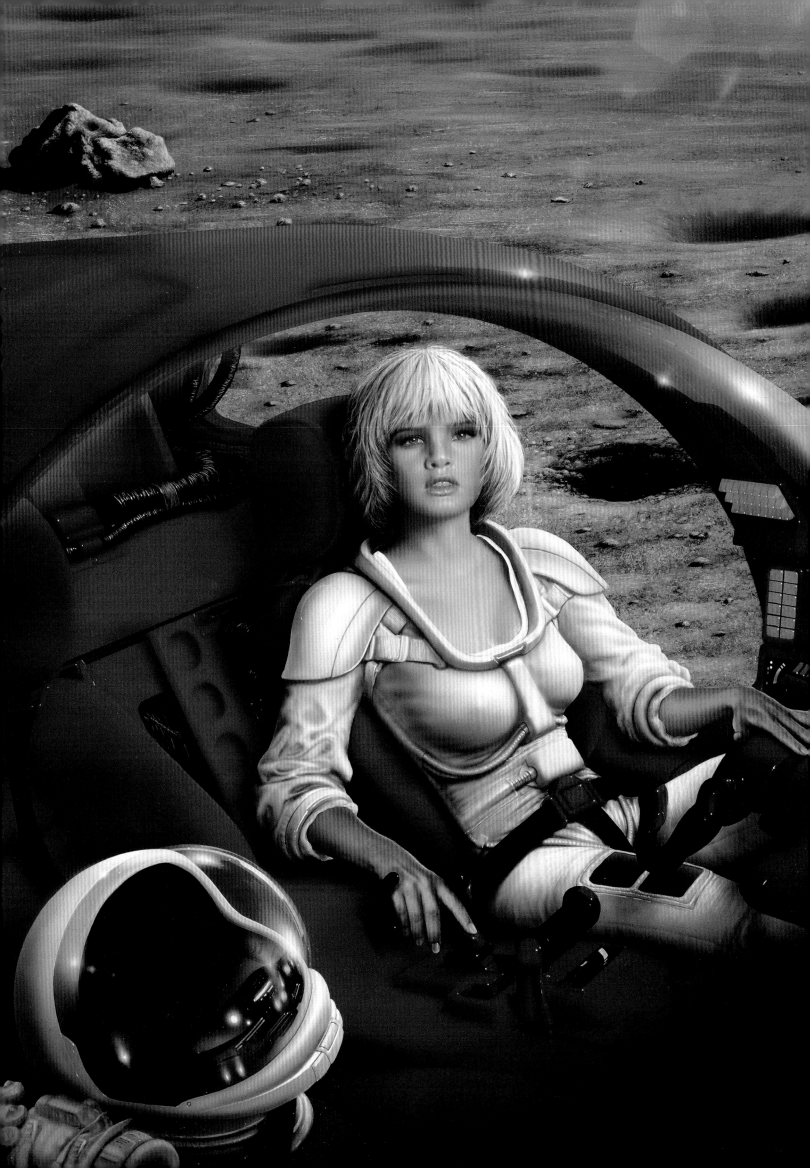

The second half of the 1970s saw a move into oil paints after years of fighting with gouache and experimenting unsuccessfully with acrylics. All of *Planet Story* was accomplished using oil paints. I found myself, with other artists, collaborating further with Harry Harrison on books like *Great Balls of Fire* and *Mechanismo*. The publisher also partnered myself and other artists on further collaborations with editor and critic Malcolm Edwards and novelist Rob Holdstock. One of these latter collaborations, *Alien Landscapes,* meant that I was to meet, albeit briefly, a writer-hero by the name of Arthur C. Clarke. Some of my most memorable voyages of the imagination had been under the sure guidance of Clarke. I think at this time I regarded him as my favourite writer of hard science fiction ever since viewing, at the age of 20, the seminal movie *2001: A Space Odyssey* (based on Clarke's short story *The Sentinel*—written in 1948, the year of my birth). I had read a lot of Clarke by the time I met him.

Above: *The Dreaming Void—Book 2 of The Void Trilogy*
(Peter F. Hamilton) Acrylics. 2007
Right: *A Second Chance at Eden* (Peter F. Hamilton) Acrylics. 1998

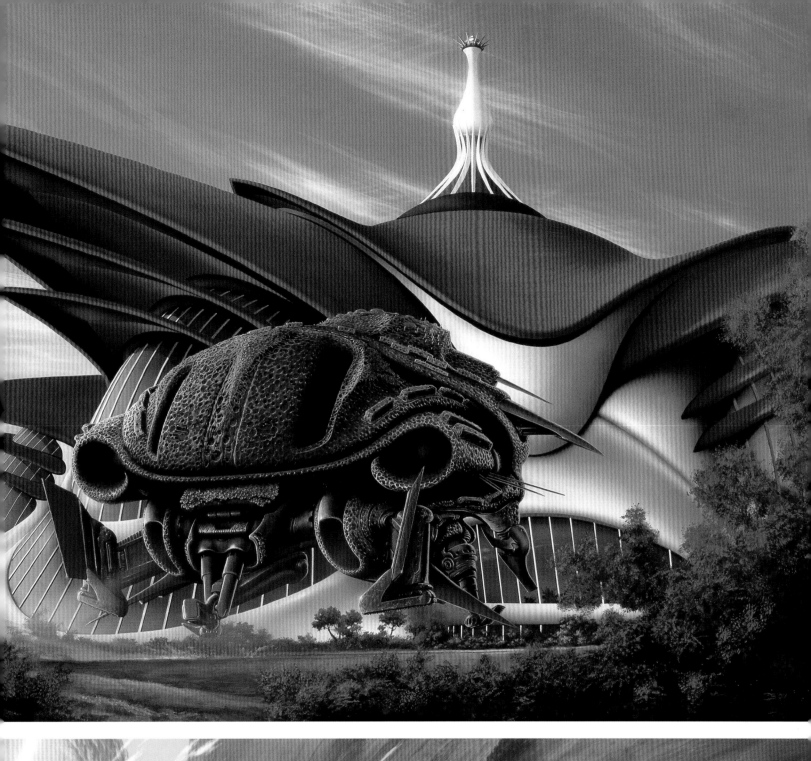
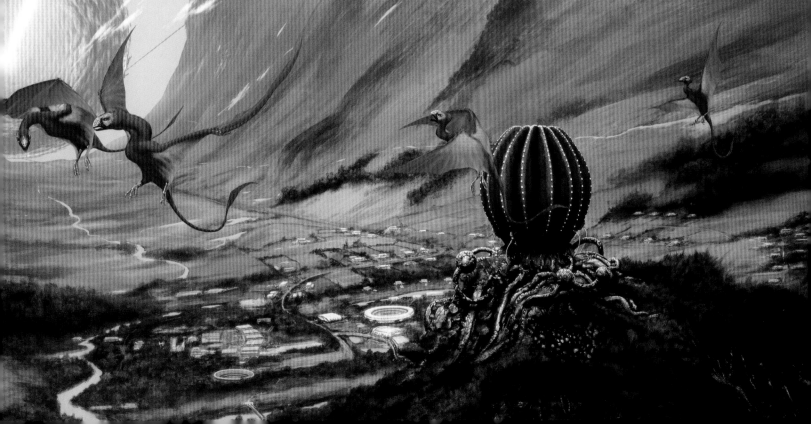

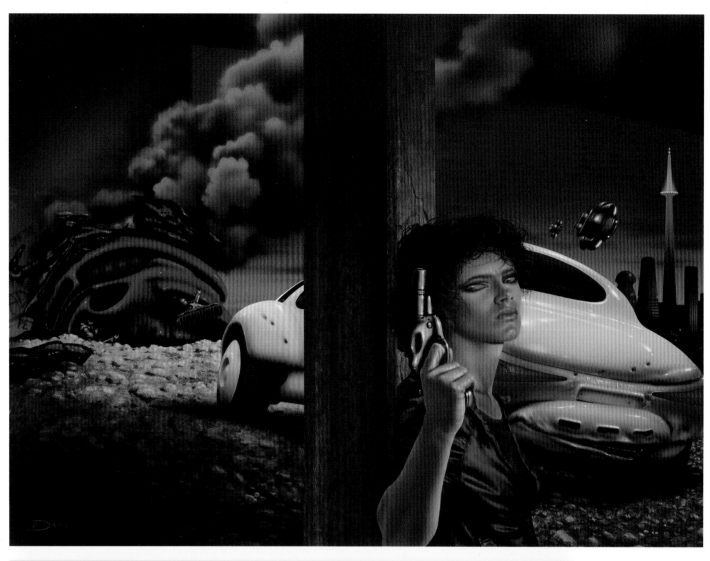

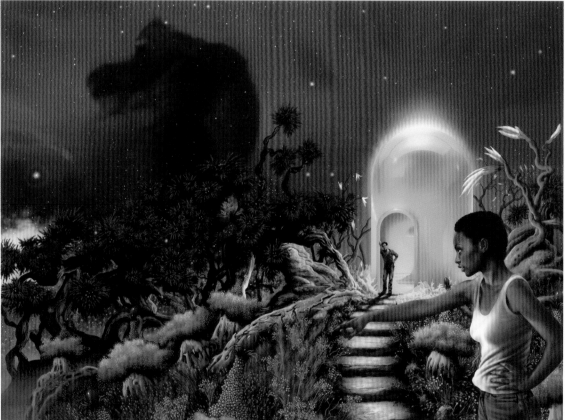

Above:
*Emperors of the Twilight—
Book 2 of the Moreau Trilogy*
(S. Andrew Swann) Acrylics.
1993. Featuring Evi Isham—a
genetically engineered
human—known as a 'Frank'
(after Frankenstein). The
other two volumes also
feature strange humans
much tampered with
genetically—both to be
found elsewhere in this book.
Look out for the tiger-man
and the rabbit-girl.

Left: *Ancient Shores* (Jack
McDevitt) Acrylics. 1995

Opposite Top:
Crossfire (Nancy Kress)
Acrylics. 2002

Opposite Bottom:
Red Dust (Paul J. McAuley)
Acrylics. 1992

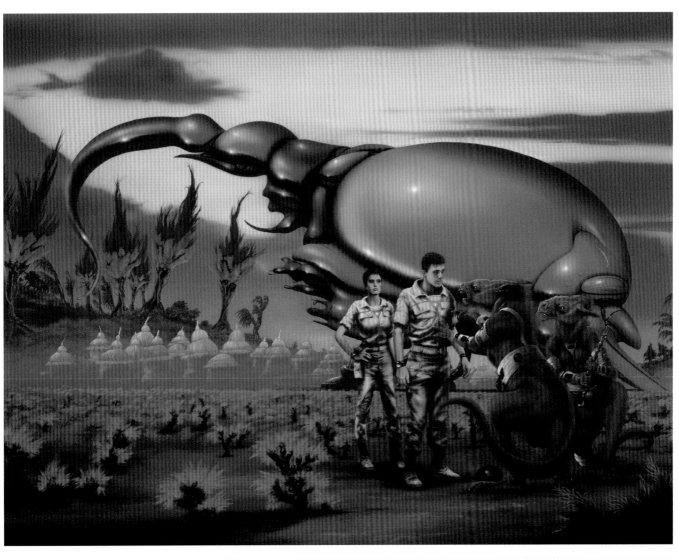

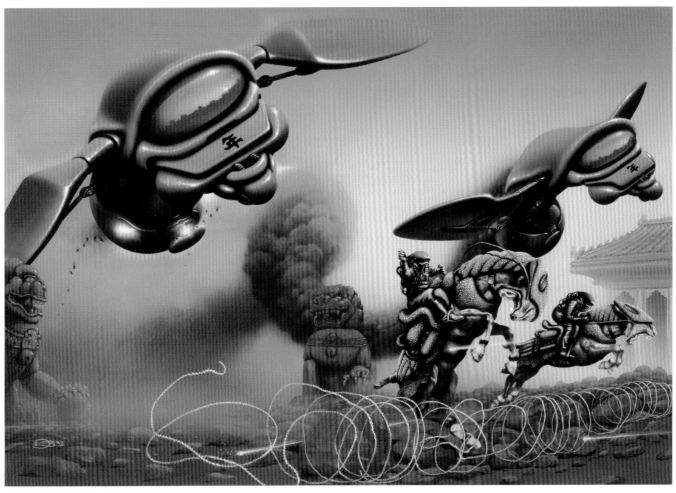

53

Top: *Slant* (Greg Bear) Acrylics. 1998. As well as being a superb writer, Greg is also an artist and knowing that, I asked him to sketch the evocatively named 'Swanjet' for me. The graceful machine in the sky is essentially Greg's design.

Above: *Eon* (Greg Bear) Acrylics. 1986. 'Bigger on the inside than on the outside'. The kind of physics-defying artifact I love in science fiction!

Opposite: *Context—Book 2 of the Nulapeiron Sequence* (John Meaney) Acrylics. 2007

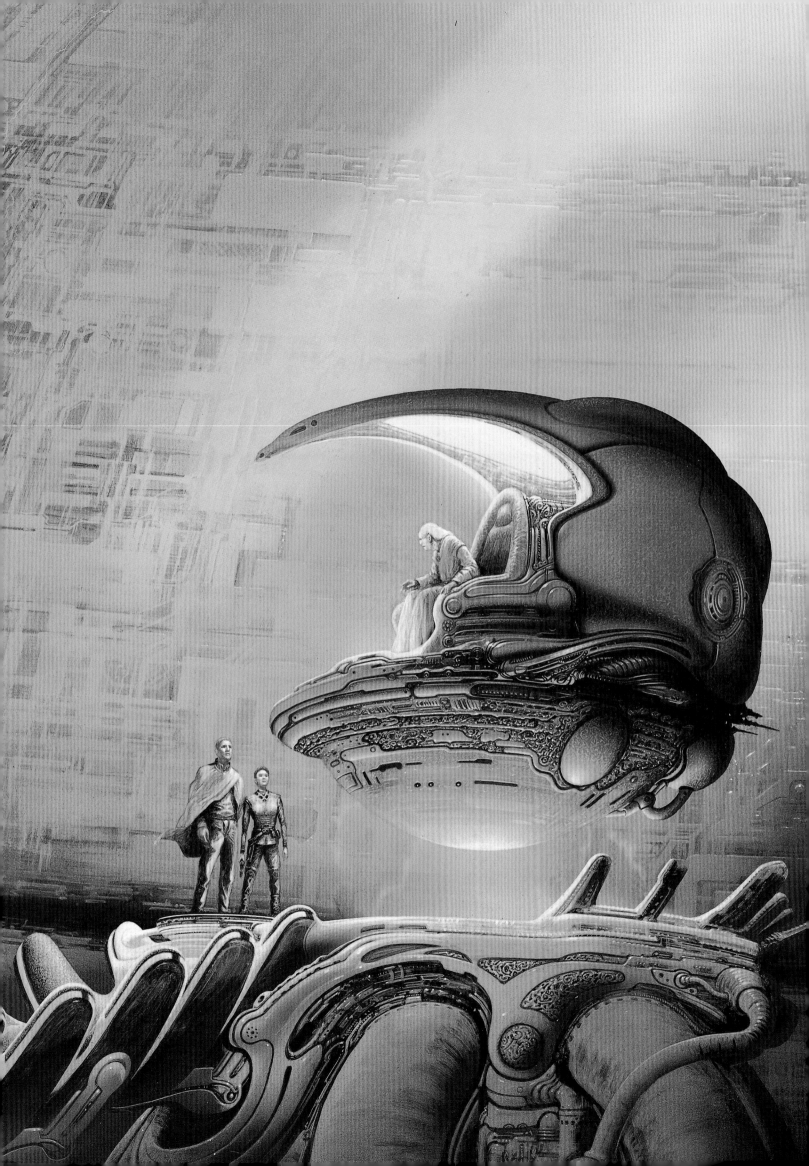

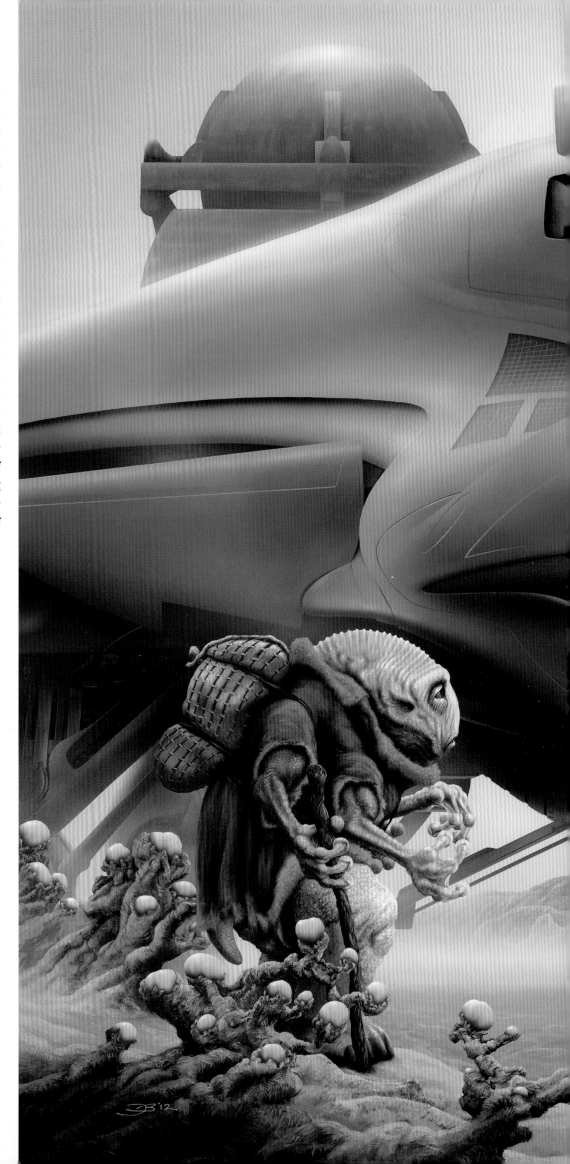

My contribution to *Alien Landscapes* had taken me aboard one of the most iconic 'machines' of science fiction—the 54 kilometre long alien cylinder ship known to us puny Earthlings as 'Rama' after the Hindu god. How I loved the feeling of awe in Clarke's writing. That sense of vast alien intelligences and we humans clambering like ants around the artifact. Then Rama's eventual automatic powering up by enormous hidden energies and moving out from our solar system, slingshotting around our sun off in the direction of the Large Magellanic Cloud—as grand, enigmatic and unknowable as at its entrance. It was immensely satisfying to stand in front of my three paintings illustrating his wondrous tale and hear his generous comments of approbation.

This Spread: *Wanderers* (Personal idea commissioned by Pat and Jeannie Wilshire, founders of Illuxcon) Acrylics. 2012

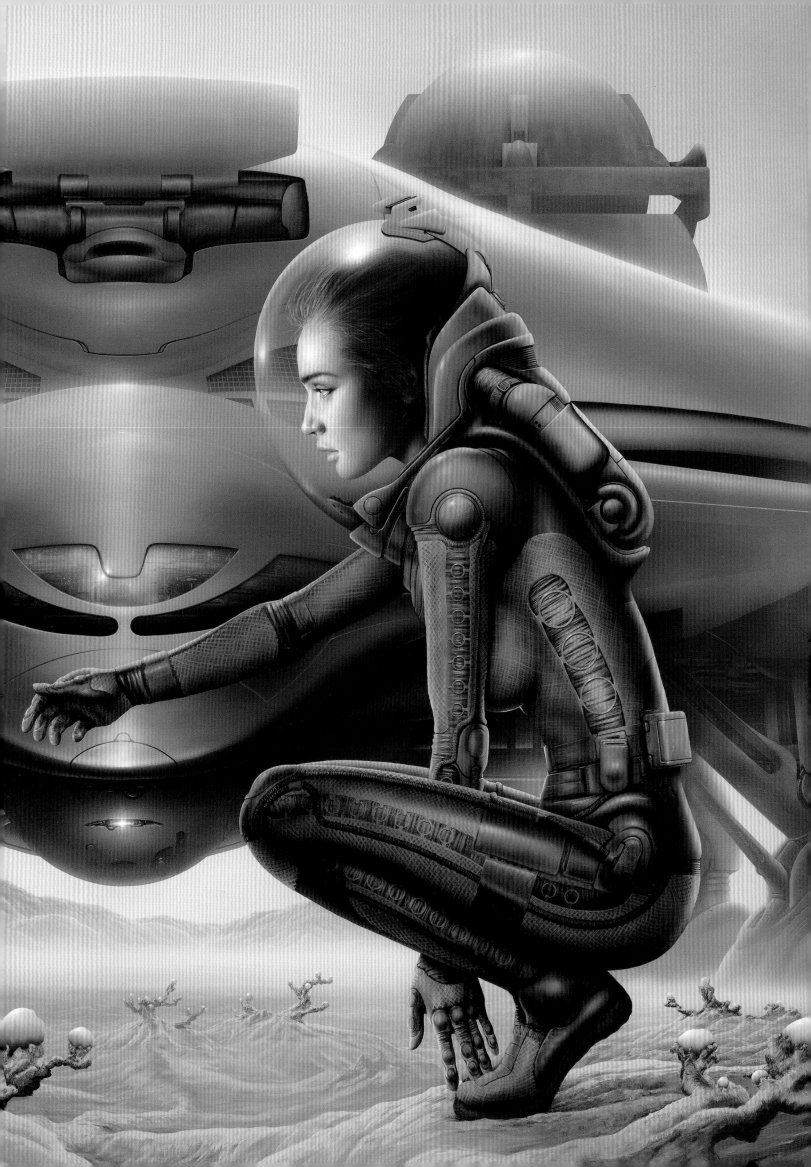

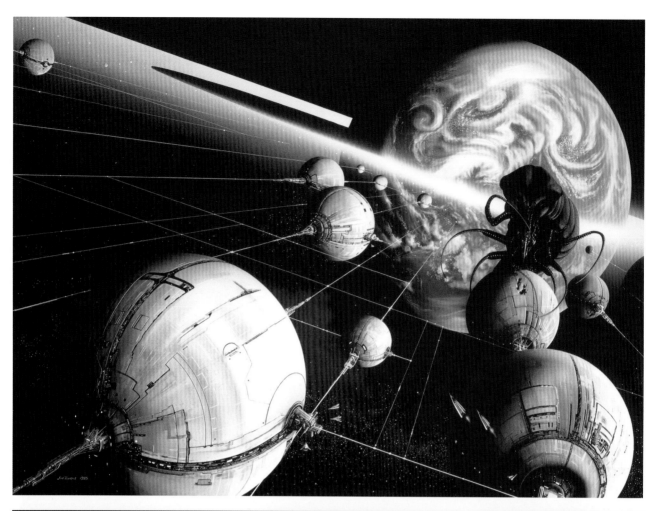

Top: *Lifeburst* (Jack Williamson) Acrylics. 1985

Above: *Refuge* (Personal) Oils. 1980

Opposite Top: *The Long Run* (Daniel Keys Moran) Acrylics 1989

Opposite Bottom: *Mechanismo.* (Personal) Oils. 1978

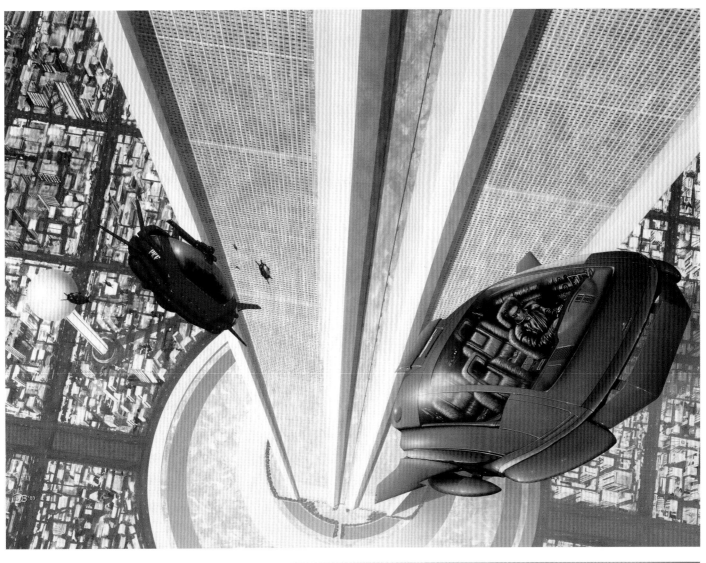

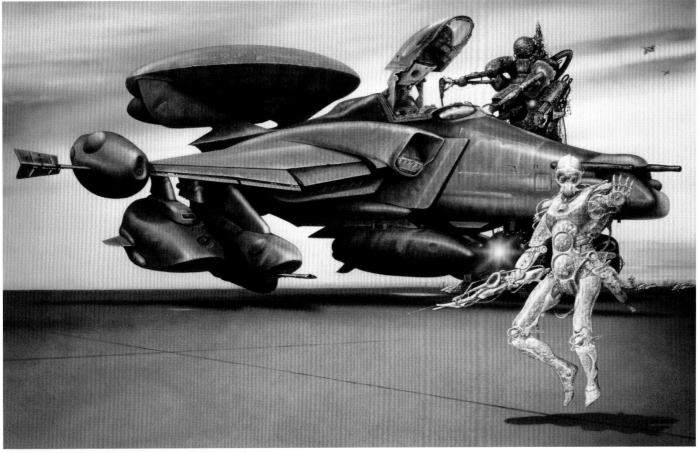

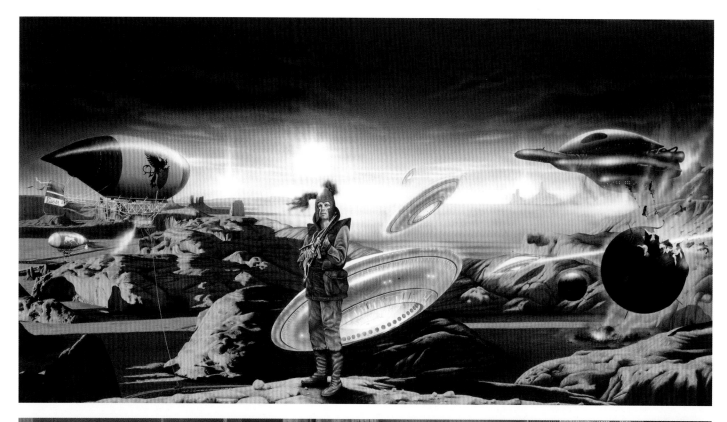

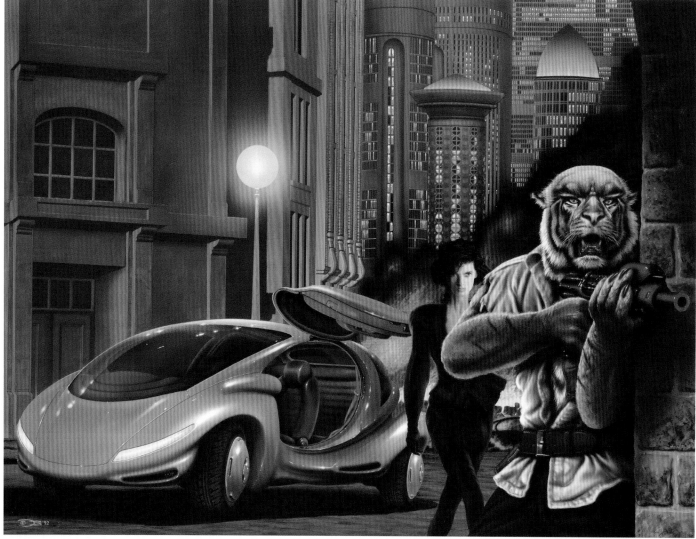

Top: *Durdane—the triptych for The Anome, The Brave Free Men and The Asutra* (Jack Vance) Gouache. 1974

Above: *Forests of the Night—Book 1 of the Moreau Trilogy* (S. Andrew Swann) Acrylics. 1992

Opposite: *Crucible* (Nancy Kress) Acrylics. 2003

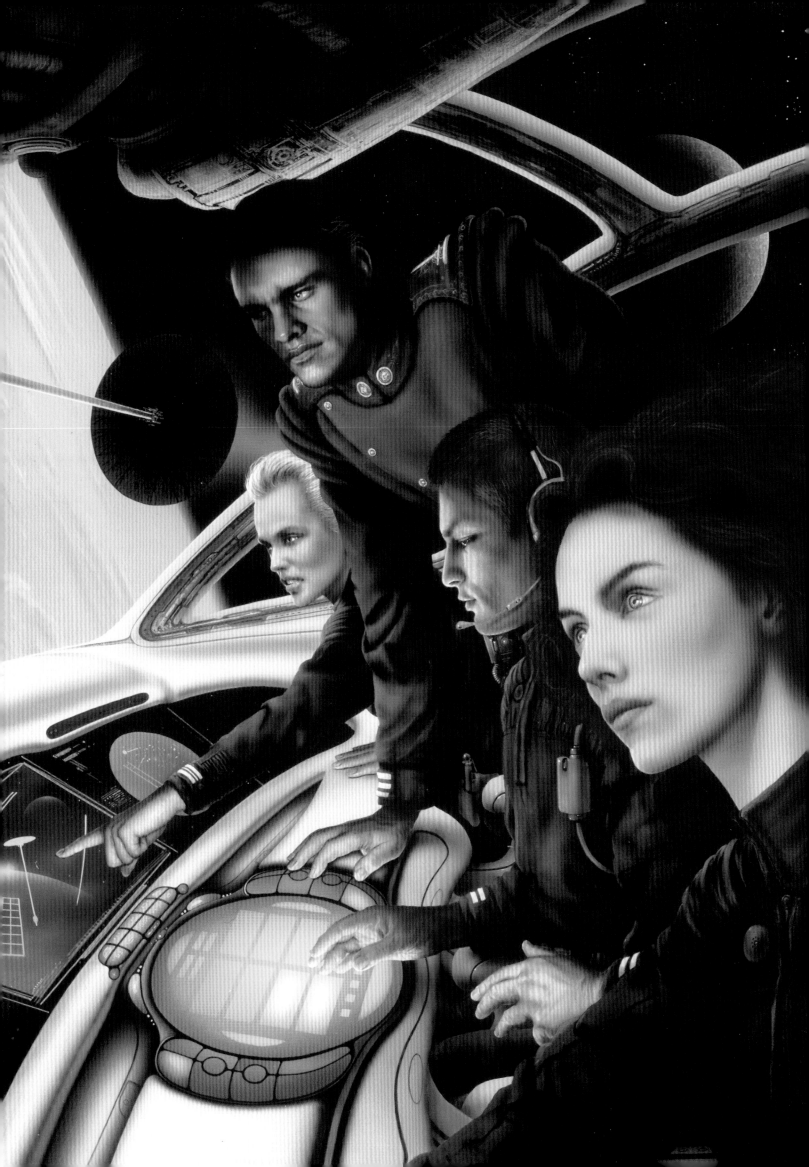

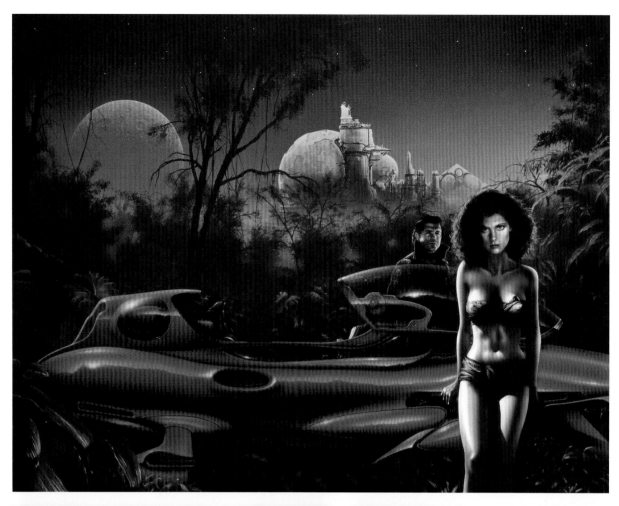

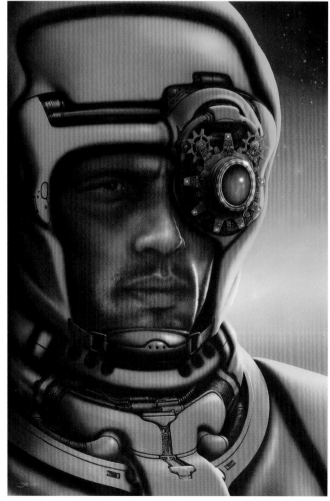

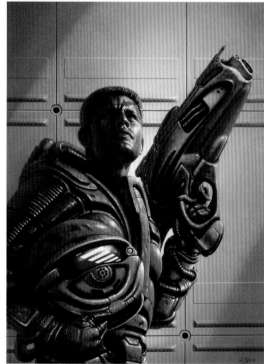

Top: *The Lovers* (Philip José Farmer) Acrylics. 1982. Brilliant, ground-breaking SF which broke the taboo on sex in science fiction when it was first published in 1953.

Above: *Armor* (John Steakley) Acrylics. 1996

Left: *The Forever War* (Joe Haldeman) Acrylics. 2003. This is the Eos edition. I've now done three different versions of *The Forever War*.

Right: *Tea From An Empty Cup, Mindplayers, Fools* (Pat Cadigan) Acrylic/digital. 2013

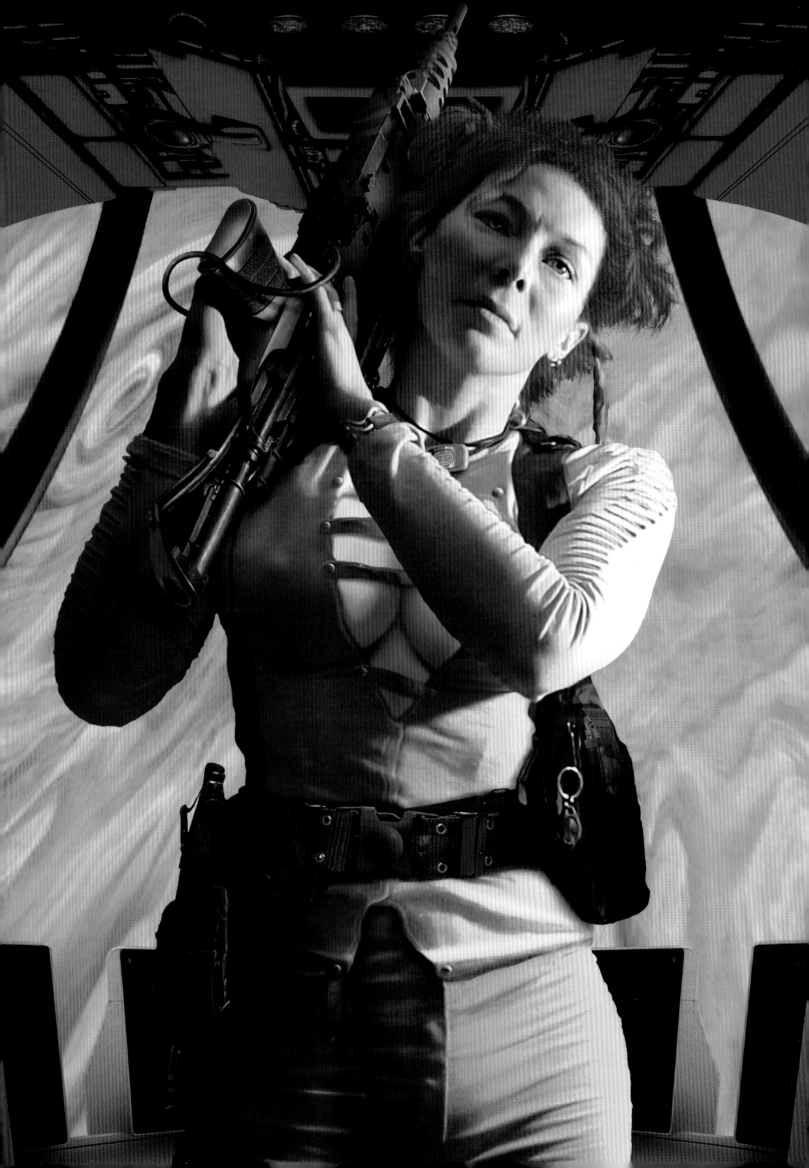

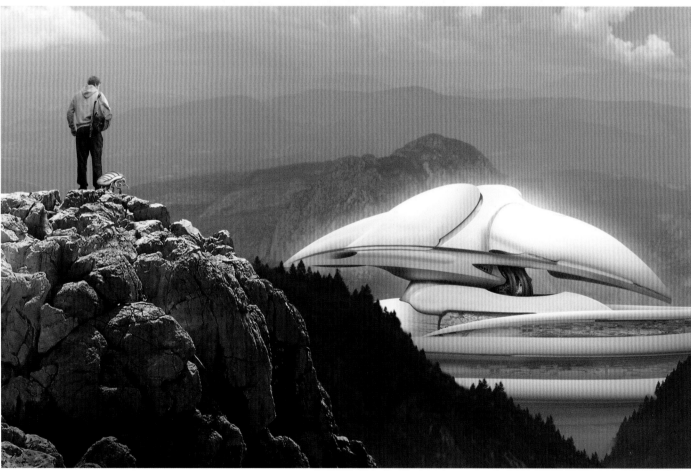

In 1979 I was invited, along with my agent, Alison Eldred to the Soho office of a film director by the name of Ridley Scott. Somewhat thrilled by the prospect (was Hollywood beckoning?) I discovered that Ridley, like many of that generation of directors who liked to dip into the worlds of science fiction for much of their creative output, was a bit of a fan. Fresh from his success with *Alien* and researching his next project he'd come across my work in *Planet Story*. One of my character depictions struck him as being very close to his own vision of one of the main protagonists in his next film. That film was *Dune* and the guy he saw reflected in Colonel Kylling was Siridar Baron Vladimir Harkonnen. Ridley Scott offered me the opportunity to travel to Hollywood and work on early concept design for that movie.

Well, we all know that Ridley Scott never made that film and my disappointment was pretty immense when Ivor Powell, Ridley's production manager phoned to tell me that the film was off. However, he was teasing me somewhat as it appeared that Scott was sufficiently impressed with my work to want to employ me on its replacement project. Had I ever heard of a writer named Philip K. Dick and a novel of his called *Do Androids Dream of Electric Sheep*? Because that's what the new film, to be called *Blade Runner* was based on. In a motel room on Sunset Strip, Ridley Scott took my painting of the flying ambulance depicting that moment in *Tour of the Universe,* turned it upside down and declared, that's our police spinner! Well, certainly it was its first incarnation.

Above: *The Engines Of God* (Jack McDevitt) Acrylics. 1996. Brilliant 'xenoarcheology', McDeviit loves to intrigue and baffle his readers with strange, unresolved ambiguities.

Below: The vehicle from *Behemoth's World* which formed the basis for the Police Spinner in the film, *Blade Runner* (Personal) Oils. 1980

Left: *Ashes* (Karl Bunker) Digital. 2014

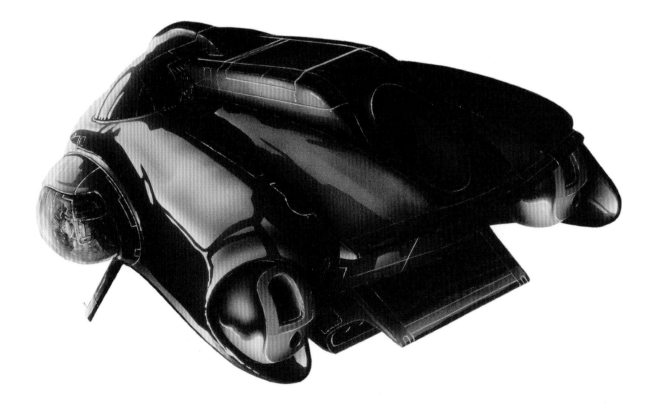

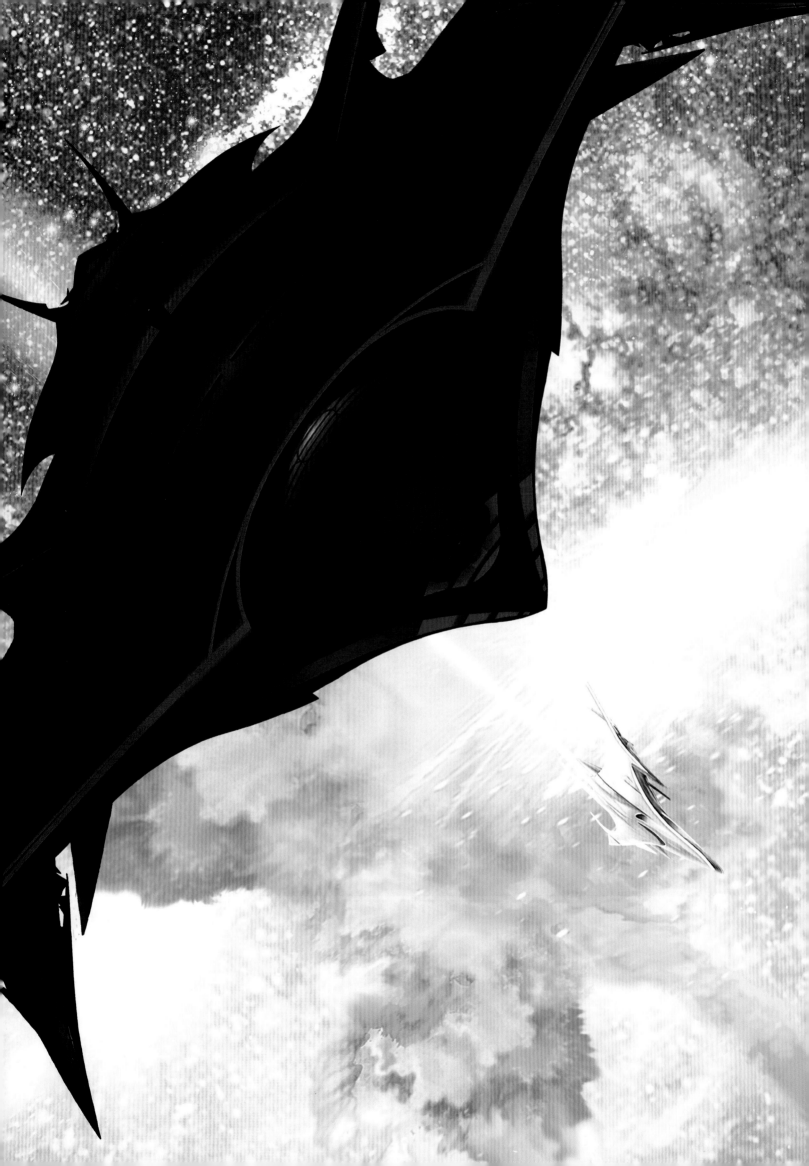

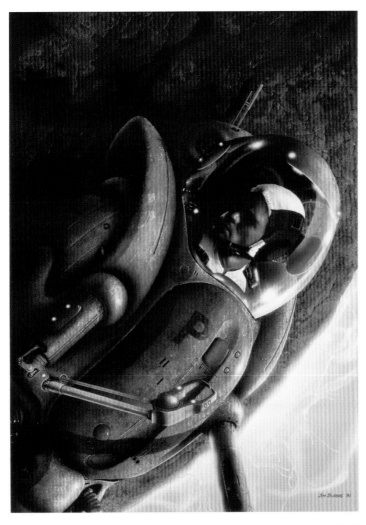

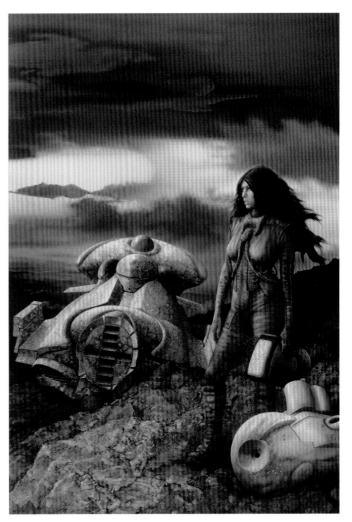

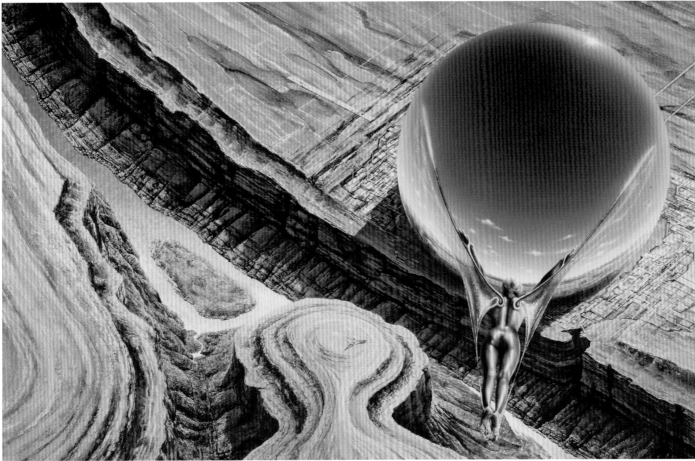

Left: *Absorption—Book 1 of the Ragnarok Trilogy* (John Meaney) Digital. 2011

Top Left: *The Best Of Arthur C. Clarke, 56-72—Summertime on Icarus* (Arthur C. Clarke) Oils. 1981

Top Right: *Brother to Demons, Brother to Gods* (Jack Williamson) Oils. 1980

Above: *Manseed* (Jack Williamson) Acrylics. 1985

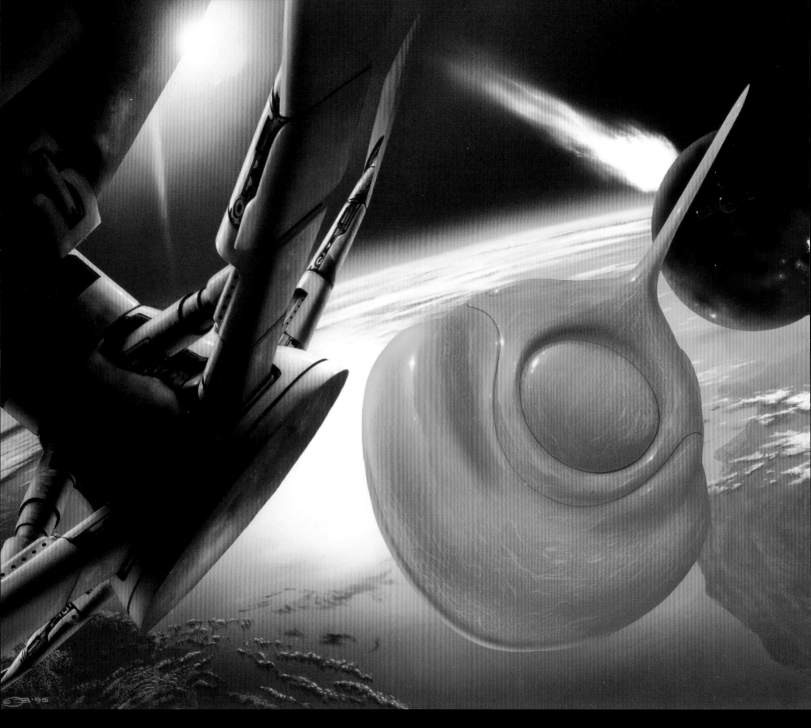

Above: *The Reality Dysfunction—Book 1 of The Night's Dawn Trilogy*
(Peter F. Hamilton) Acrylics, 1995

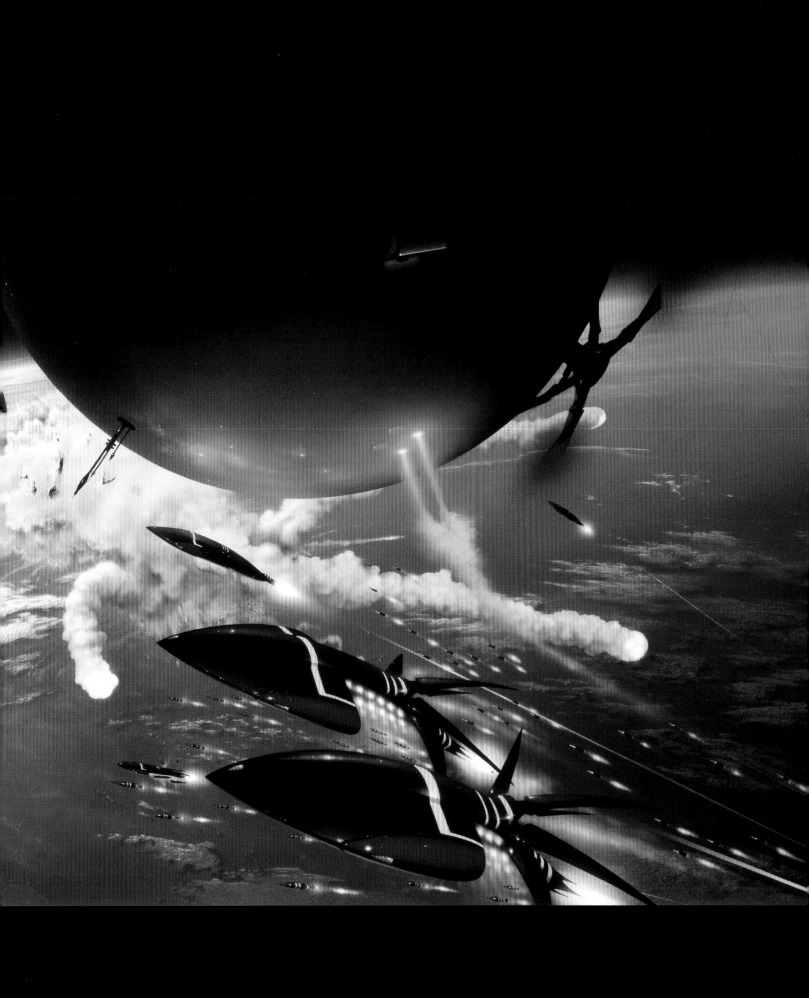

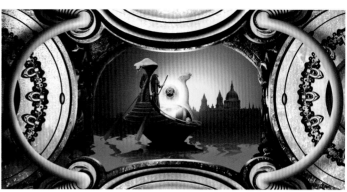

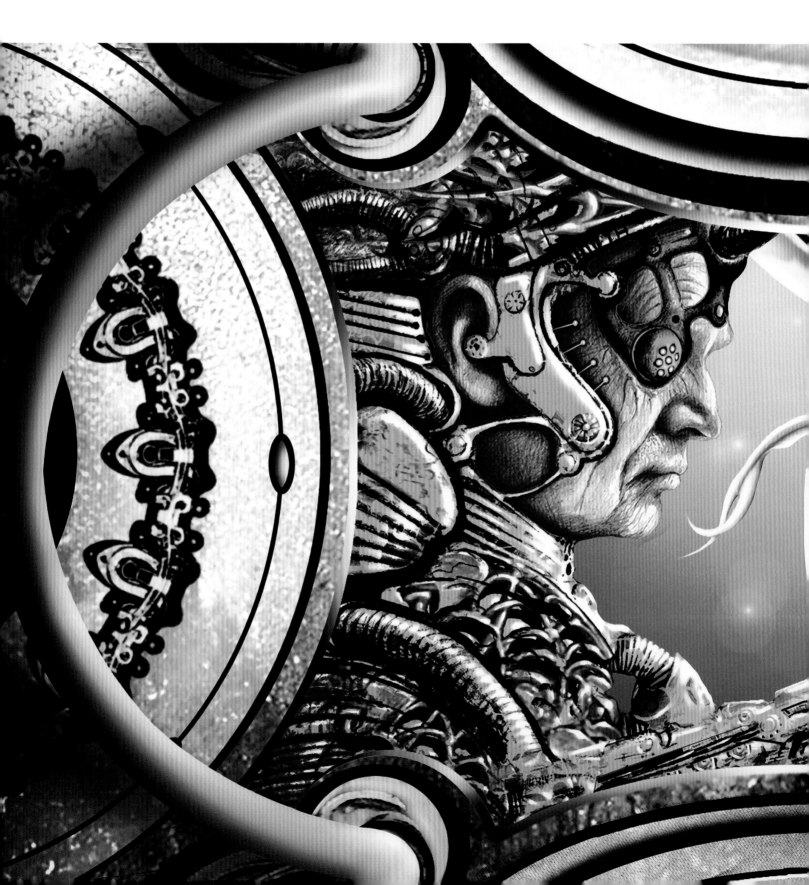

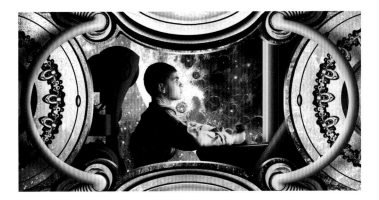

Some of the acrylic/digital hybrid pieces I created for the SFBC 50th Anniversary Edition series in 2006

L-R: *Startide Rising* (David Brin); *The Anubis Gates* (Tim Powers); *Ender's Game* (Orson Scott Card)

Below: *Schismatrix Plus* (Bruce Sterling)

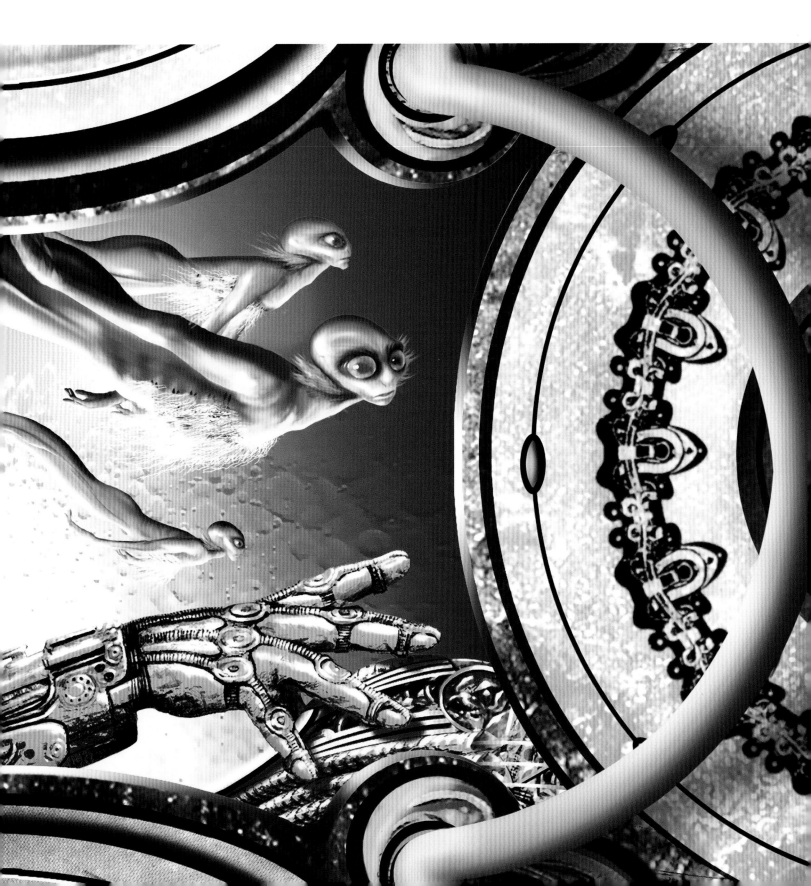

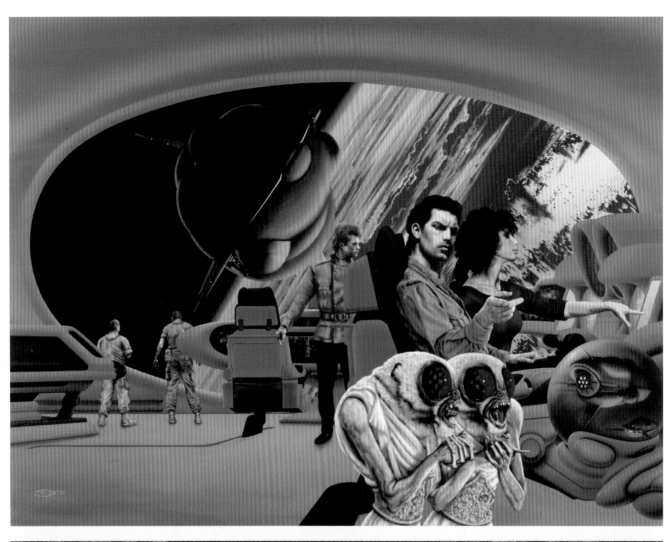

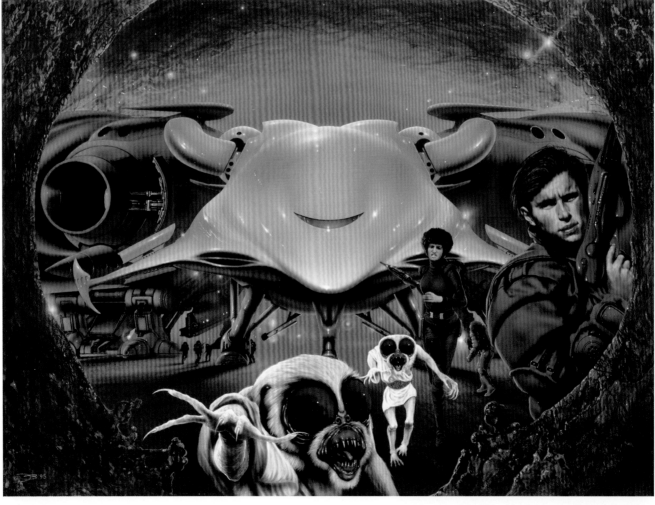

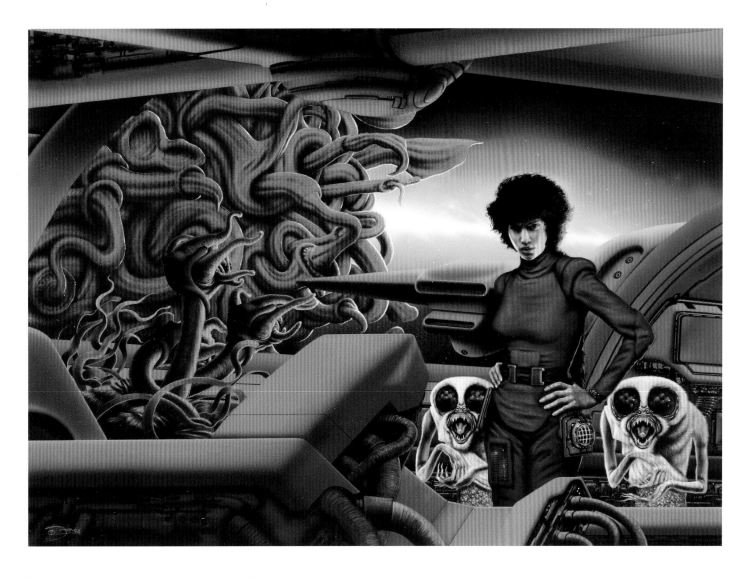

For one's first trip abroad ten weeks working in Hollywood had a lot going for it, but on my return to the UK it was time to knuckle down once more and focus on the book jacket work. The agency I was part of had a kind of satellite agency in New York. Alan Lynch, who first worked with Young Artists in London in the 70s, had moved to the US, married his American sweetheart and set up his own agency. This opened up a much bigger potential client base for my work and, looking back, I would say that in terms of career-building, the 1980s were my most important time. US publishers seemed to like what I had to offer and so began a long and fruitful period working with many of the major American science fiction and fantasy imprints.

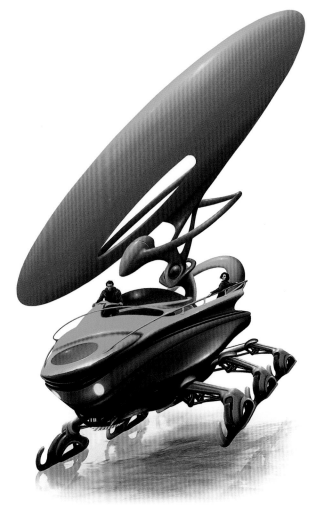

Above: *Exordium 4—Rifter's Covenant* (Sherwood Smith & Dave Trowbridge) Acrylics. 1994. The writers of the five-volume Exordium series describe it as 'a cross between *Star Wars* and *Dangerous Liaisons* with a touch of the *Three Stooges*'. I was certainly entertained by its multi-layered universe.

Right: *A Martian Romance—detail* (Kim Stanley Robinson) Digital. 1999

Opposite Page

Top: *Exordium 1—Phoenix in Flight* (Sherwood Smith & Dave Trowbridge) Acrylics. 1992

Bottom: *Exordium 5—The Thrones of Kronos* (Sherwood Smith & Dave Trowbridge) Acrylics. 1995

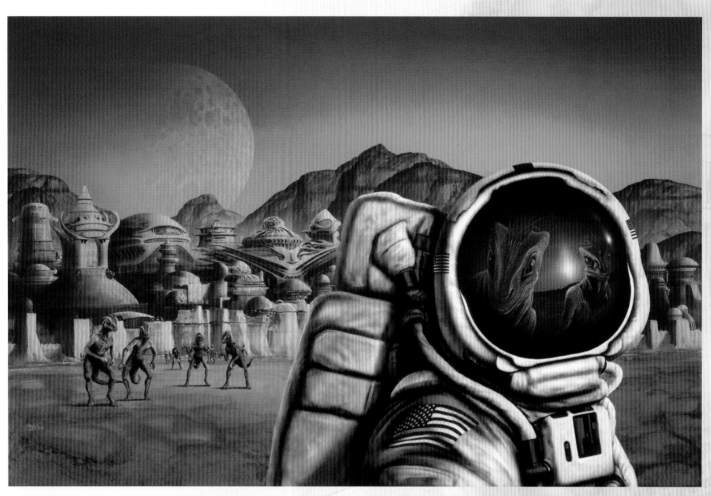

In the late 70s I had already created several covers for yet another of the 'true greats'—Robert Silverberg. Already under my belt were covers for *Born With The Dead*, *The Stochastic Man*, *The Gate Of Worlds*, and *Son Of Man*. Great novels all but the 1980s saw me develop a close and fruitful working relationship with Bob—at a Transatlantic distance admittedly as it would be a few years before we met in person. Eventually I would create the covers for over 40 Silverberg novels, sometimes working on different covers for the same book for both the US and UK markets at more or less the same time.

Top: *Homeward Bound* (Harry Turtledove) Acrylics. 2004
Above: Two alternative digital sketches for *Homeward Bound*
Opposite: *Seed Of Light*. (Edmund Cooper) Oils. 1978

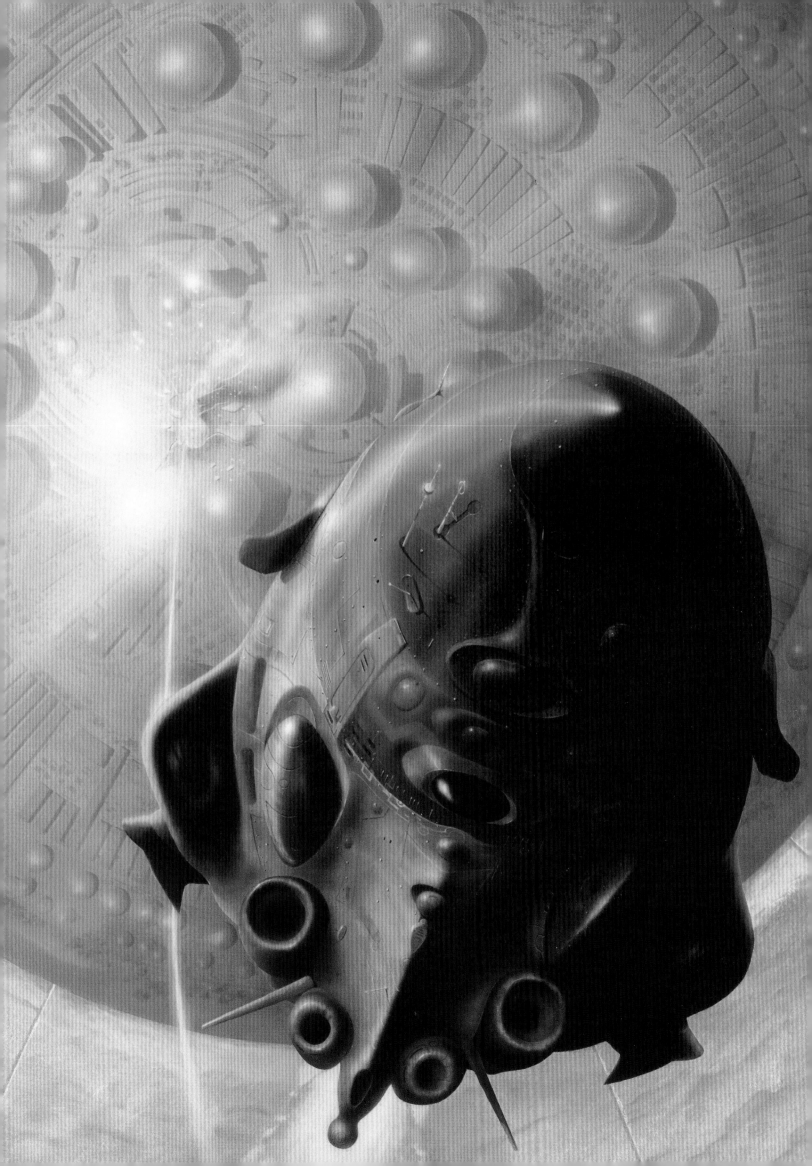

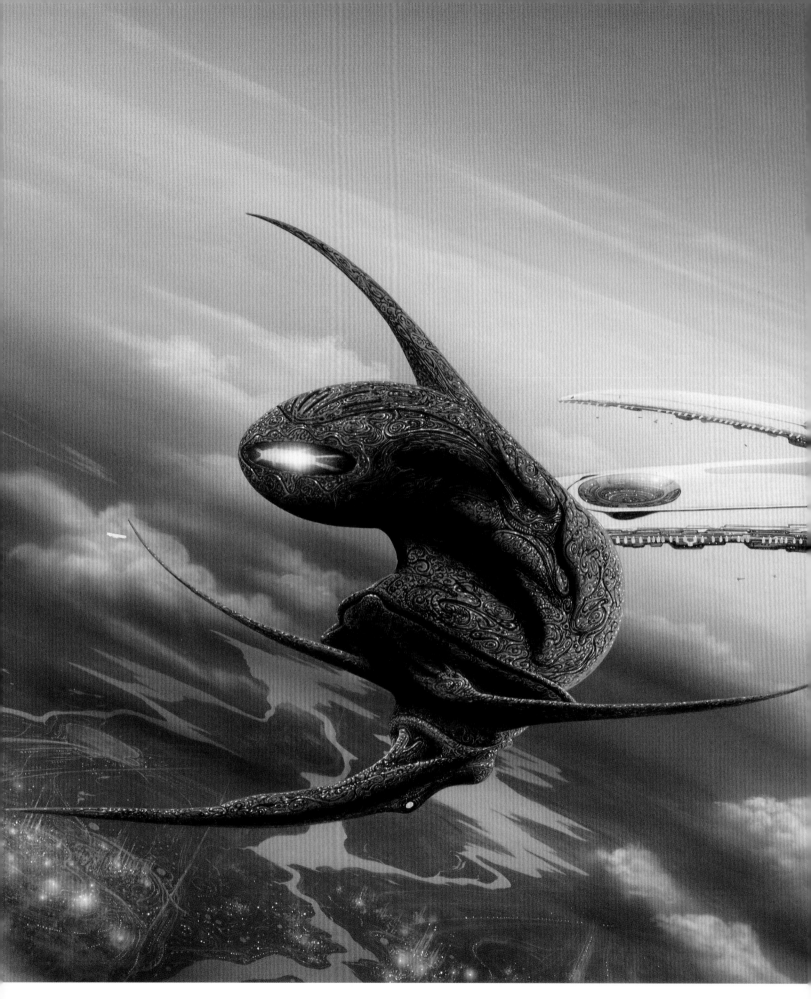

Dominant amongst these were the Silverberg covers I produced for his rich and exotic *Majipoor* books. Masterful world-building, 'future medievalism' and reminiscent of Jack Vance, it is indeed regarded by some as Silverberg's finest work. I was hooked from the moment I met Valentine, the wandering amnesiac outside the city of Pidruid on the huge planet of Majipoor,

Above: *The Naked God—Book 3 of The Night's Dawn Trilogy* (Peter F. Hamilton) Acrylics. 1999. Peter's favourite of the covers I created for his books.

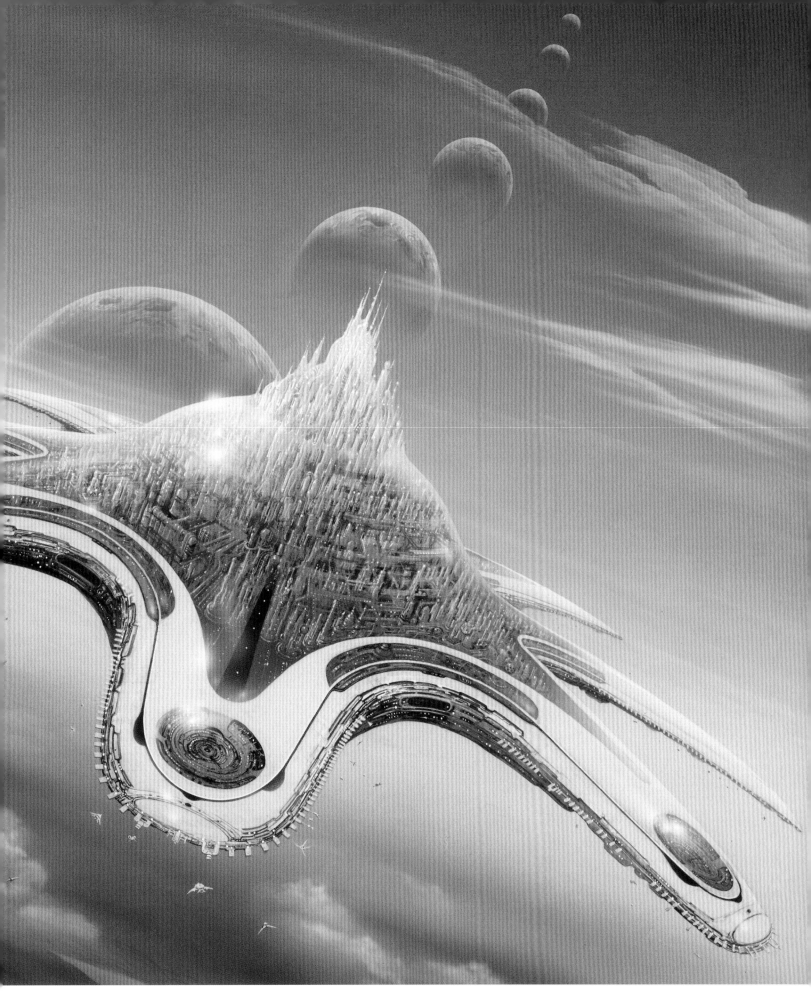

who joins a troupe of jugglers and acrobats, human and variously mixed alien races. Including the Skandar, who with 4 arms apiece are particularly effective jugglers, octopoidal Vroons, squat, bureacratically-minded Hjorts and many others. I completed nine covers in all for the Majipoor series, the early ones being in oils, later acrylics and eventually a couple of digital pieces.

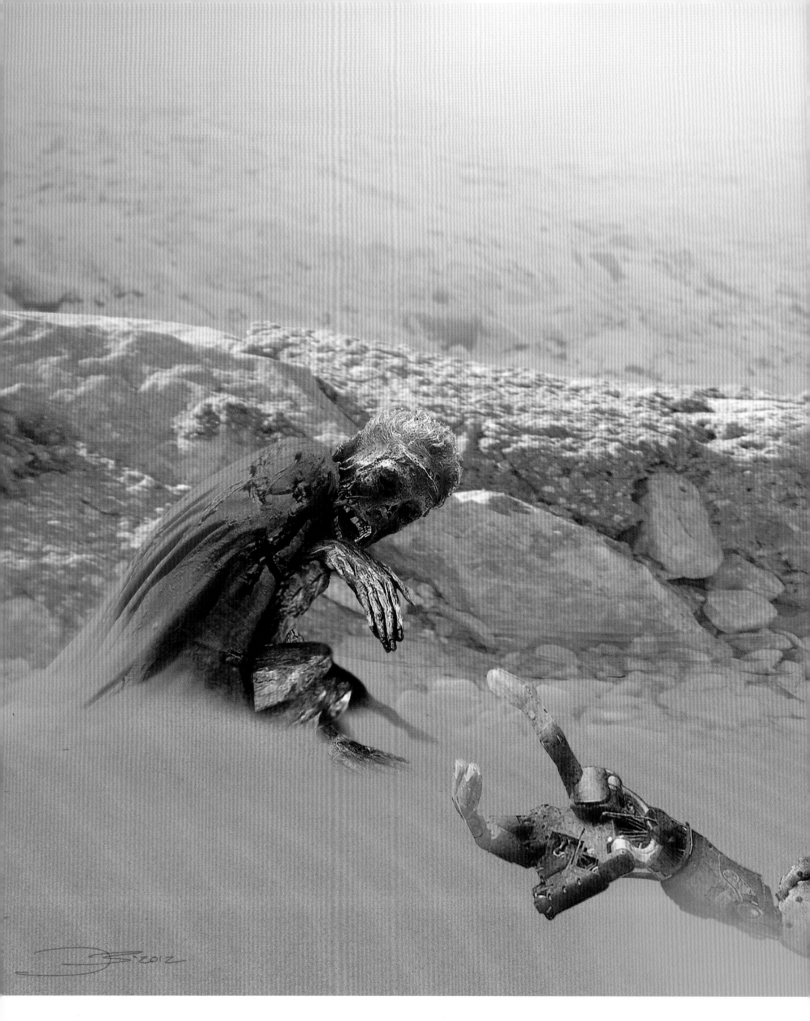

One of the most pleasurable parts of my work over the years has been, as with Silverberg, the building up of strong working relationships with specific authors and producing the cover art for many of their books—sometimes entire series. The mutual respect that has (usually!) resulted has been a massive bonus in both my professional and my social life.

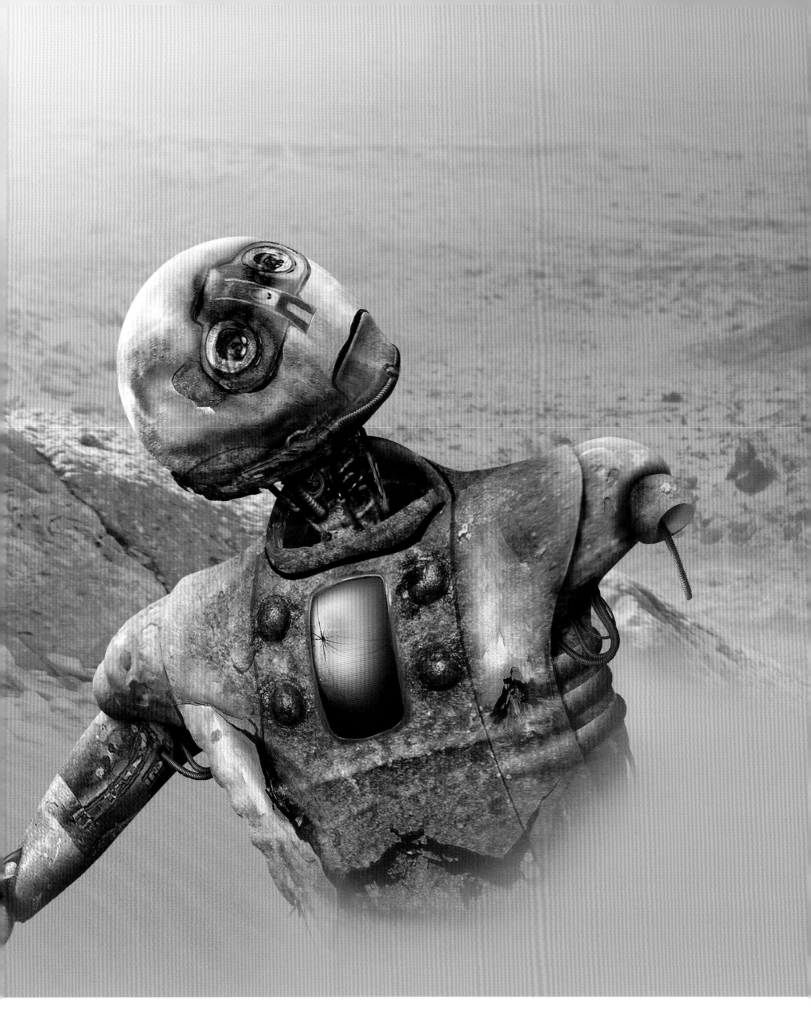

Above: *iRobot* Digital. 2012. Excellent and poignant story by my local sometime-drinking chum, Guy Haley. Man is but a memory in this bleak tale.

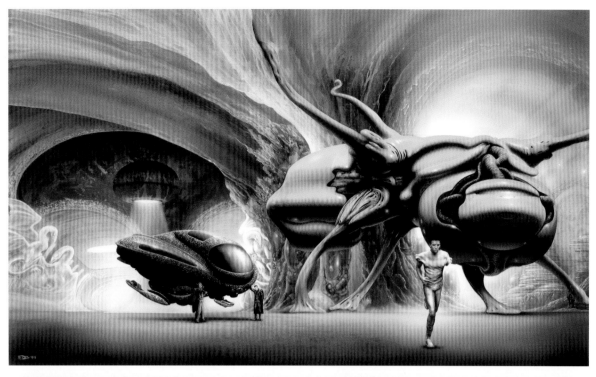

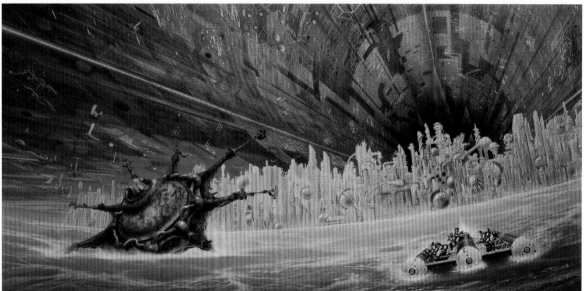

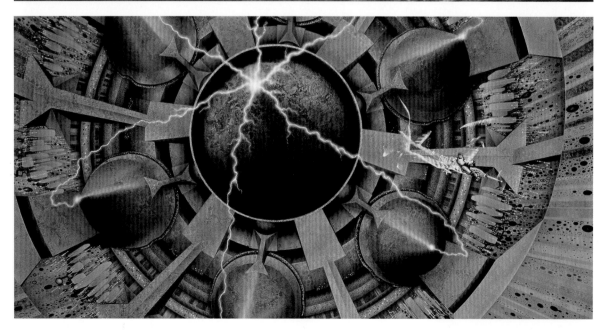

Top: *Paradox—Book 1 of the Nulapeiron Sequence* (John Meaney) Acrylics. 1999 **Bottom**: *Rendezvous with Rama* (Arthur C. Clarke) Oils. 1979

Middle: *Rendezvous with Rama—the Cylindrical Sea* (Arthur C. Clarke) Oils. 1979

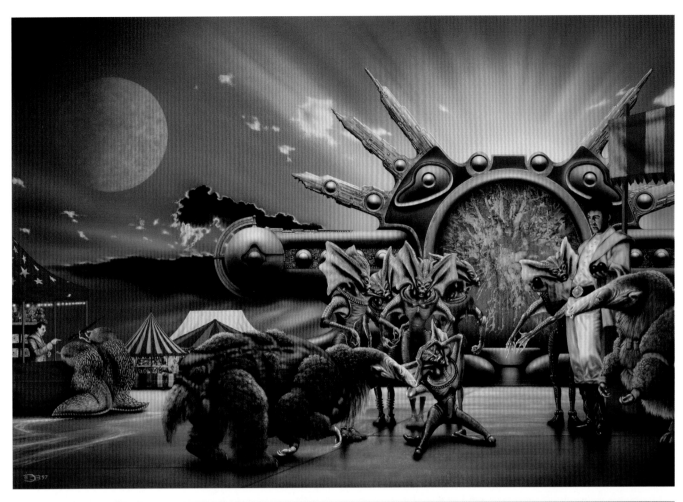

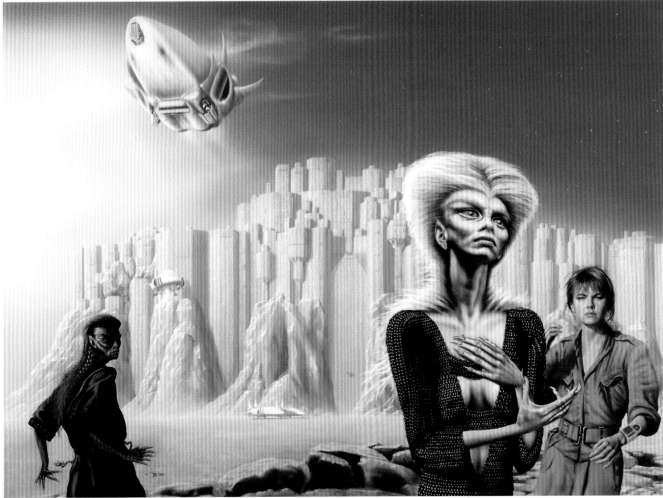

Top: *O Pioneer* (Fred Pohl) Acrylics. 1997

Above: *Ancient Light* (Mary Gentle) Acrylics. 1988

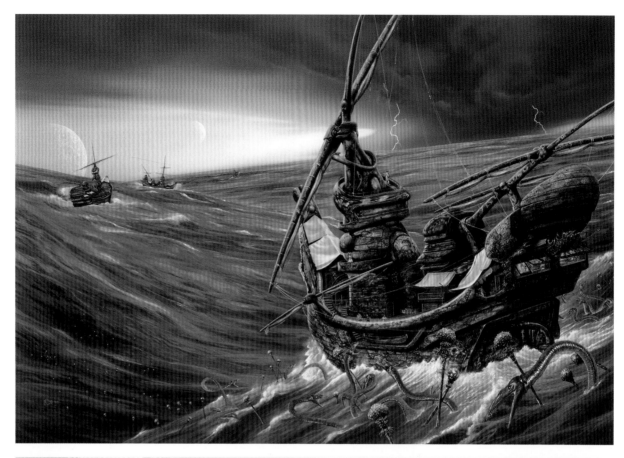

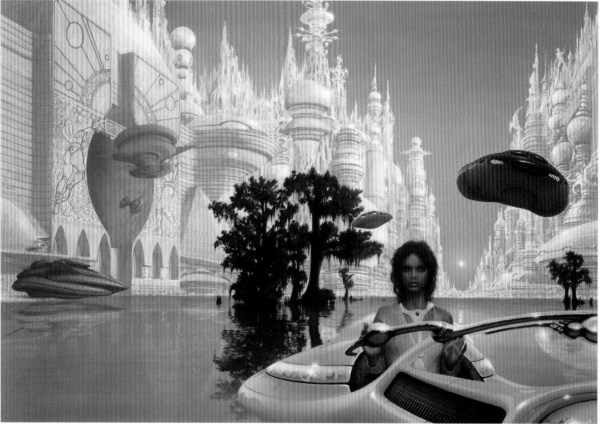

Two British writers with whom I've had long-standing and mutually rewarding professional relationships are Peter F. Hamilton and John Meaney. Peter is perhaps the most successful writer of 'hard SF' in the country. His sure hand has led me on stupendous journeys of the imagination over the last couple of decades. His books are huge 1000-page jobs and correspondingly the work I created for his *Night's Dawn Trilogy*, *Commonwealth Saga* and *Void Trilogy* are some of the biggest paintings I've ever attempted.

Top: *The Face of the Waters* (Robert Silverberg) Acrylics. 1990

Above: *The Majipoor Chronicles (UK version)* (Robert Silverberg) Acrylics. 1982

Opposite: *Tower of Glass* (Robert Silverberg) Acrylics. 1982

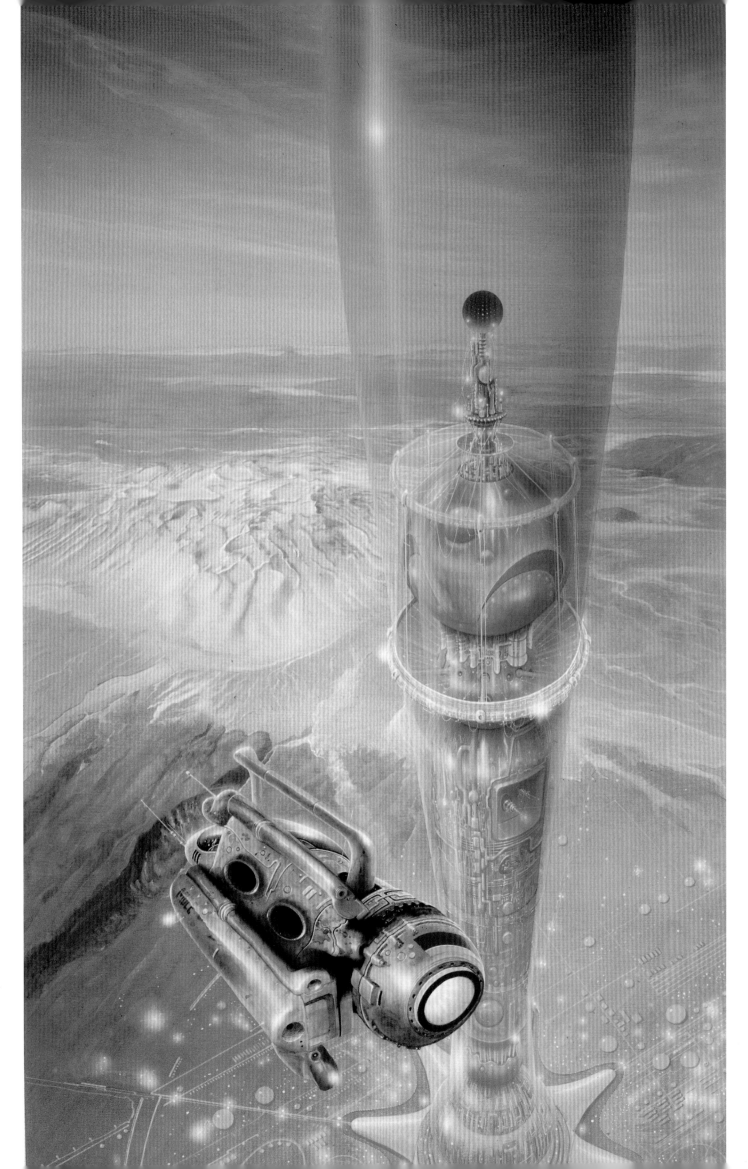

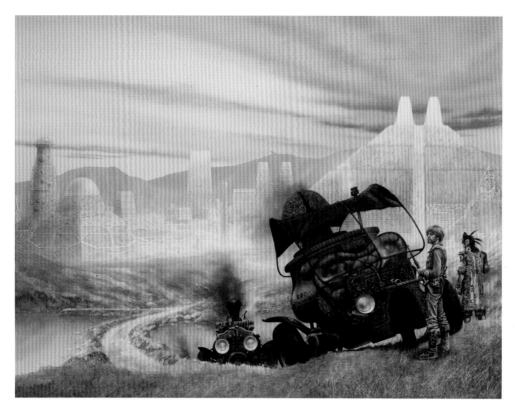

Whilst John Meaney's *Nulapeiron* and *Ragnarok* space opera trilogies have placed him in my mind at the absolute cutting edge of bar-raising, inventive, scientifically-informed writing. What Charles Stross has called "the fiendishly difficult trick of combining vivid world-building with hard science rigour". Exploring a never-ending variety of increasingly strange versions of the universe we inhabit, courtesy of these extraordinary imaginations, has been a privilege.

Left: *The Gate of Worlds* (Robert Silverberg) Oils. 1980

Below: *The Longest Way Home—detail* (Robert Silverberg) Digital. 2002

Right: *Downward to the Earth* (Robert Silverberg) Acrylics. 1983

Next Spread: *The Dryad of the Oaks* (Personal) Acrylics. 2006

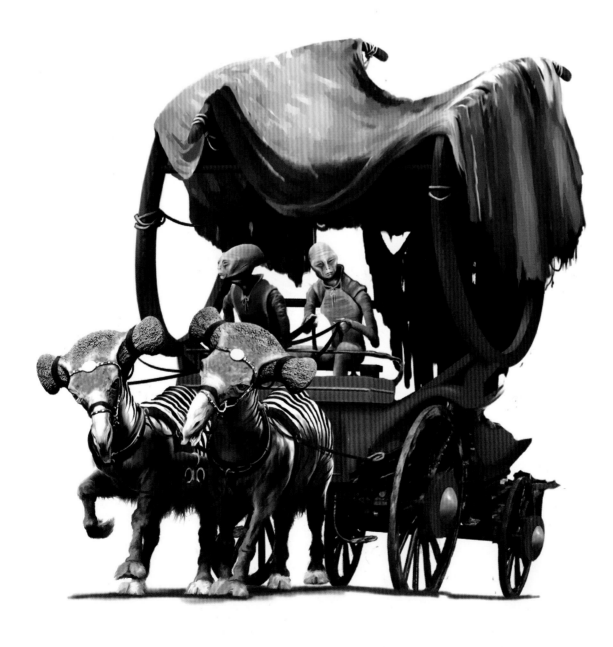

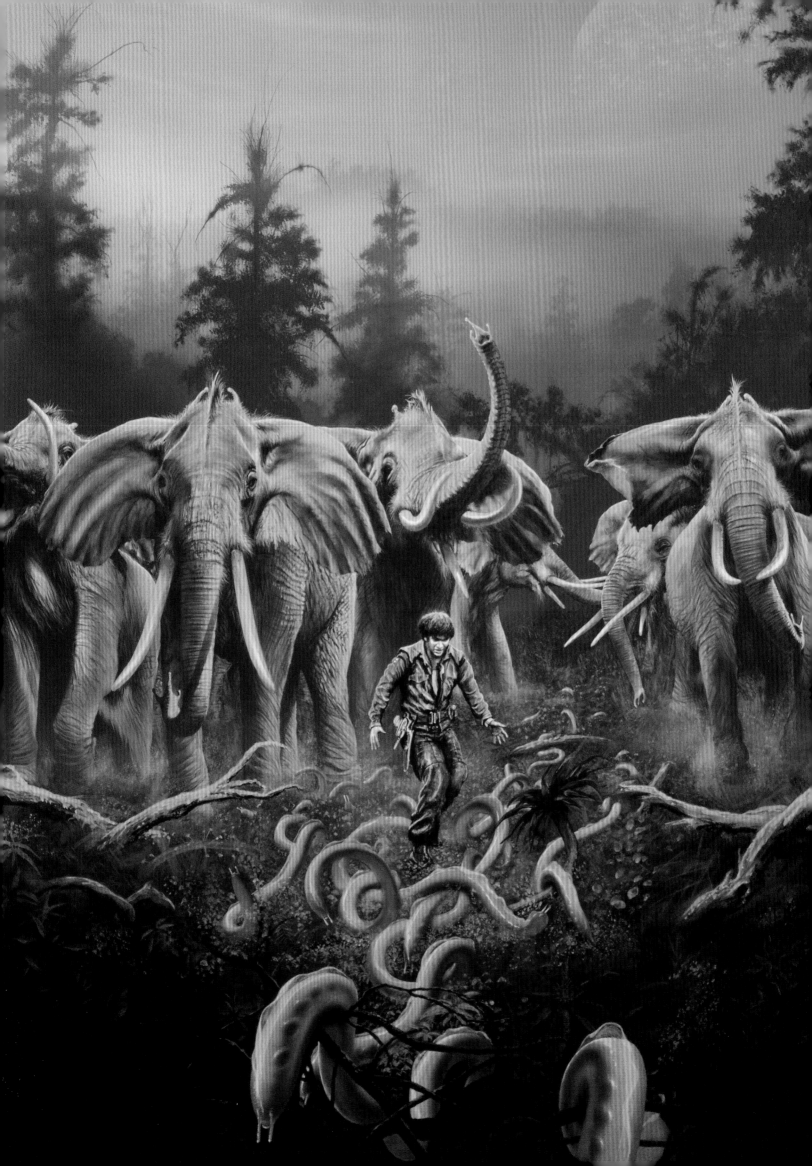

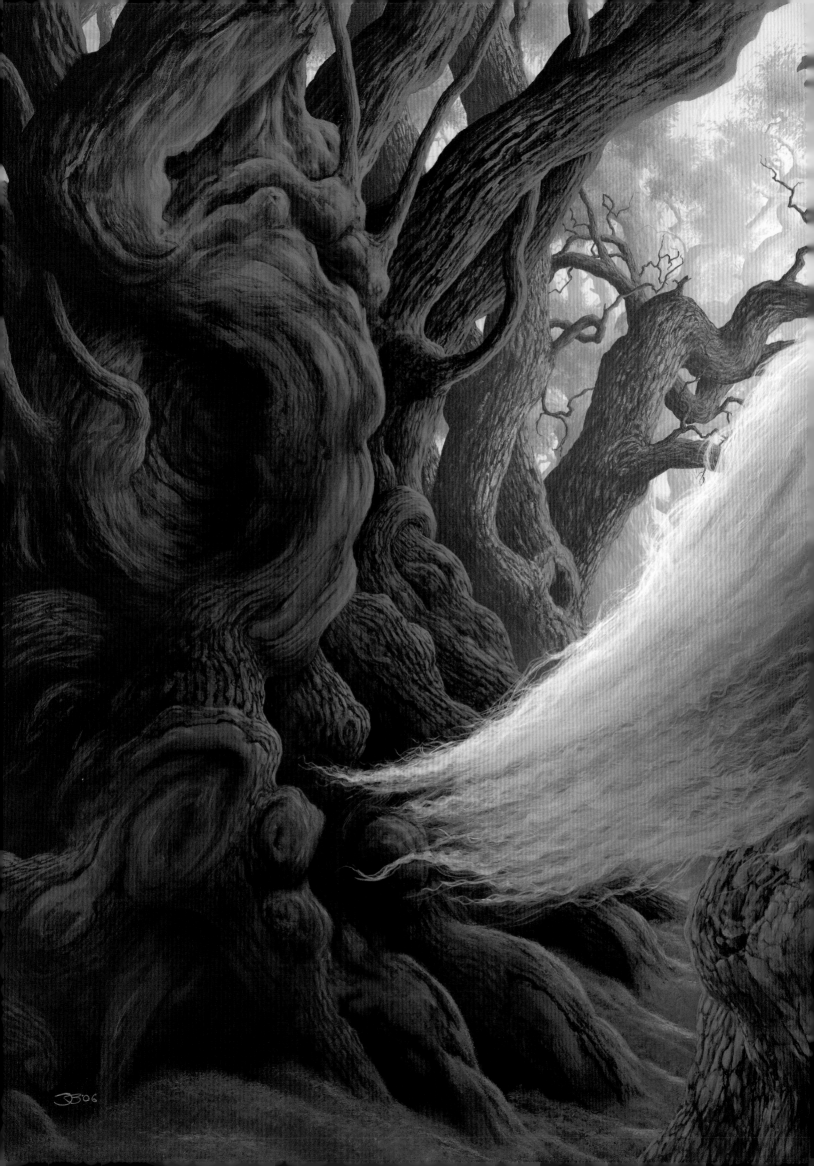

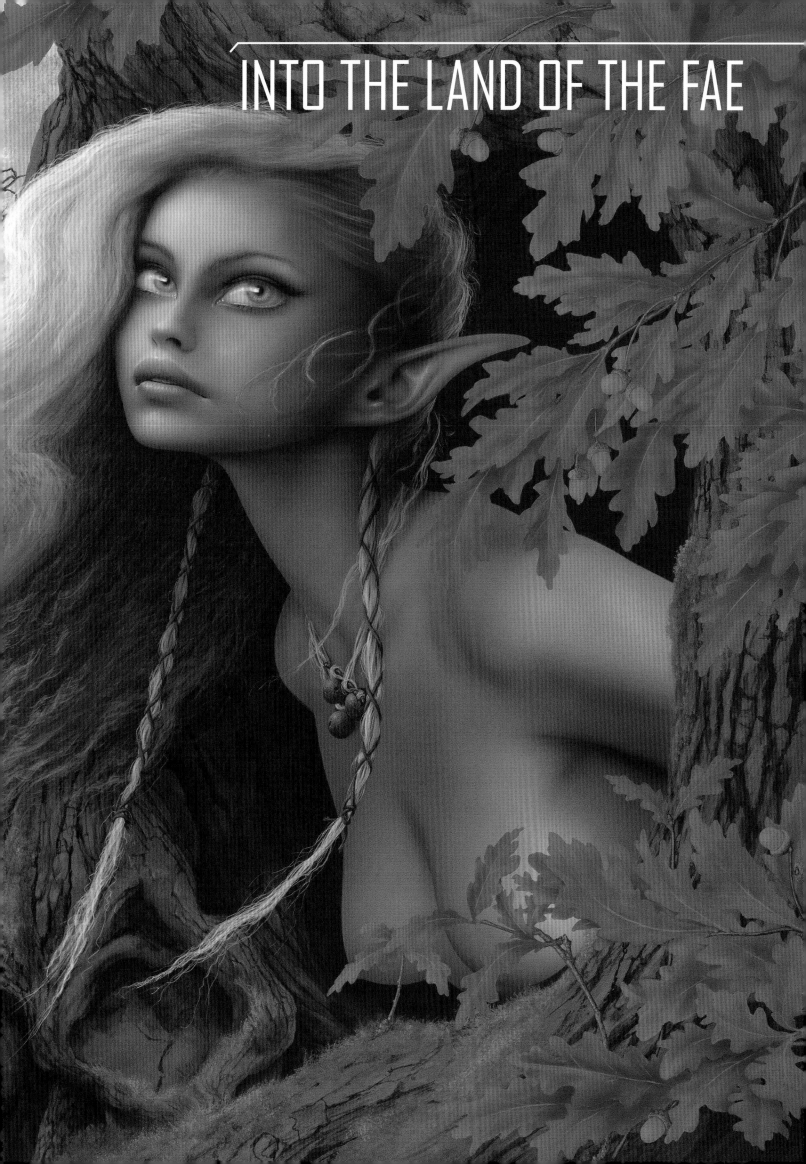

The problem with attempting to shepherd the 'Literature of the Fantastic' into some kind of coherent order is that the boundaries between various sub-genres are most decidedly blurred.

But at least one can say that in its speculation on possible futures based in very large part on scientific extrapolation and at least a notional 'rationalism', science fiction does have some kind of inner logic. Fantasy on the other hand occupies quite different territory, essentially that of the irrational. Of magic and the supernatural.

This is an incredibly simplified way of looking at the related genres, I realise. Some writing allows elements of science fiction and fantasy to co-exist—a sub-genre not unreasonably called 'science fantasy'. Writers such as Gene Wolfe, Jack Vance and some of Robert Silverberg's output occupy this territory. Peter F. Hamilton can, by some definitions of the genre, fit into this category. Often we find ourselves in a world littered with the semi-functioning detritus of a technological, space-faring age now long past and superceded by natural laws which no longer fully obey physics and where the supernatural finds a toehold. This can make for fascinating reading particularly from the viewpoint of an artist. The collision of apparently disparate themes can send the imagination off down delicious roads of speculation as to how things might look in the wreckage of such timelines.

Fantasy, per se, unencumbered by any particular associations with science fiction, follows rules of its own making. Its form is essentially 'medievalist' and of course the daddy of them all is the monumental *The Lord of the Rings* by J. R. R. Tolkien.

I shall probably shock you by saying that I have never read Tolkien. Neither have I ever by choice, as an adult—as far as I recall—ever picked up a book about magic or dragons or elves! Those I have read have been because I have been commissioned to illustrate them. My own personal prejudices have often been confounded by the great enjoyment I've discovered in reading some fantasy novels. Indeed the best of it, Gene Wolfe's *Shadow of the Torturer* books for instance, are amongst the best works of the imagination I have ever read.

One has to make choices in life and generally speaking my predilections were always towards those zones of speculative fiction that focused more on science, extrapolation and technology, rather than on magic.

So my 'Fantasy' output has been nothing like as large as my science fiction output. This section of the book tries to focus on this territory but as I've indicated above, the boundaries get very blurred. What we have here is an 'approximation' of fantasy, spiced with elements from other zones of the speculative.

This Spread: *Showboat World* (Jack Vance) Oils. 1977
We are in a distant future on a world colonised by all kinds of misfits from Earth. But beyond that fact, Showboat World is situated pretty firmly in the realm of a fantasy adventure. And it's classic Vance. I loved painting that ship, 'Miraldra's Enchantment'.

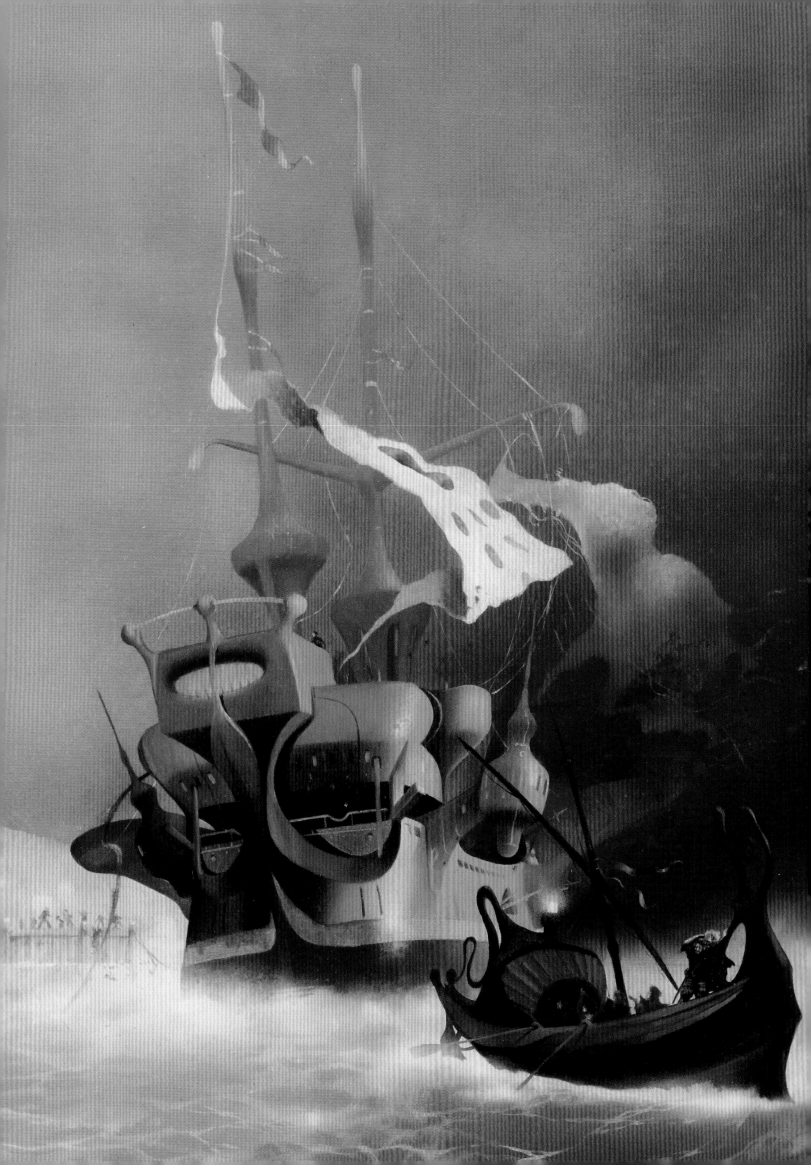

A painting called 'The Dryad of The Oaks' heads up this section I call 'Into The Land of the Fae'. A personal piece engaging with the themes of mythology—territory I'd like to explore more. The Dryad, a tree nymph from Greek mythology, is a shy, gentle, beautiful creature. The word 'dryad' derives from the Greek for 'oak'. I have it half in mind to create more tree nymphs—a different tree, a different look. A 'Caryatid' is associated with walnut trees, the 'Meliai' with the Ash and the 'Epimeliad' with Apple trees. Maybe I will paint them but so many other ideas jostle for attention.

Top: *Study for a possible dragon painting* (Personal)
Pencil and digital colour. Mid-2000s
I have an idea for a painting showing a dragon and its lovely girl rider stopping off for lunch. She's sitting at her steed's feet chewing on a chicken drumstick and the dragon has a huge bleeding haunch dripping from its mouth. I'll probably call it 'Lunch Break'.

Above: *Dragon sketch* (Personal) Ink and digital colour. Late 1990s

Right: *Children of Forgotten Gods* (Private commission). Acrylics. 2003

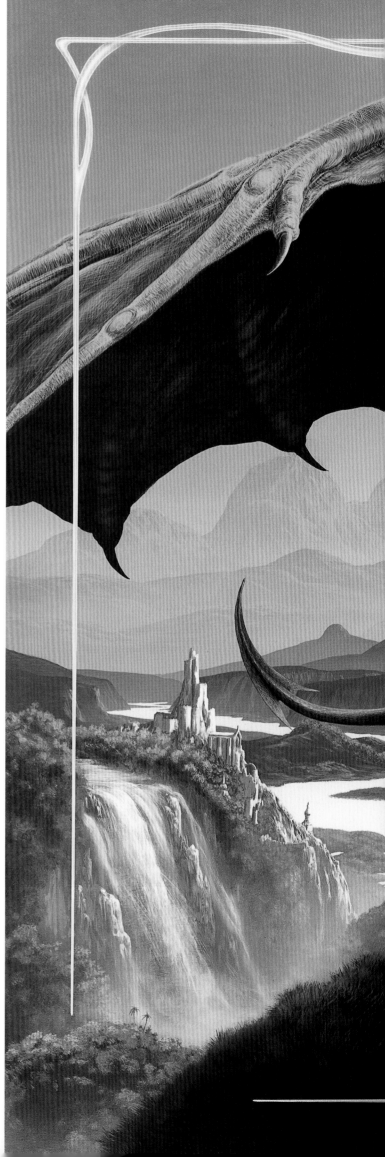

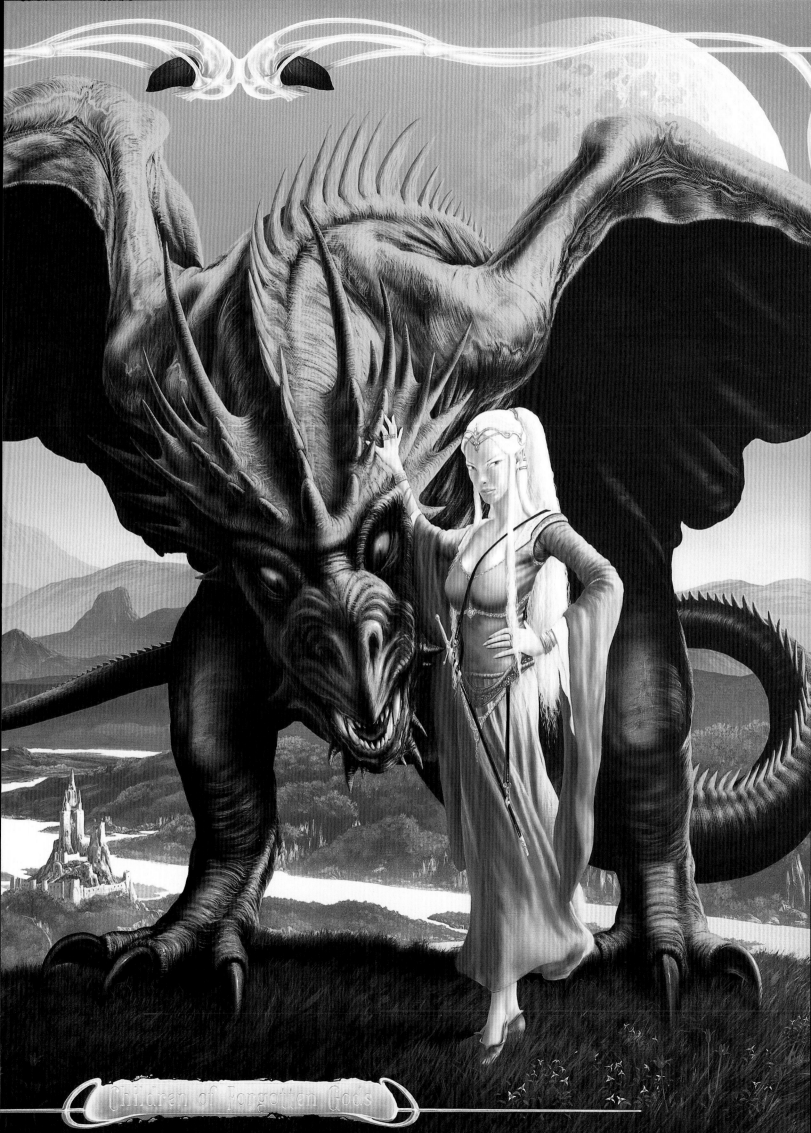

Children of Forgotten Gods

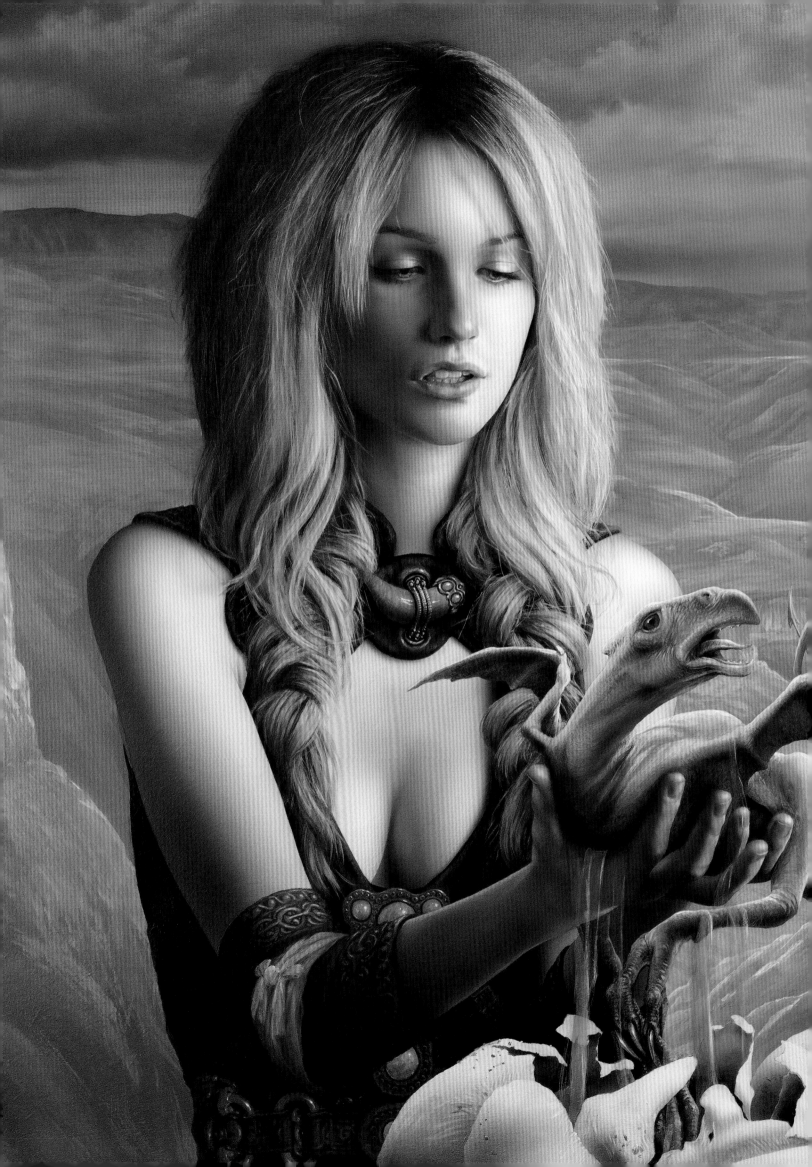

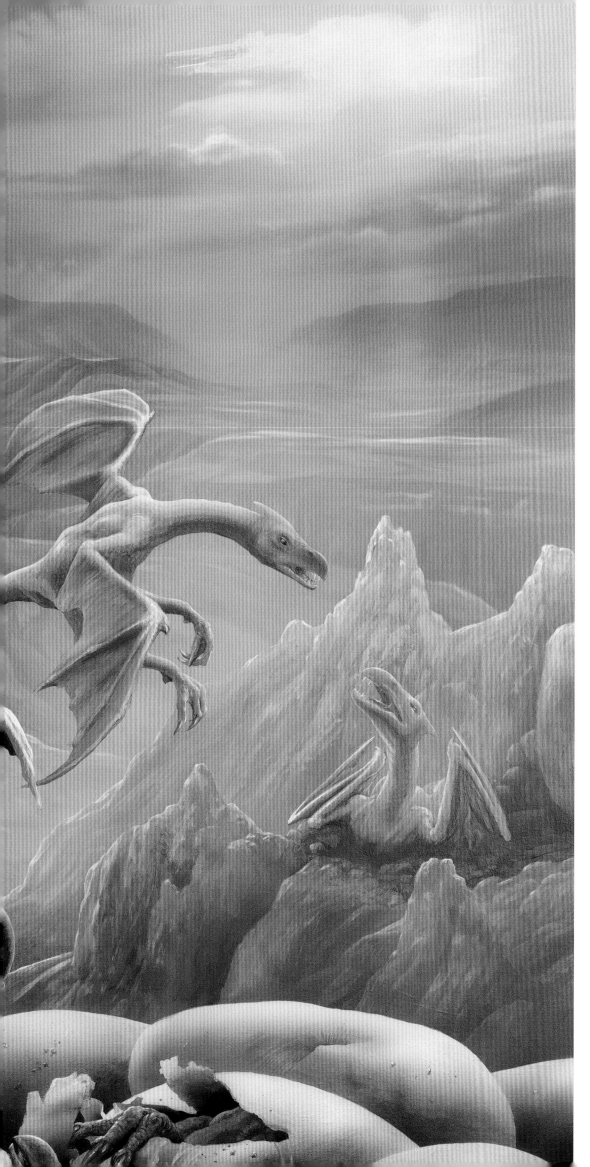

I've always had issues with the skeletal implausibility of dragons. Some artists much better than I at being able to convince us of the six-limbed anatomical soundness of the design do pull it off. I'm never terribly convinced by my own efforts. So I tend to cop-out and go for the wyvern-form instead where at least the pectoral girdle isn't compromised by various colliding limb articulations. If it's worked for pterodactyls and bats then it can work for the wyvern. I know of no natural creature where there is such an unlikely formation of bones, tendons, and muscles as in the classic six-limbed dragon's form. Evolution obviously regarded it as a 'bad idea'!

Both 'Hatchling' and 'Children of Forgotten Gods' (previous spread) take the wyvern route.

Left: *Hatchling* (Personal idea used as commissioned official art for DragonCon 2013). Acrylics. 2013. The 'wyvern-mistress' modeled by my local barmaid!

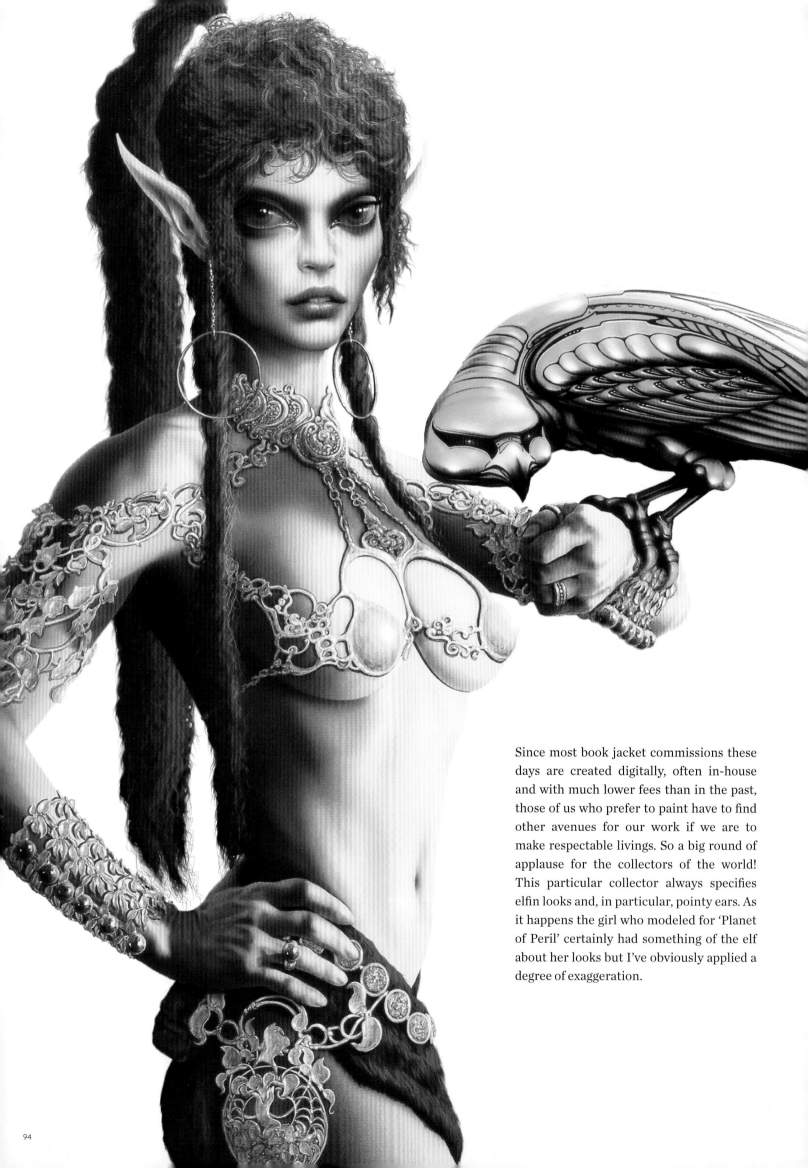

Since most book jacket commissions these days are created digitally, often in-house and with much lower fees than in the past, those of us who prefer to paint have to find other avenues for our work if we are to make respectable livings. So a big round of applause for the collectors of the world! This particular collector always specifies elfin looks and, in particular, pointy ears. As it happens the girl who modeled for 'Planet of Peril' certainly had something of the elf about her looks but I've obviously applied a degree of exaggeration.

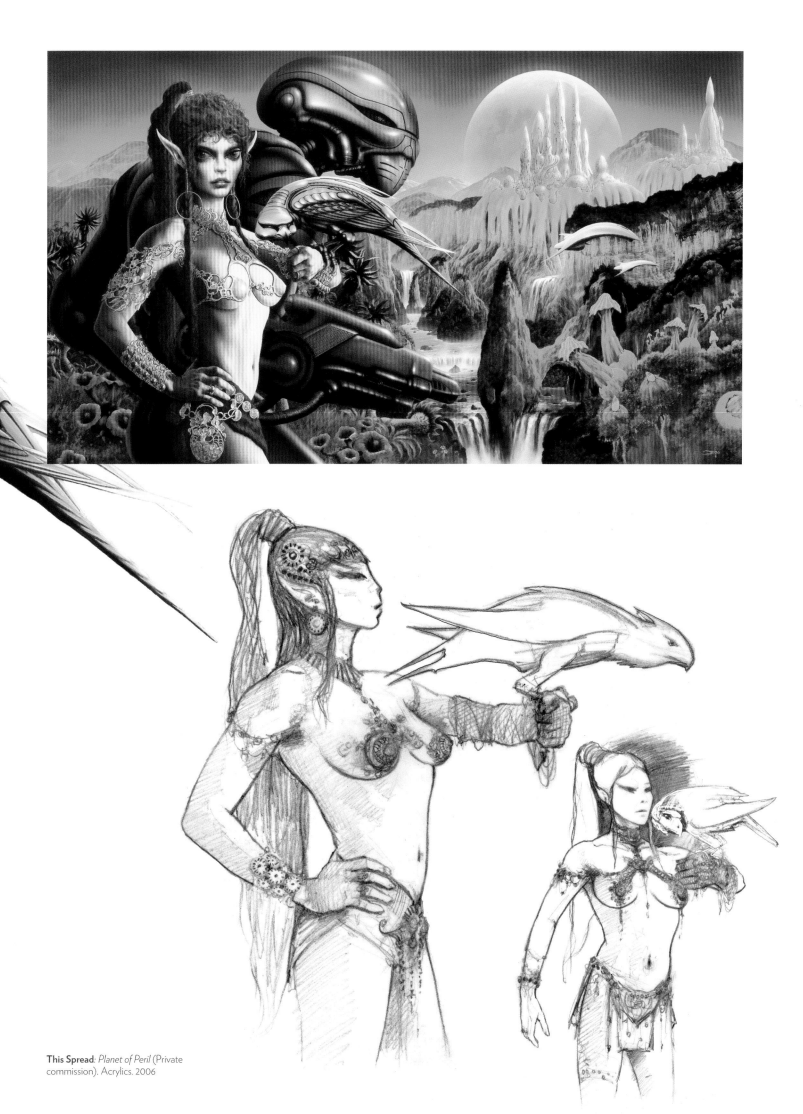

This Spread: *Planet of Peril* (Private commission). Acrylics. 2006

95

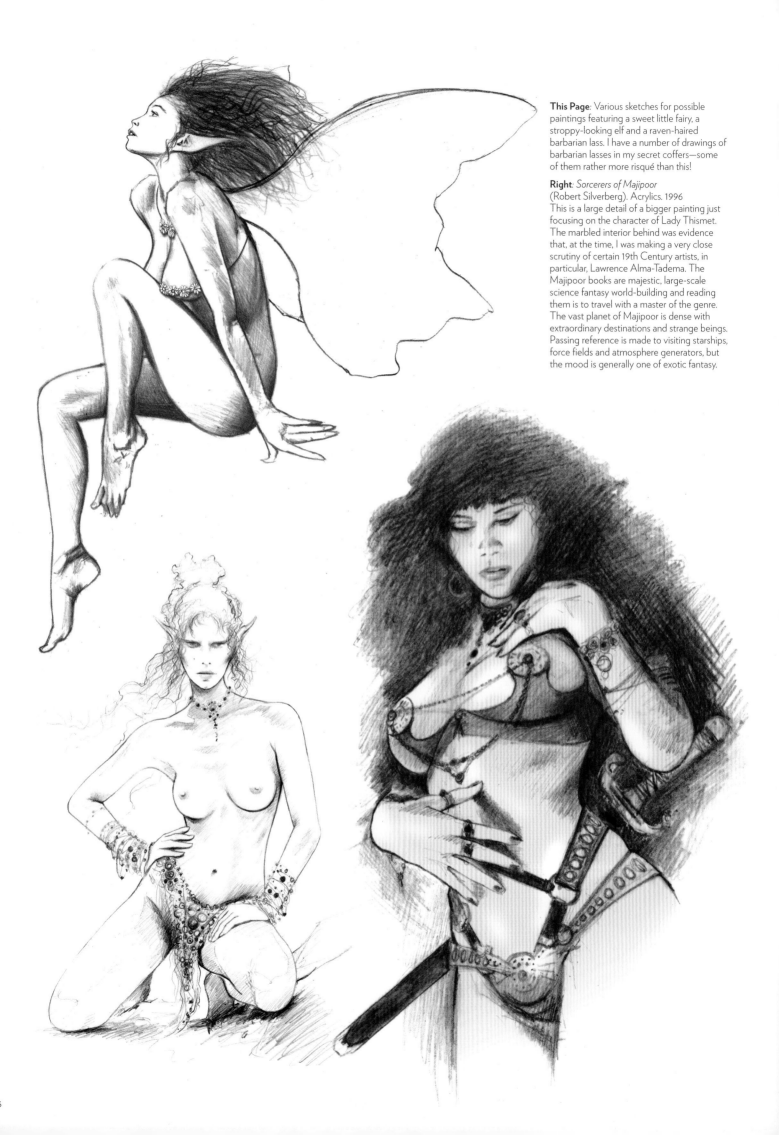

This Page: Various sketches for possible paintings featuring a sweet little fairy, a stroppy-looking elf and a raven-haired barbarian lass. I have a number of drawings of barbarian lasses in my secret coffers—some of them rather more risqué than this!

Right: *Sorcerers of Majipoor* (Robert Silverberg). Acrylics. 1996
This is a large detail of a bigger painting just focusing on the character of Lady Thismet. The marbled interior behind was evidence that, at the time, I was making a very close scrutiny of certain 19th Century artists, in particular, Lawrence Alma-Tadema. The Majipoor books are majestic, large-scale science fantasy world-building and reading them is to travel with a master of the genre. The vast planet of Majipoor is dense with extraordinary destinations and strange beings. Passing reference is made to visiting starships, force fields and atmosphere generators, but the mood is generally one of exotic fantasy.

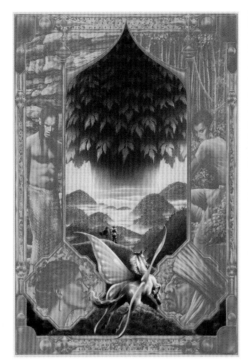

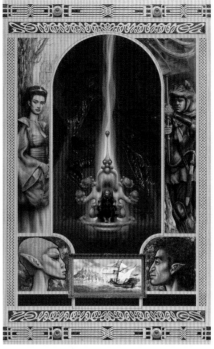

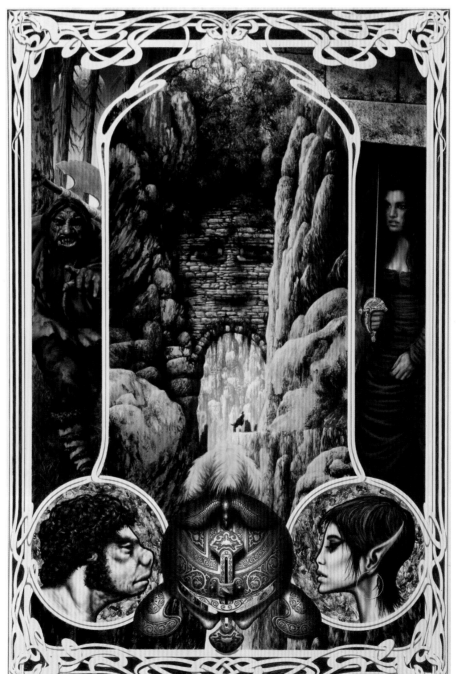

Welcome to Pandemia and prophecies of apocalyptic chaos as the year 3000 approaches. Goblin hordes, dragons, pixies and warlocks. The ingredients of classic fantasy from Dave Duncan!

Clockwise From Top Left:

The Living God—Book 4 of A Handful of Men.

The Cutting Edge—Book 1 of A Handful of Men.

Upland Outlaws—Book 2 of A Handful of Men. Acrylics. 1992-3

Opposite: *The Stricken Field— Book 3 of A Handful of Men.*

Next Spread: *Days of Gloriana* (Private commission). Acrylics. 2009. Another commission from the collector who likes pointy ears. His third piece was Children of Forgotten Gods. More pointy ears there!

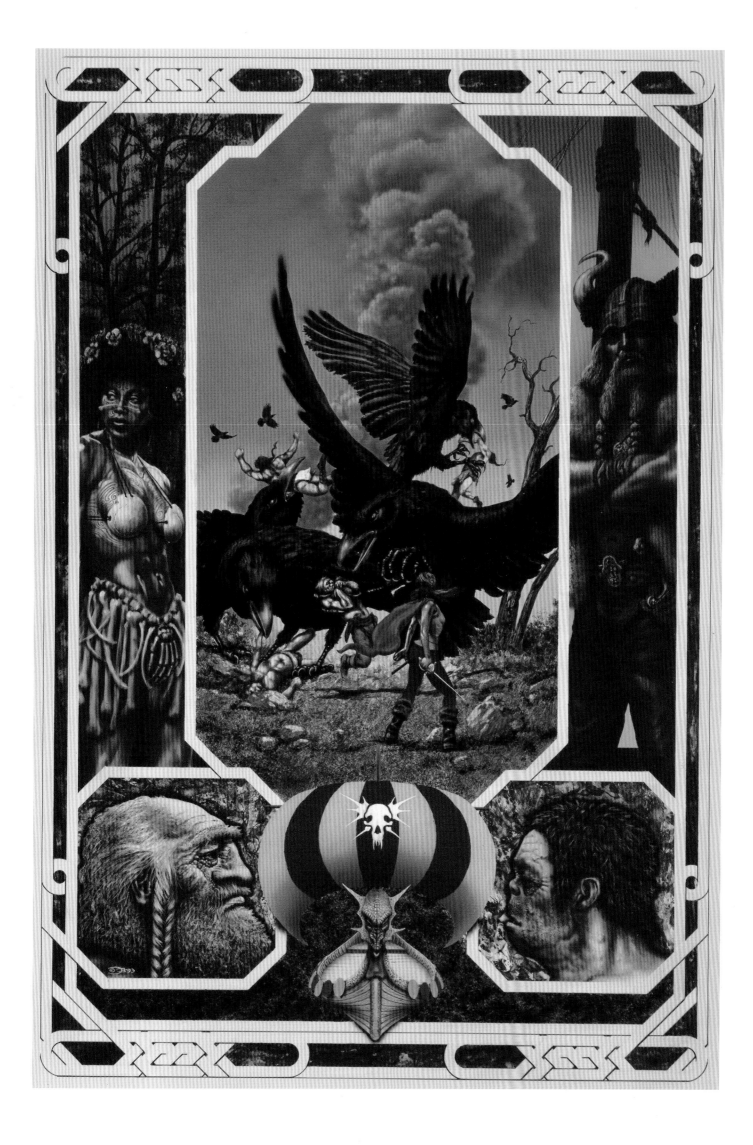

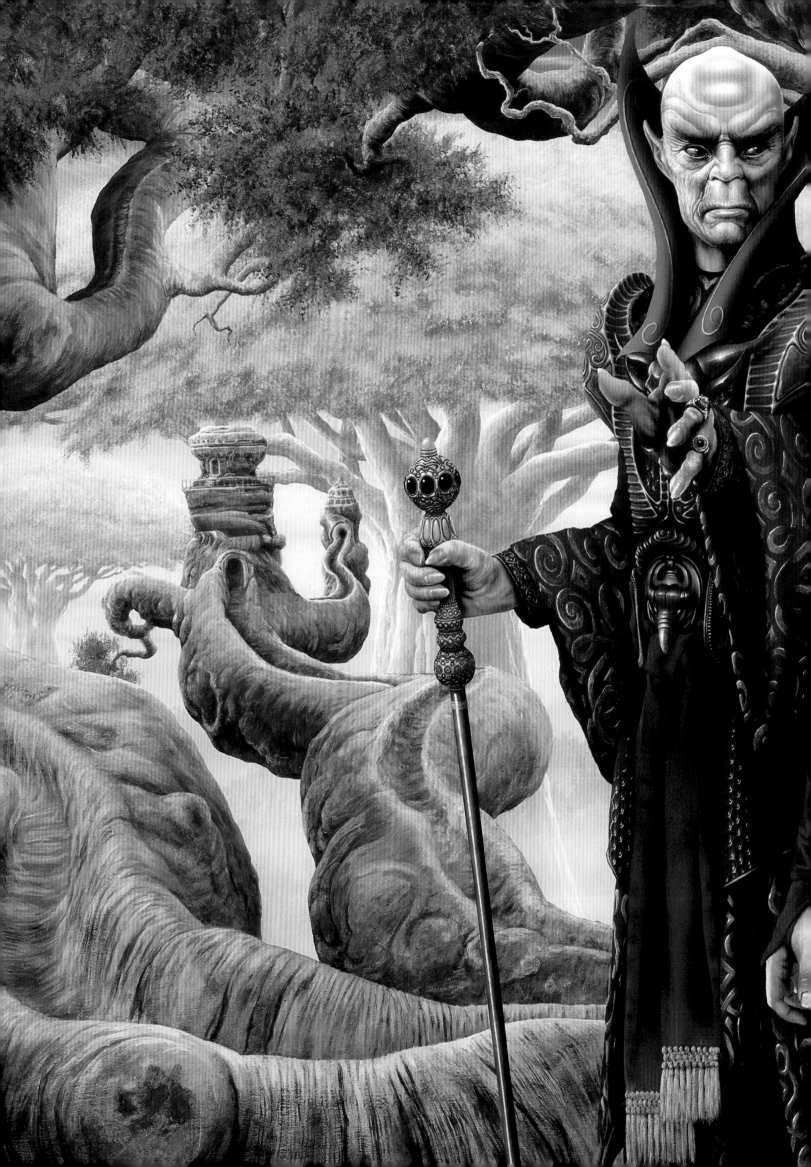

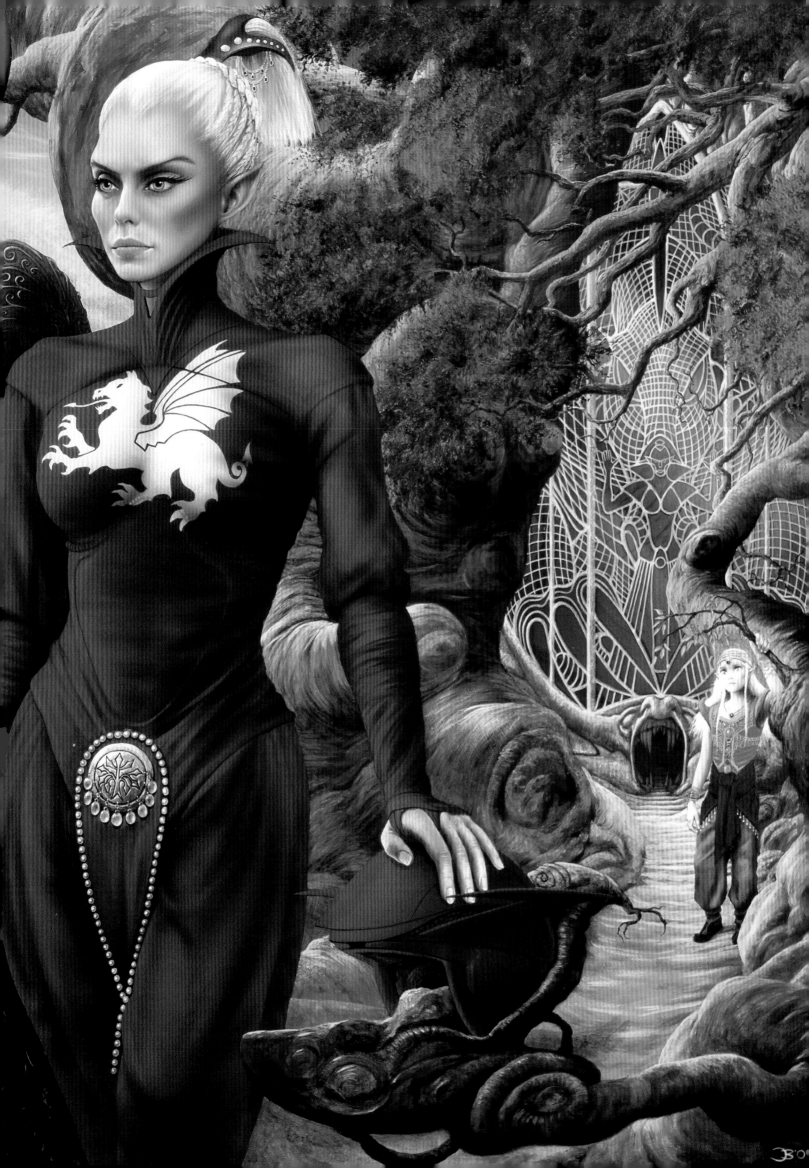

A Song Of Ice And Fire George R. R. Martin. Acrylics and real wood veneers.

Clockwise From Top Left:

Book 1—A Game of Thrones. 1995; *Book 2—A Clash Of Kings*. 1997;

Book 3—A Storm Of Swords 2. 2000; *Book 3—A Storm Of Swords 1*. 1999

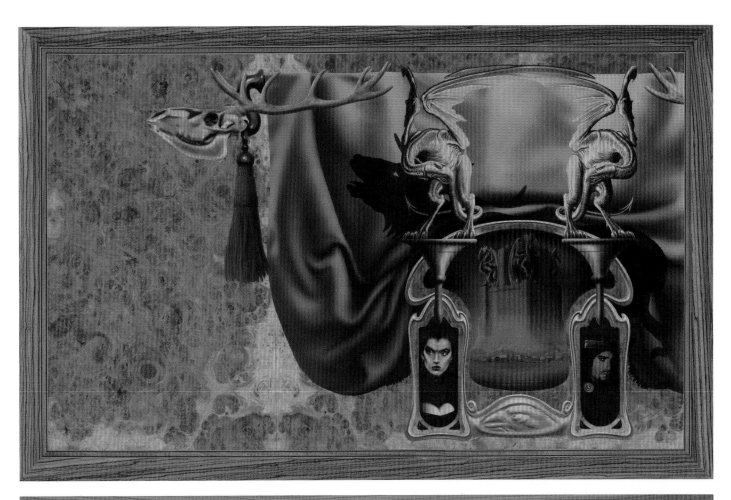

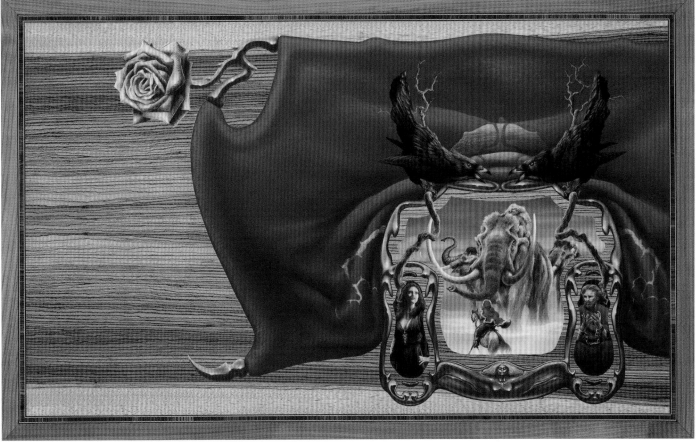

What is 'High Fantasy'? *A Song of Ice and Fire* probably defines that term better than any other novel or sequence of novels. Dense and complex, the books tell of the power struggles between high-born families. Recent editions of these novels reflect the contemporary preference for simple 'iconic' cover design. When I created these covers in the mid to late 90s for the very first editions, the preferred look for fantasy novels was that of ornamented, detailed richness, paneled elements, and vibrant colour. Using real wood veneers with cut-outs for painted areas can't be that difficult can it? My own daft idea and a road I'm unlikely to go down again any time soon.

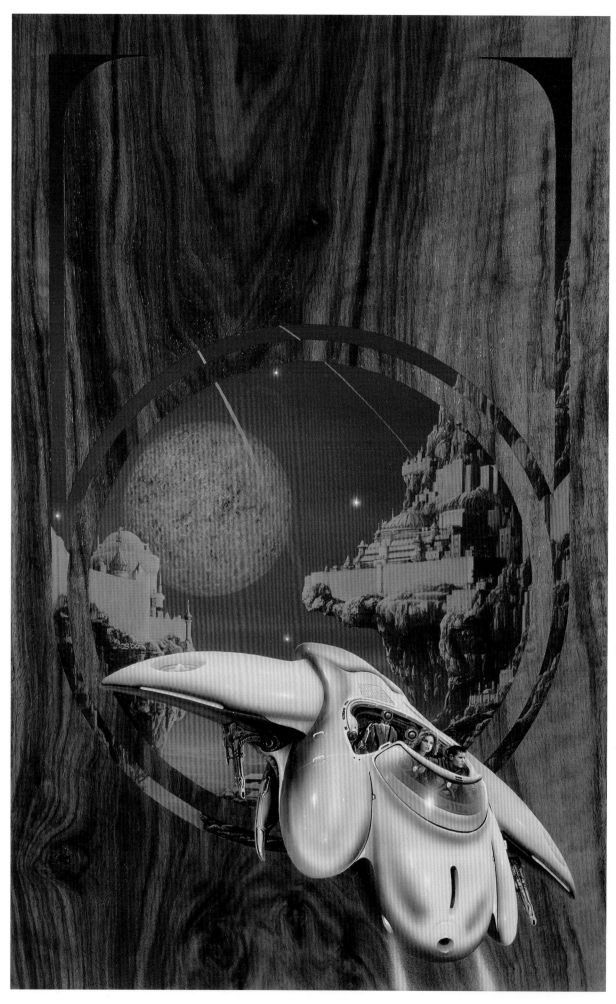

Above: *Dying of the Light* (George R. R. Martin) Acrylics and real wood veneers. 2000

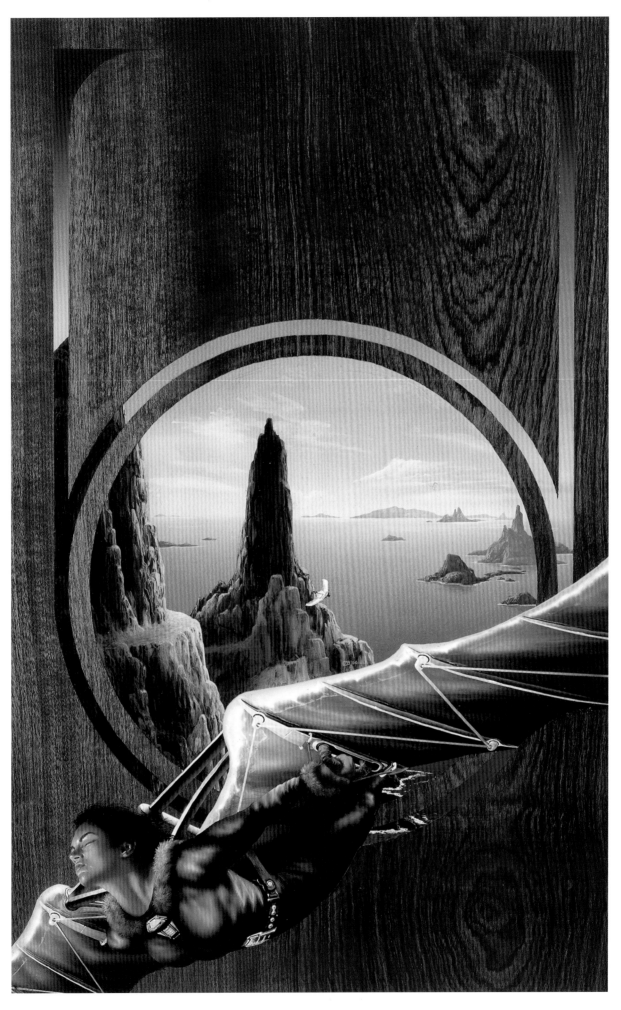

Above: *Windhaven* (George R. R. Martin & Lisa Tuttle) Acrylics and real wood veneers. 2000

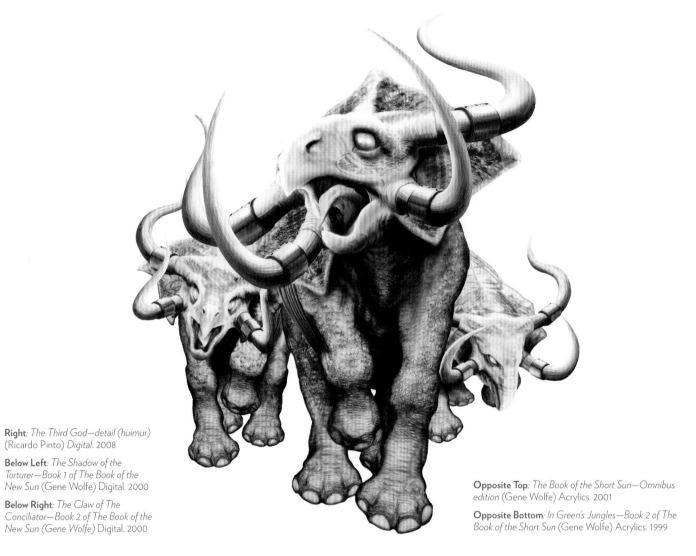

Right: *The Third God—detail (huimur)*
(Ricardo Pinto) *Digital*. 2008

Below Left: *The Shadow of the
Torturer—Book 1 of The Book of the
New Sun* (Gene Wolfe) *Digital*. 2000

Below Right: *The Claw of The
Conciliator—Book 2 of The Book of the
New Sun* (Gene Wolfe) *Digital*. 2000

Opposite Top: *The Book of the Short Sun—Omnibus
edition* (Gene Wolfe) *Acrylics*. 2001

Opposite Bottom: *In Green's Jungles—Book 2 of The
Book of the Short Sun* (Gene Wolfe) *Acrylics*. 1999

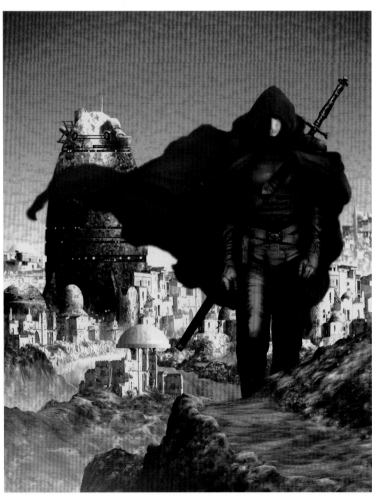

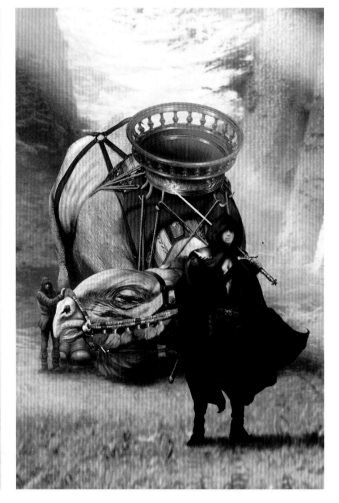

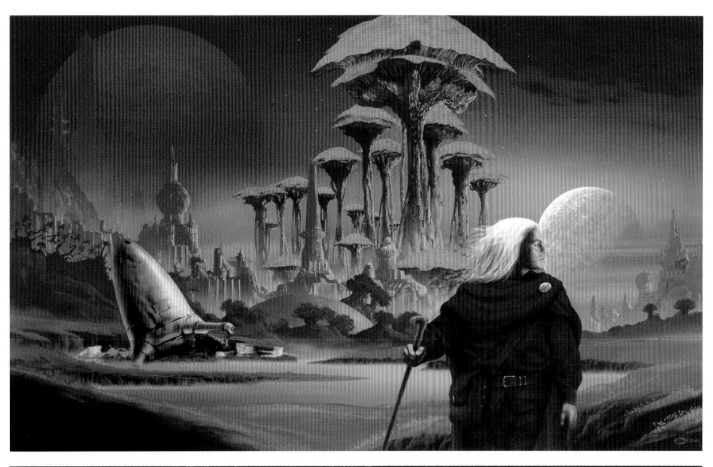

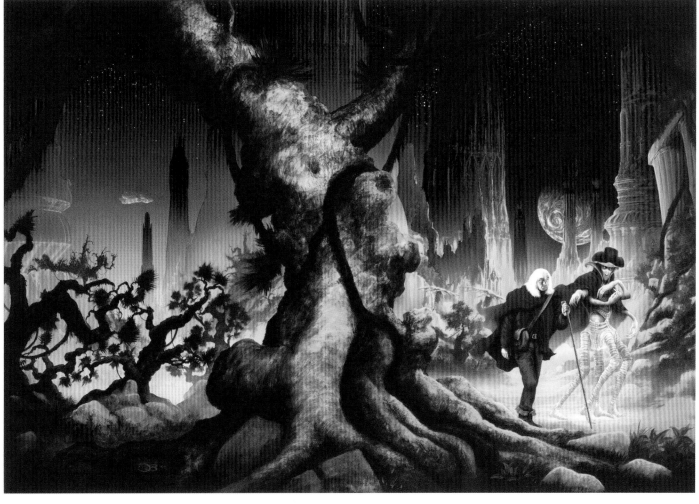

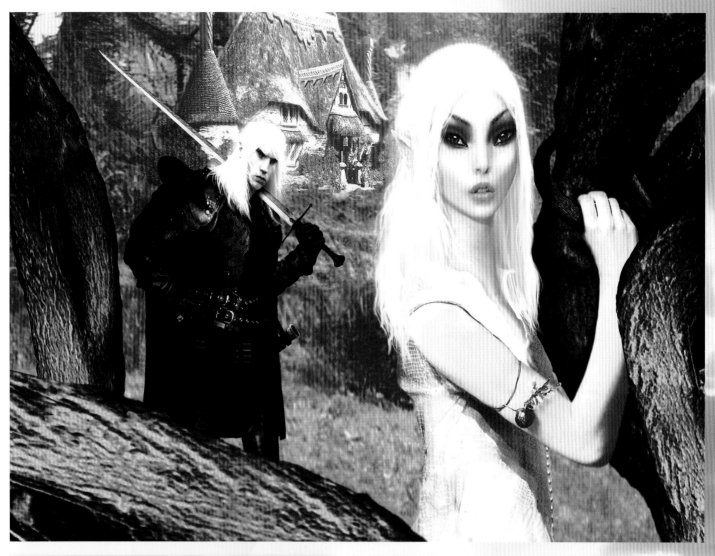

Top: *The Dreamthief's Daughter* (Michael Moorcock) Digital. 2001

Bottom: *The Green and the Gray* (Timothy Zahn) Acrylics 2004

More science fiction than fantasy but featuring my youngest daughter, Gwendolen looking strange and 'fae' as she emerges, dryad-like from a tree. I decided it could easily fit into this section of the book.

Opposite: *Jaran* (Kate Elliott) Acrylics 1991

Next Spread: *Keith was away with the Fairyfolk* (Private Commission) Acrylics 2012. The collector himself features as the main protagonist in this painting along with a couple of his favourite things in life like the works of James Joyce—from which he can quote large opaque chunks—and busty fairyfolk. I do have some very interesting friends.

Of the literature I have read which can be termed 'Fantasy', I think the sequence of novels by Gene Wolfe, *The Book of the New Sun,* has to be my personal favourite. Following the travels and travails of the apprentice torturer, Severian—exiled for showing compassion towards his victim—they stand out for me because of the sheer literacy Wolfe brings to the novels. Wolfe is an absolutely top class writer by any measure—something I realised back in 1974 when I was asked to illustrate the cover for his early novella *The Fifth Head of Cerberus.* He has been called by The Washington Post 'the finest writer the science fiction world has yet produced'. He unreservedly demands intelligence in his readers.

I illustrated some later novels set in the same Universe as inhabited by Severian in *The Book of the New Sun* sequence, two of which are included here.

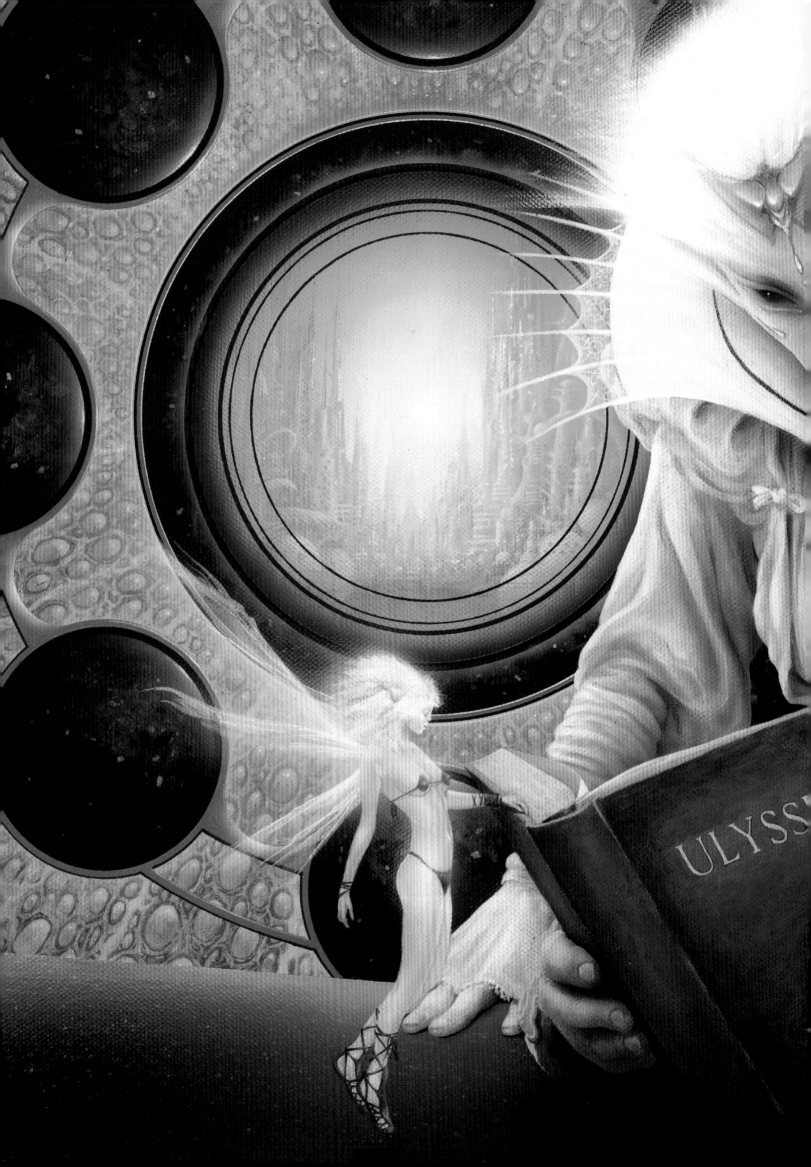

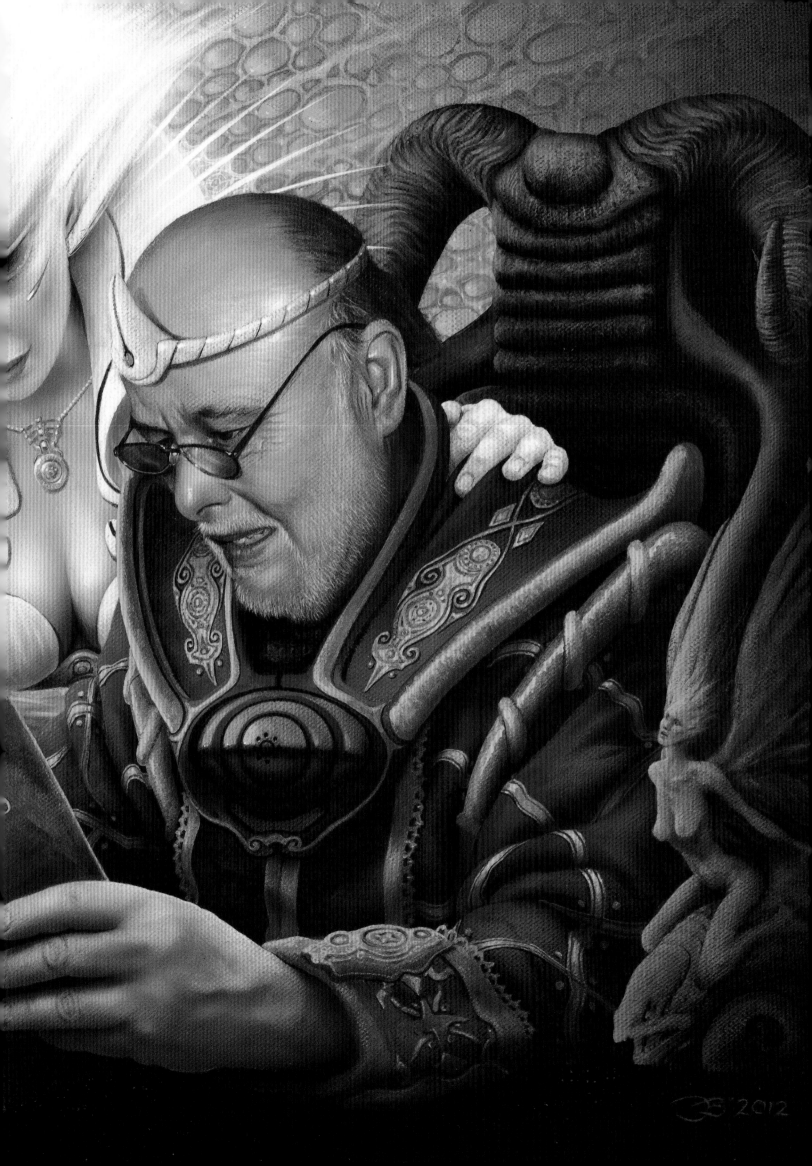

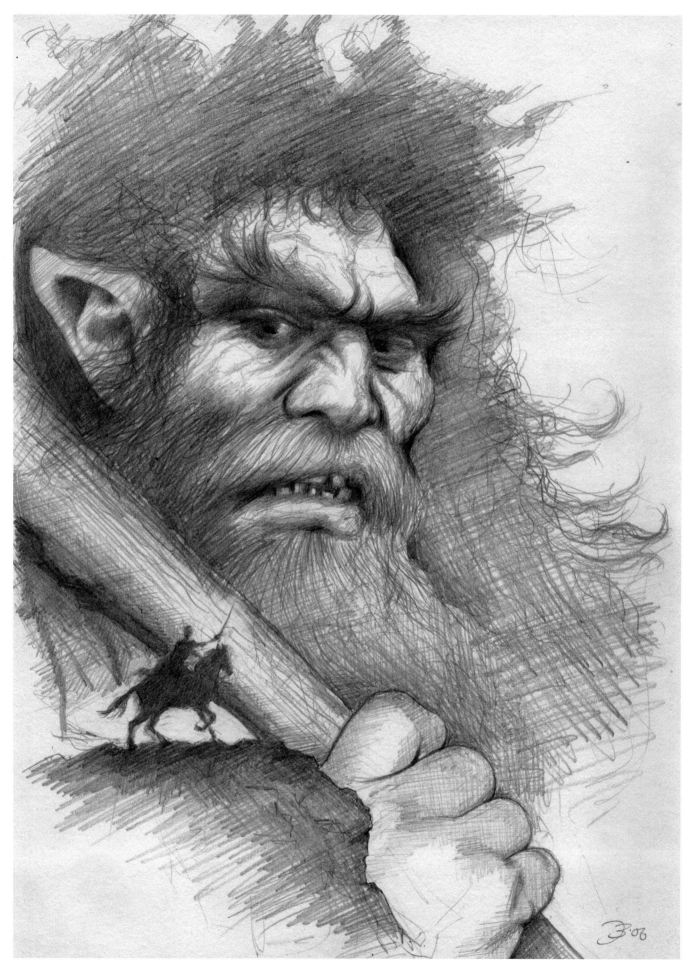

Above: *Giant and foolhardy horseman* (Personal) Pencil sketch. 2006

Opposite: *Porphyrion* (Personal) Pencil sketch and digital colouring. 2006
Toying around in my sketchbook with ideas for possible paintings. Porphyrion was a giant from Greek mythology. This section started with Greek mythology in my 'The Dryad of the Oaks'. I'm very drawn to the subject I must say and am currently working on what will be a major painting for me based on the Pandora myth.

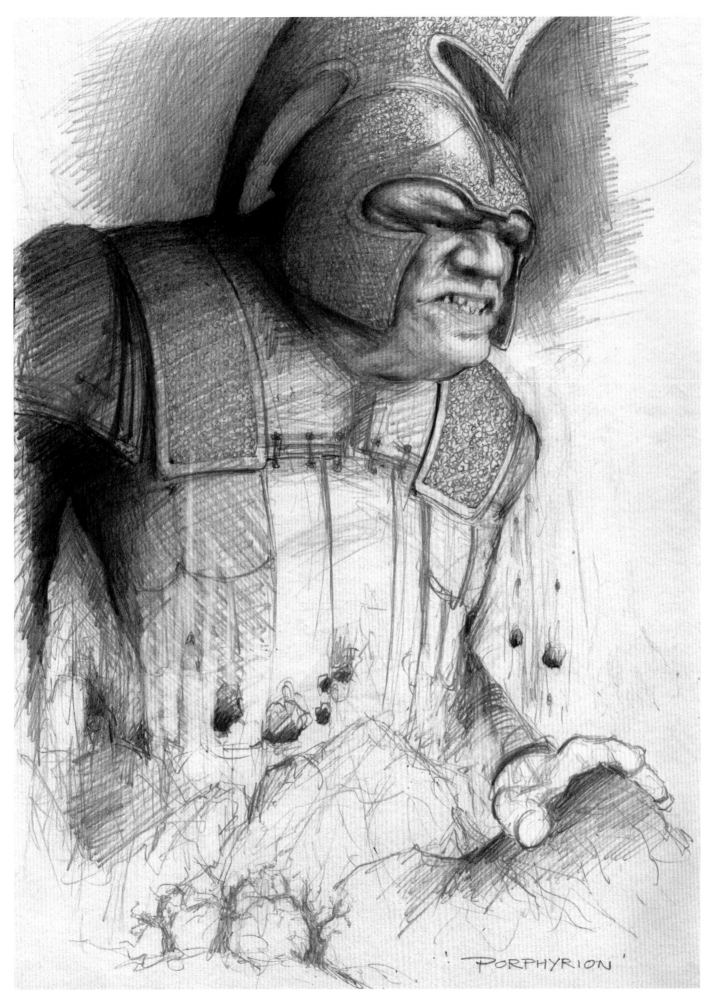

'PORPHYRION'

Next Spread: *Other Edens 3* (Anthology—Edited by Chris Evans and Rob Holdstock) Acrylics. 1989
An idea of my own to convey a sense of surreal strangeness that would hopefully encapsulate in some way the short stories within.

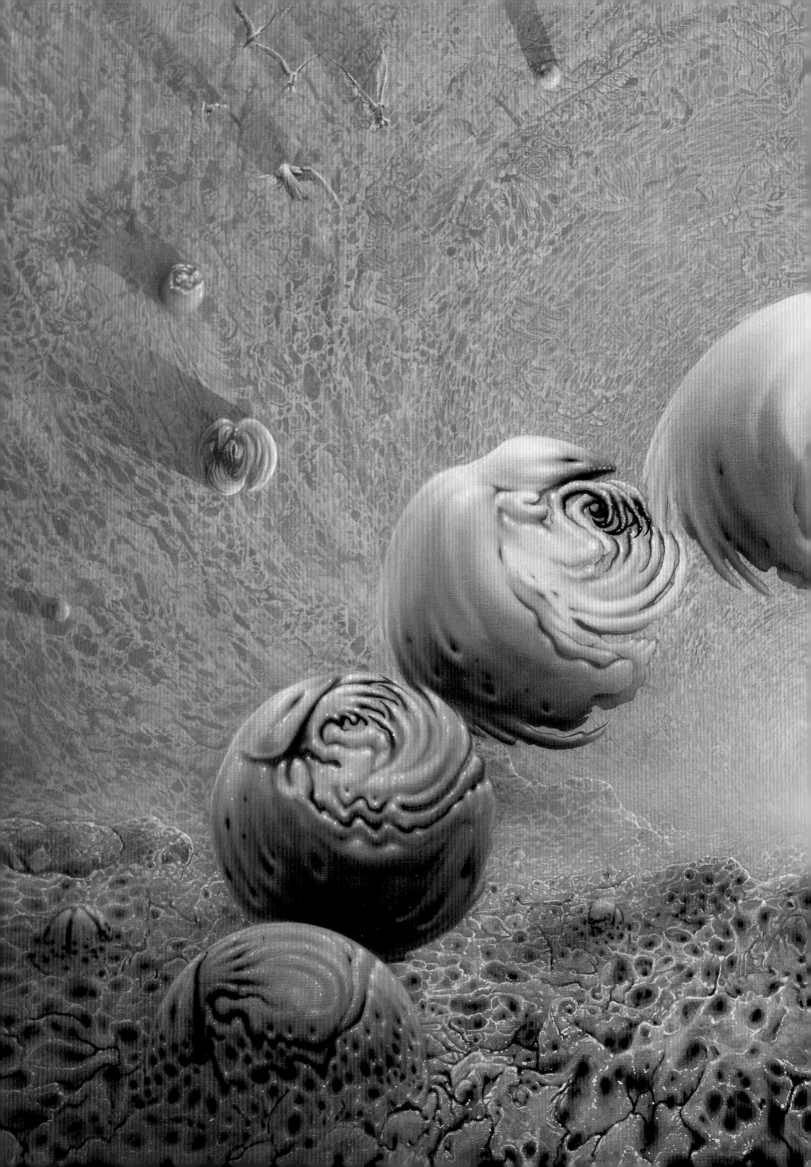

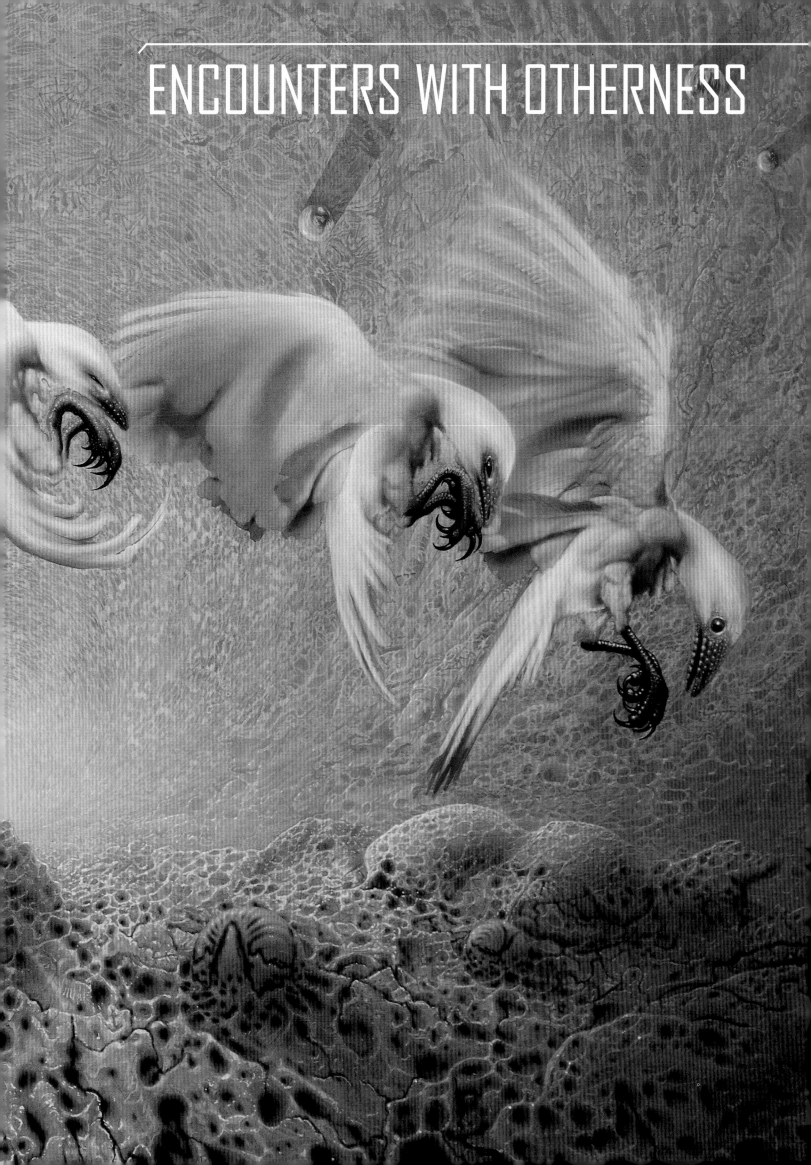

My young obsession with the classic tropes and themes of science fiction inevitably evolved as I grew older. These days my imagination tends to inhabit darker zones and most contemporary science fiction doesn't really go there. Which isn't to say I've entered some new 'dark place of the soul', I simply find imagery that inclines, let us say, towards the 'unsettling' more interesting. Don't get me wrong, in the hands of a skilled writer science fiction can be satisfyingly provocative in it's depictions of dystopian possibilities for our future—extrapolating, as always on the actual here and now—which, let's face it sometimes looks pretty dismal. From an artist's perspective when depicting a spaceship or an alien becomes a bit easy, you need new roads to go down, new avenues to explore. Physically I'm rather an indolent sort of person but when it comes to expressing myself in paint I really do want to actively explore new zones of the

imagination. I'm currently working on some mythological subject matter including a 'Pandora' painting which I hope to bring some sense of darkness to, and so interpret it more in line with the 'beautiful evil' of the original story. Also from Slavic mythology comes the tale of tragic, strange Rusalka the water sprite. That too is in the pipeline as well as paintings based on the works of Poe. I do have commissions for the kind of material people are more used to seeing from me—sexy spacegirls draped over sleek hardware for instance—and I will enjoy painting them (of course I will!) but looking back through the archives of over 40 years of work I see that there has always been a thread of something a little stranger, a little darker, a little more surreal. It's time, I think, to explore that territory more fully now.

This Spread: *Still Life* (Tim Lebbon) Digital. 2013

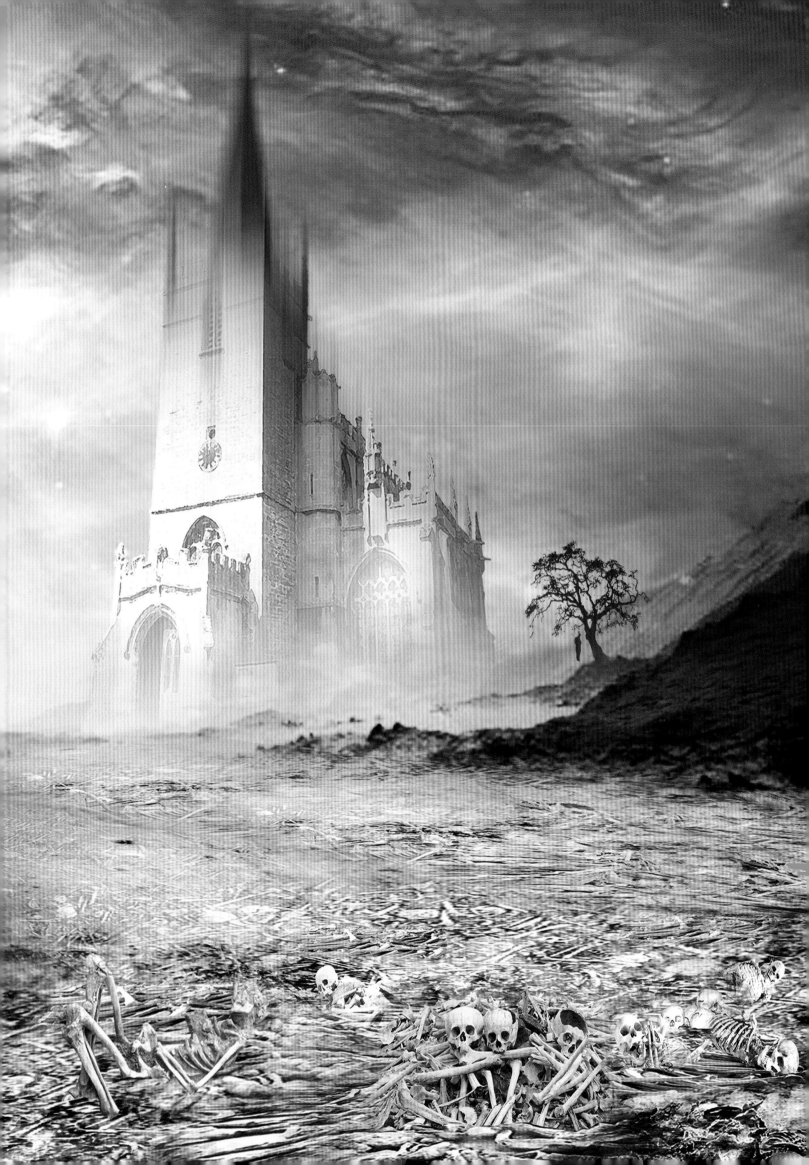

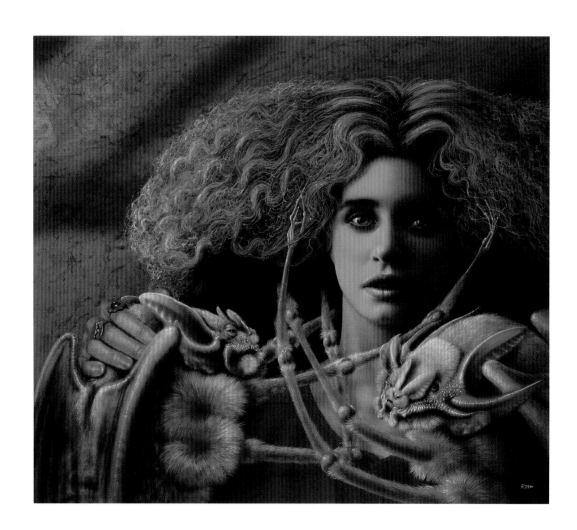

Top: *Artificial Things* (Karen Joy Fowler) Acrylics. 1989
What would a bat-moth hybrid look like? I wondered...

Right: *The Book of Skulls—detail* (Robert Silverberg) Acrylics. 1982

Opposite: *Arkangel* (Christopher Fowler) Digital. 2011
I was mooching around the grounds of Salisbury Cathedral one day, taking pictures of the exterior. The crumbling architecture here is largely stitched together from sampled elements taken from that photo session.

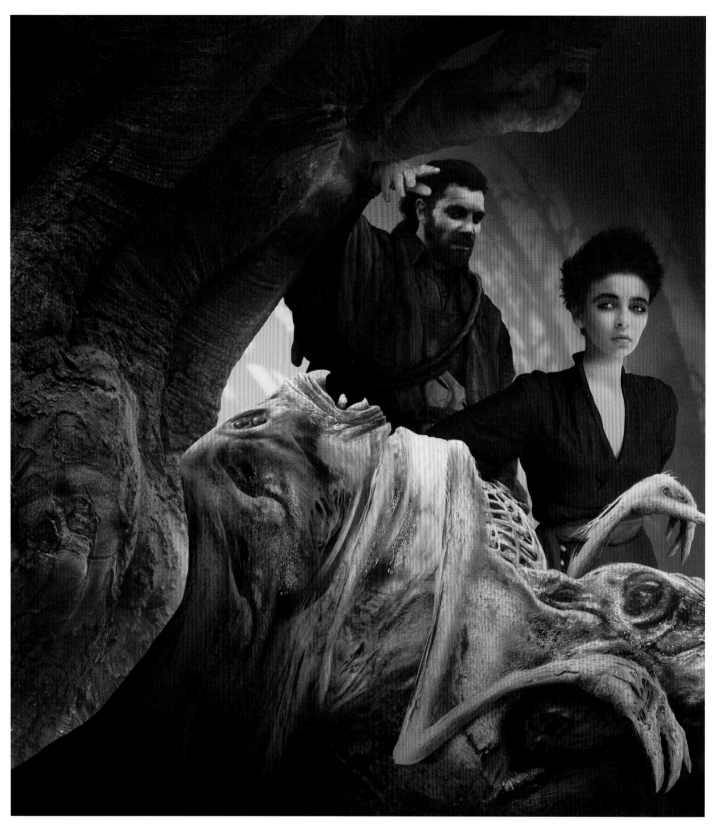

Above: *Eater-of-Bone* (Robert Reed) Digital 2011

Opposite: *Tertiary Node*. 2002
These 'Lost Narratives' paintings (and the writing) I create for my own amusement. This one features my middle daughter,
Megan, as 'Sheer'. The number '59' suggests a lot of paintings in the series but truth be told, I have so far completed only two!

No 59 in the 'Lost Narratives' series.

Sheer located the first of the invasive nodal eruptions near the rear of the ship—towards the port side of the cargo deck main buttress housing. The semi-sentient invader, oblivious to her alarmed presence, appeared to have been seeded at least 3 days previously, ship-time. It had already had the time to summon into this dimensional strand a control blister which it was busily manipulating with its 4-fingered but eerily human hands. Who knew what damage had been done in that time—and how many more eruptions would be found throughout the huge vessel? And this was only a tertiary node! The secondary and primary node seedings would inevitably follow. Something the human crew were ill-equipped to handle....

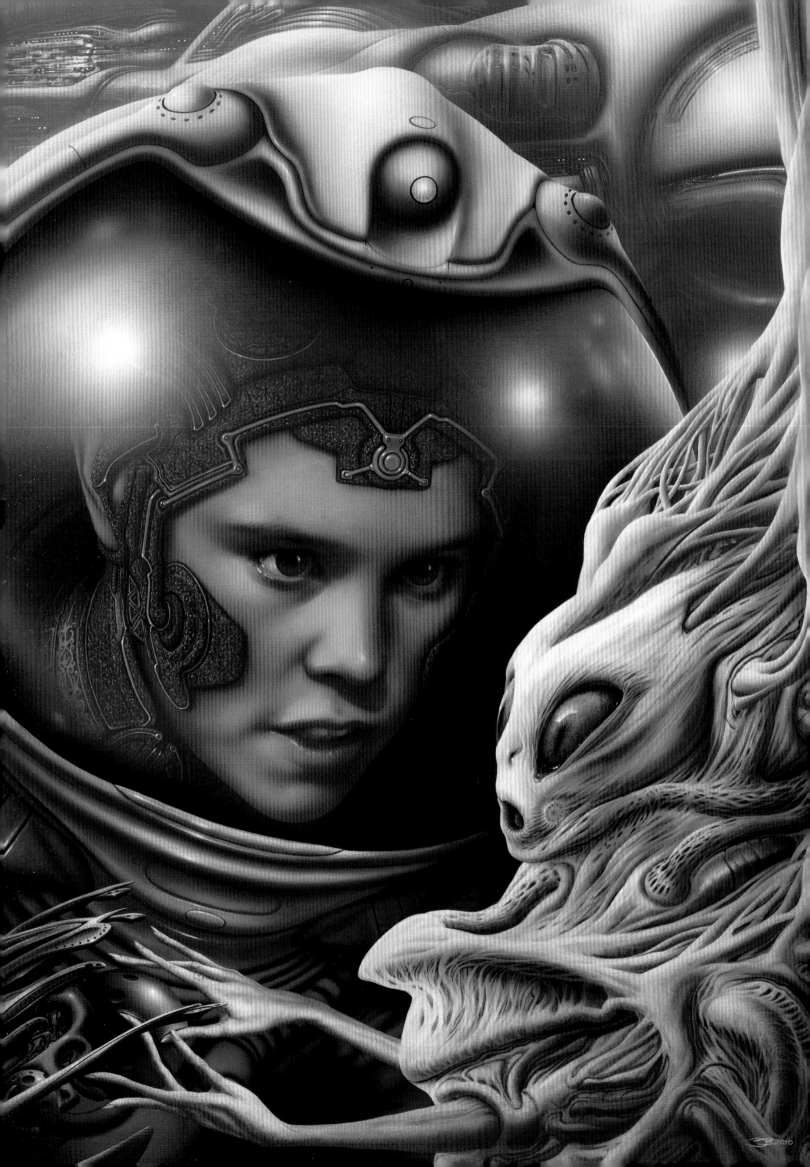

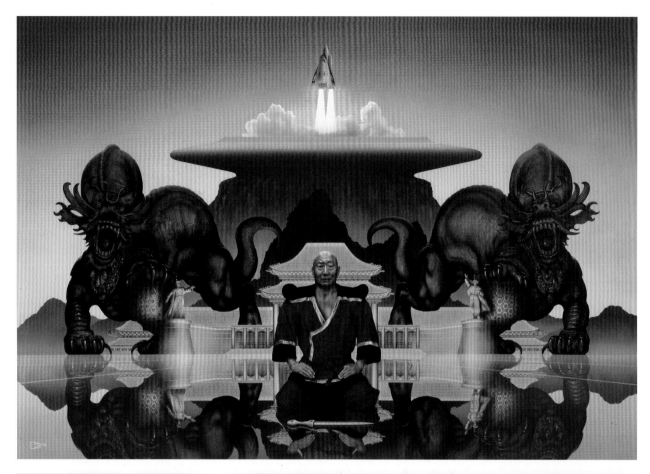

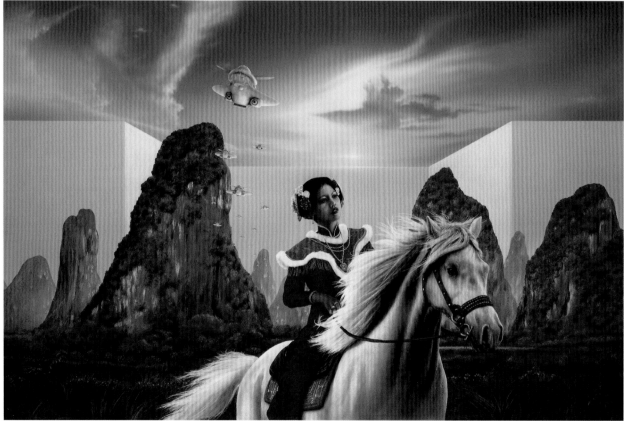

David Wingrove's epic series of *Chung Kuo* novels takes us some 200 years into the future into a minutely observed and deeply researched Chinese dominated world. Somewhat prescient of him I suspect! It was truly a massive undertaking on David's part and it has been compared to Frank Herbert's *Dune* series, James Clavell's *Shogun* and Isaac Asimov's *Foundation*' sequence. Here are three of the six large paintings I created for that series. It was fascinating trying to combine elements of the traditionally Chinese with near future overlays.

Top: *Chung Kuo 3—The White Mountain* Acrylics. 1991

Above: *Chung Kuo 2—The Broken Wheel* Acrylics. 1990

Opposite: *Chung Kuo 1—The Middle Kingdom* Acrylics. 1990

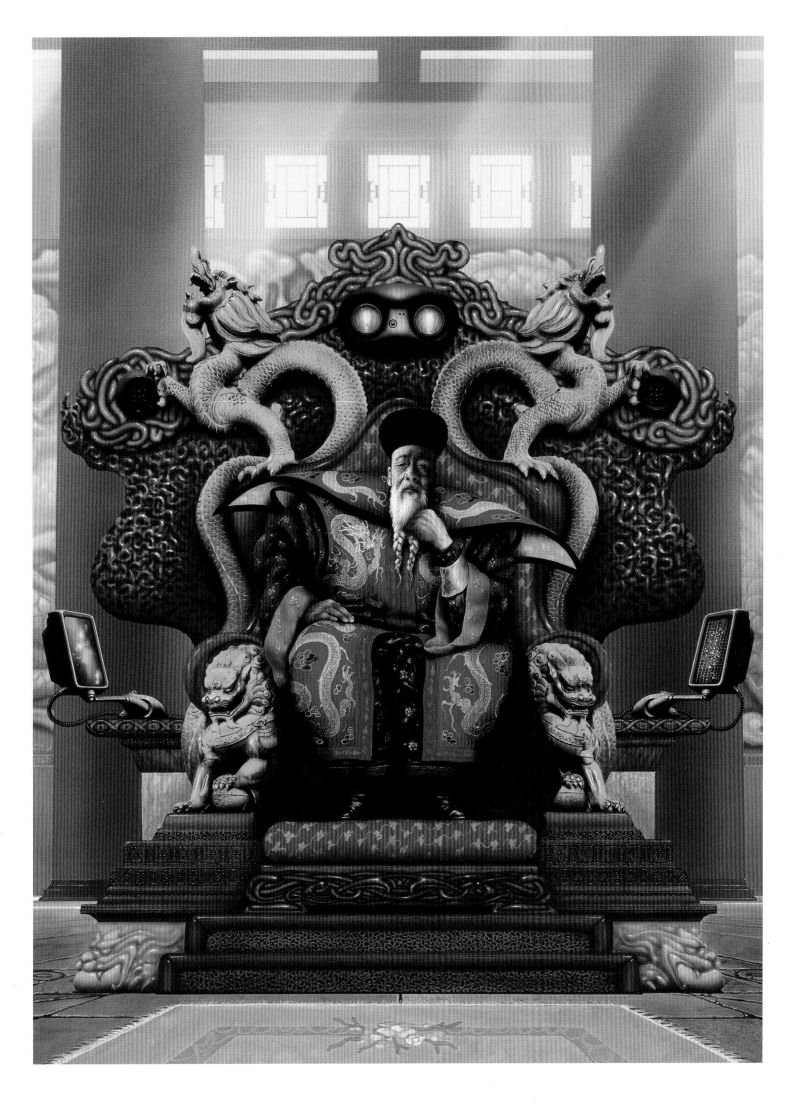

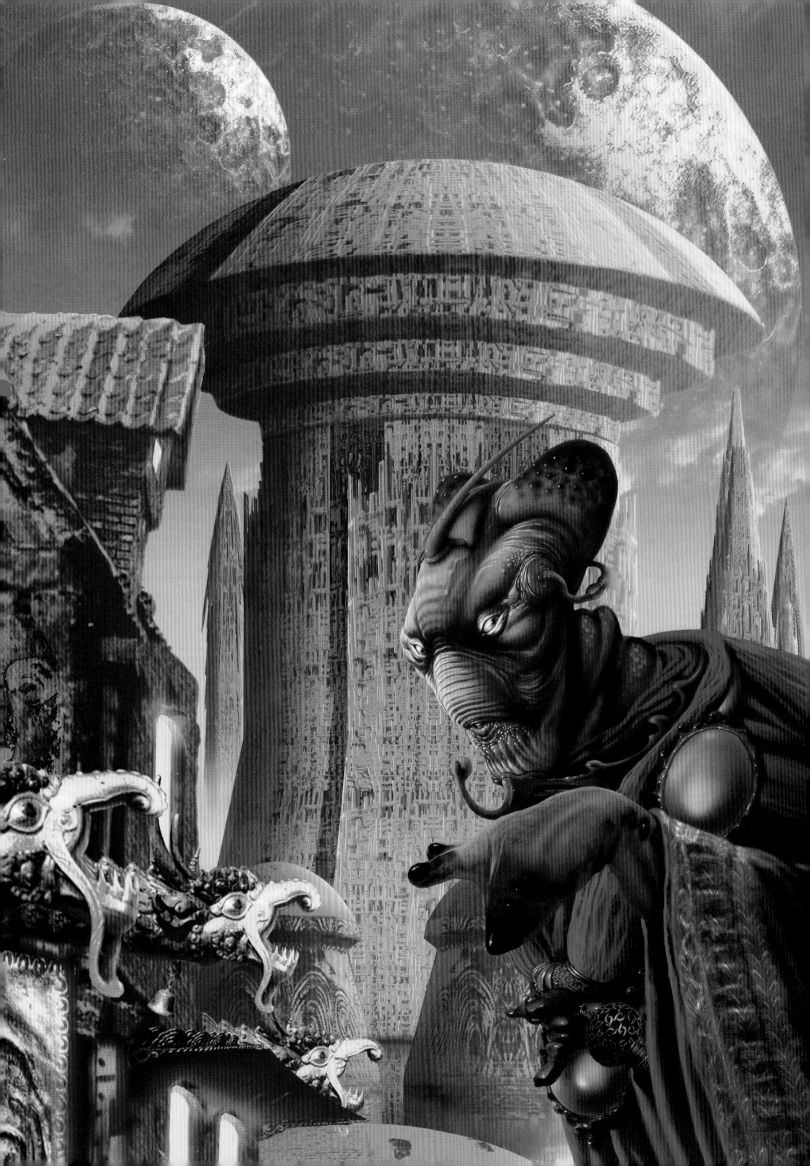

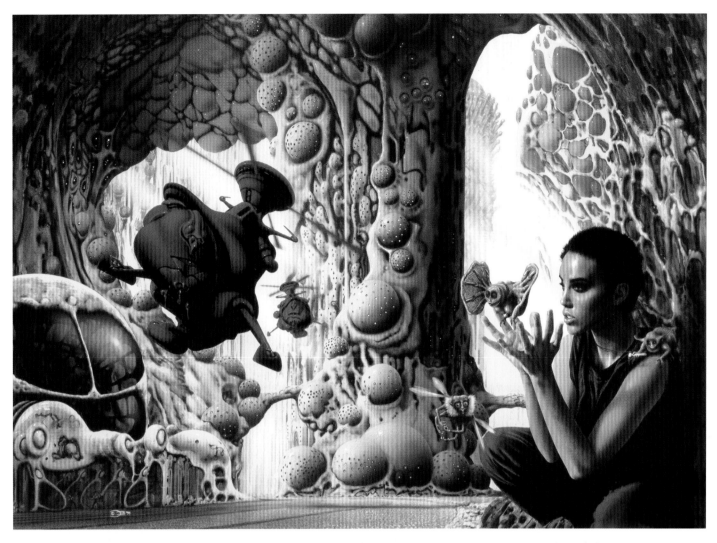

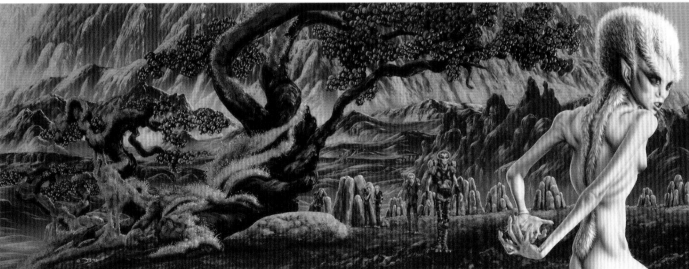

Few works of speculative fiction approach the strangeness of Ian McDonald's novels and few are written in such a lyrical, almost poetical, style. In *Hearts, Hands and Voices* (Known in the U.S. as *The Broken Land*) we accompany young Mathembe Fileli as she journeys through the intense weirdness of 'The Land'. Set 30,000 years into a biotechnological future where literally everything—from transportation to housing—is organically grown, the novel is a wonderful allegory on the conflicts born of colonisation in our own time.

Left: *Polistor* (Personal) Mixed acrylics and digital. The alien was 'extracted' from an acrylic I was privately commissioned to paint in 2001. I then dropped him on to a newly created digital background. This was for fun really and to try and learn some Photoshop skills back in the mid 2000s.

Top: *Hearts, Hands and Voices* (Ian McDonald) Acrylics. 1991

Above: *Kingdoms of the Wall* (Robert Silverberg) Acrylics. 1992. Strange indeed. We follow the humanoid alien Poilar Crookleg and his band of friends on their epic quest for knowledge. Wonderfully realised aliens and a terrific shock ending

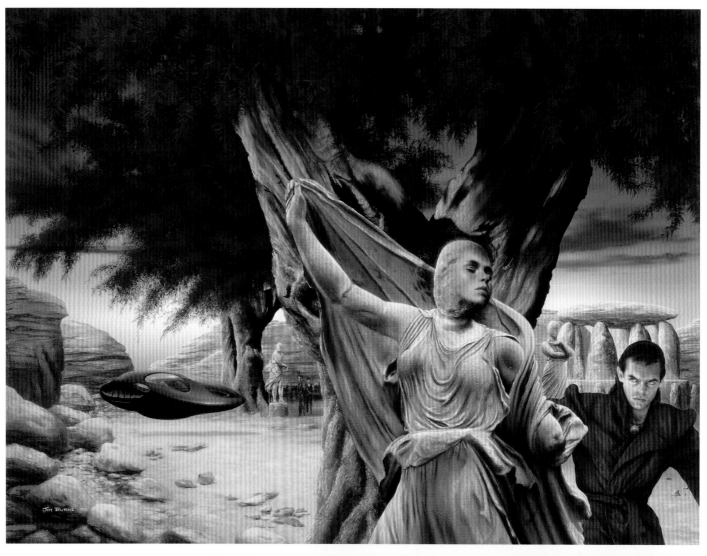

In *The Man Who Melted,* Jack Dann created a dystopian near-future to rank with *1984* and *Brave New World.* Mass manipulation of humanity by hugely powerful corporations. The novel truly fits the definition sometimes applied to the genre, namely 'The Literature of Warning'. *Science Fiction Age* has called it "one of the greatest science fiction novels of all time".

Above: *The Man Who Melted* (Jack Dann) Acrylics. 1985

Right: *Spectres of the Dawn—Book 3 of the Moreau Trilogy* (S. Andrew Swann). 1994. Angel the 'moreau', a creature part human and part genetically manipulated rabbit stock.

Opposite: *The Ever-Dreaming Verdict of Plagues* (Jason Sanford) Digital. 2011. Crista the Plague Bird releases the blood A.I. 'Red-Day' from her slashed wrist.

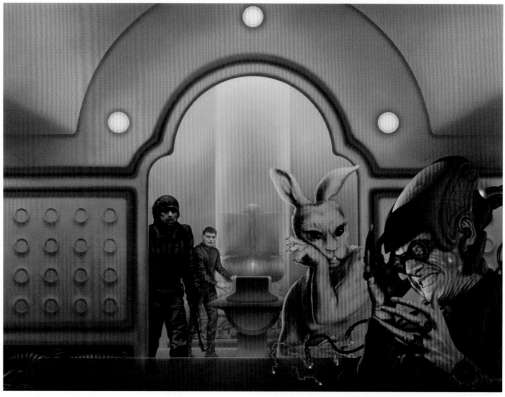

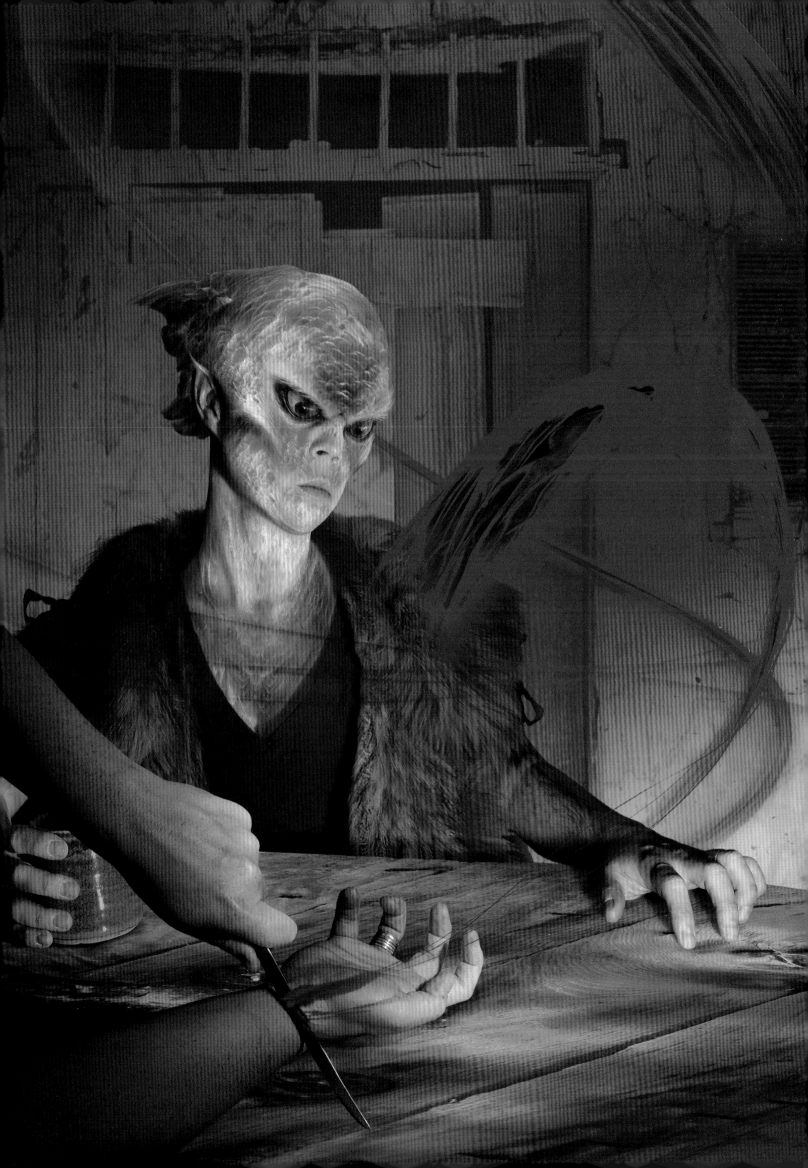

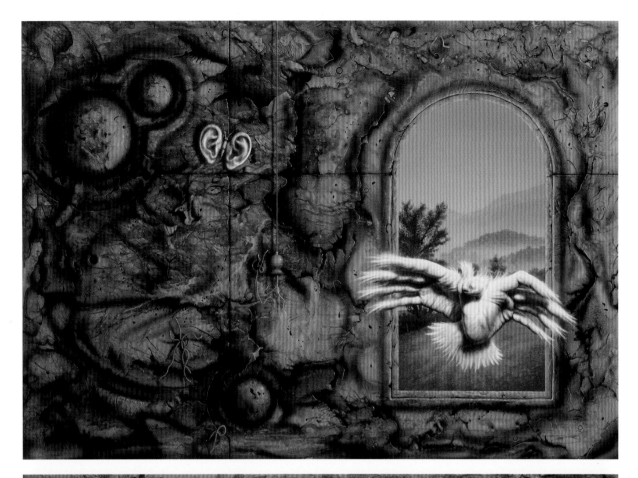

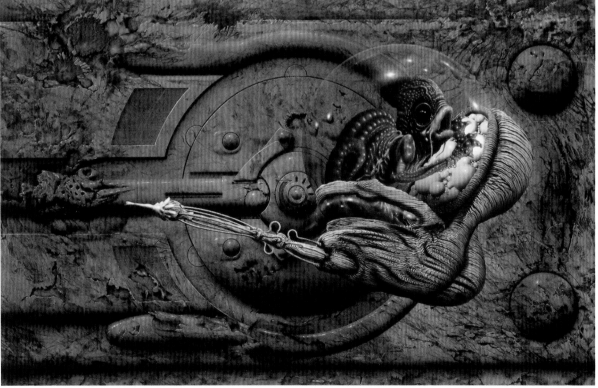

New Scientist magazine called Garry Kilworth "the best short story writer in any genre". In his story *Hogfoot Right and Bird-Hands* he can definitely claim to be one of the strangest! I drew on that tale for *The Other Edens 1* cover—an anthology of British based science fiction short stories. Here we see Bird-hands (my wife modeled the hands) and Moth-Ears against an appropriately surreal backdrop of a creepily textured wall and a bucolic country view through the aperture. A journey into an unsettling nightmare.

Top: *Other Edens 1* (Anthology—Edited by Chris Evans and Rob Holdstock) Acrylics. 1987
Above: *The Terran Derelict* (Personal) Acrylics. 1989

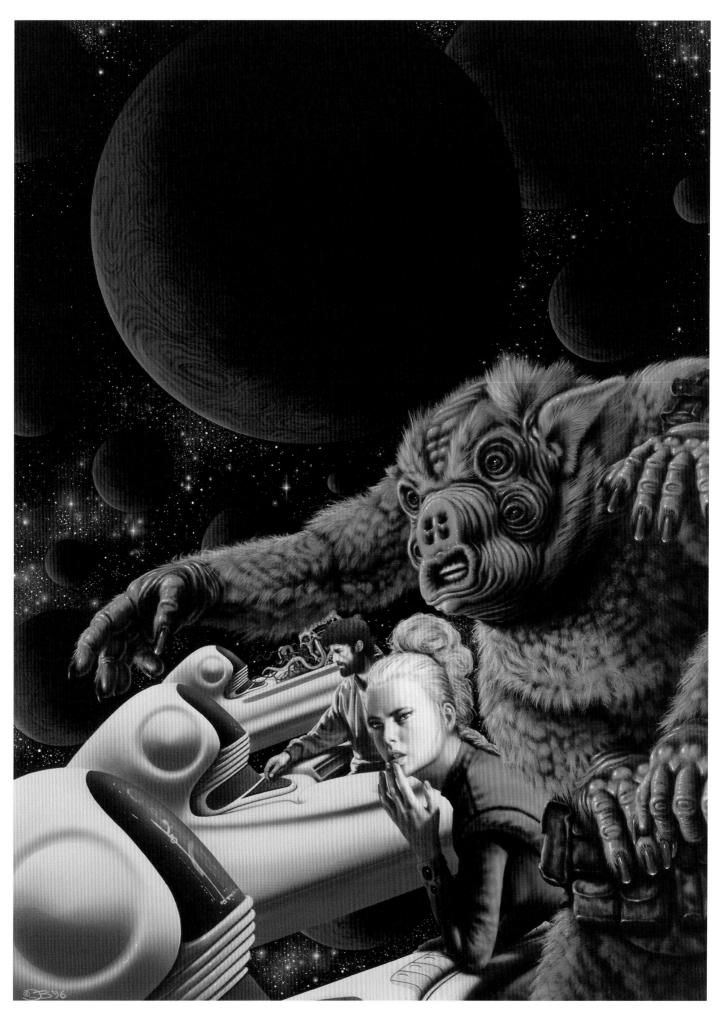

Above: *Starplex 1* (Robert Sawyer) Acrylics. 1996

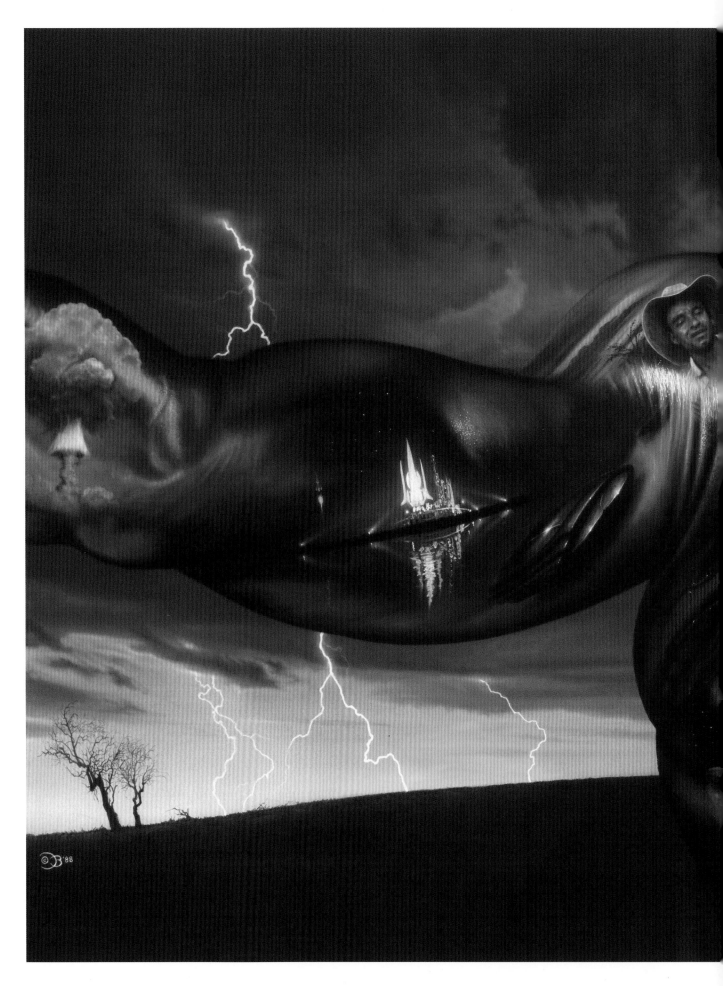

Is there a greater gift to an illustrator of the fantastic than Ray Bradbury's 'The Illustrated Man'. Upon his skin, tales that encompass Human experience in a crawling kaleidoscopic melding of the magical and the mundane, at once both marvelous and repellent. 'You'll be sorry you asked me to stay' states the Illustrated Man at the beginning of the book, establishing the tone for the unsettling tales that follow. And then, shortly after we read 'The first illustration quivered

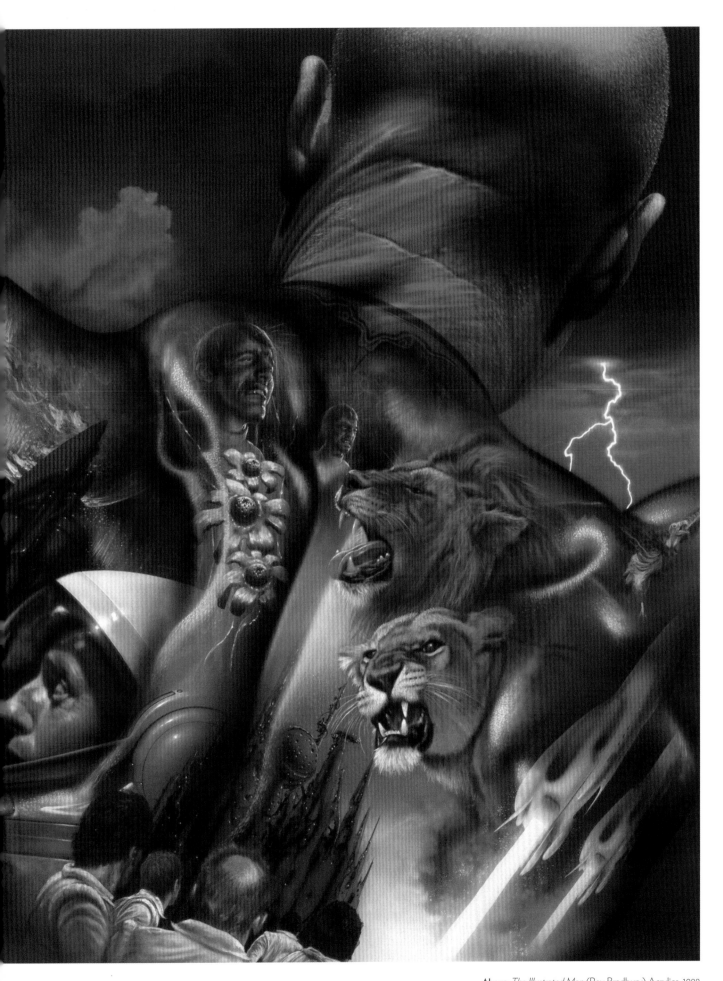

and came to life' and a mood is set which immediately gave me the hook for the approach I would take with this wonderful collection.

What delirious journeys of the imagination we embark on whilst we watch his skin talk...

Above: *The Illustrated Man* (Ray Bradbury) Acrylics. 1988

Next spread: *Darwinia* (Robert Charles Wilson) Acrylics. 1997 Thematically you don't get much bigger than 'human destiny' novels. Alternate histories of which this is one lead you down roads of the familiar before precipitating you into struggles for the survival of consciousness itself at 'The End of Time'.

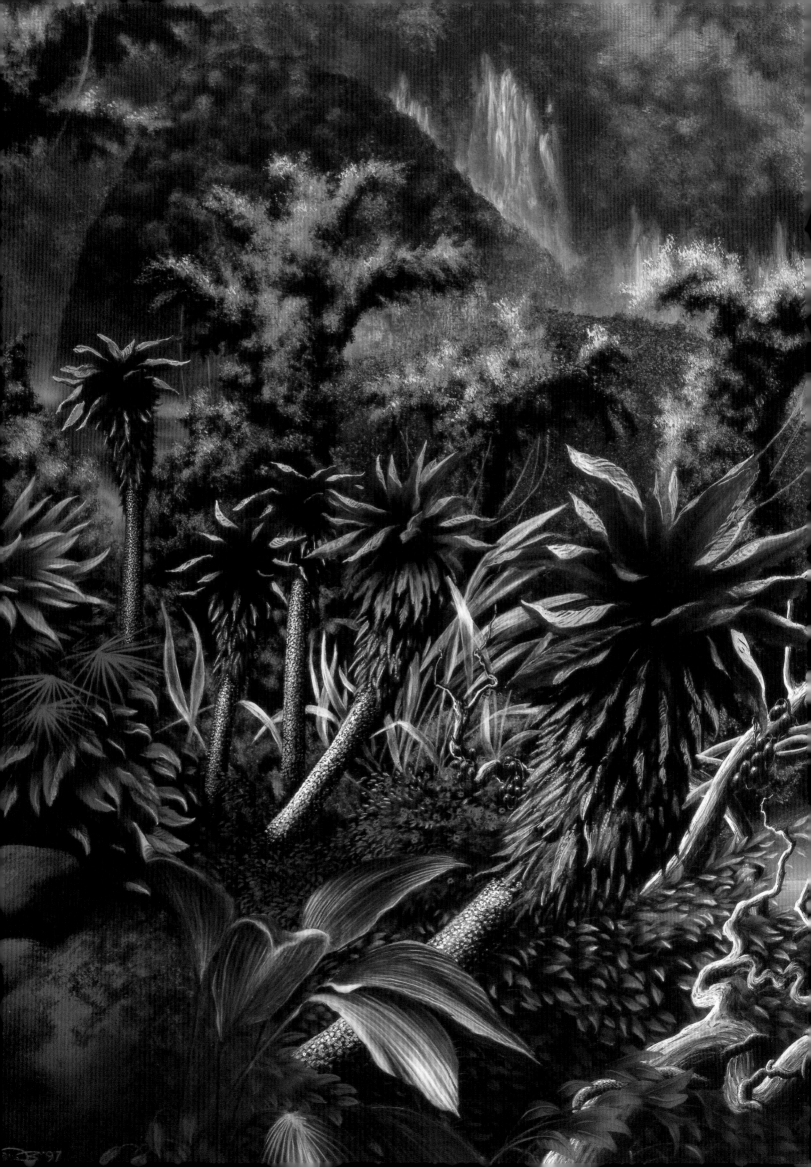

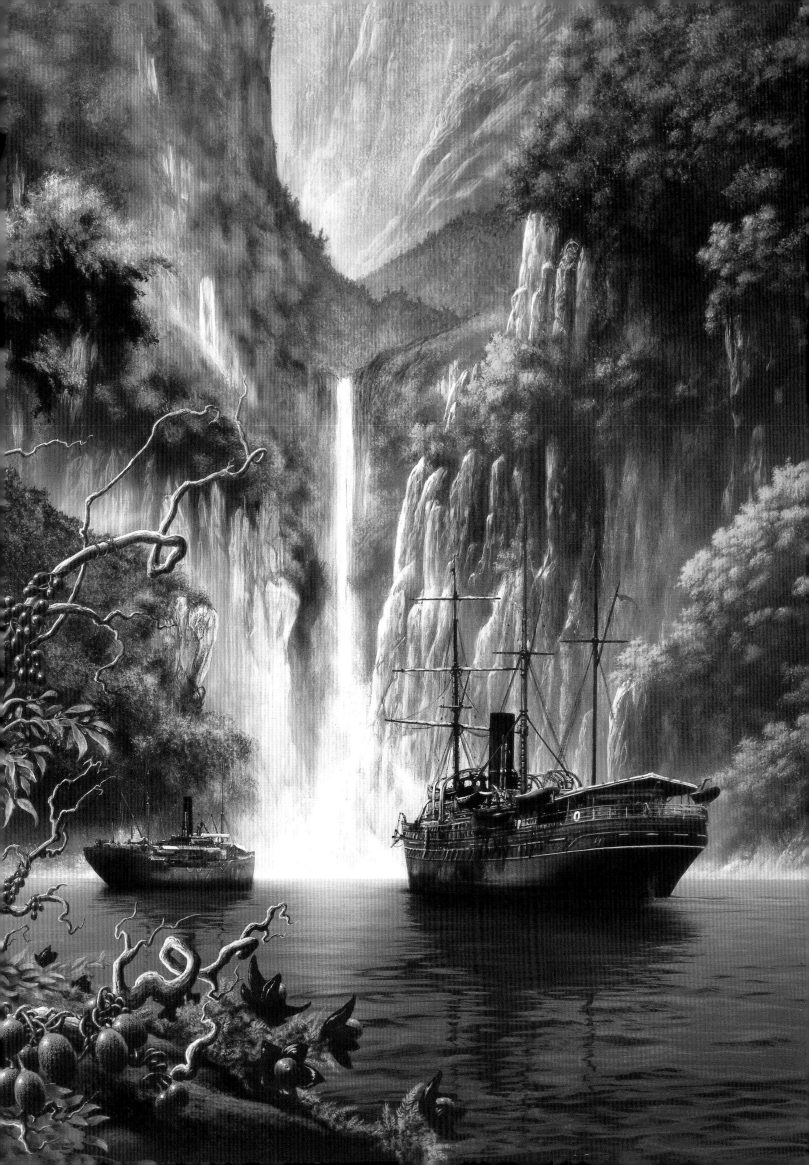

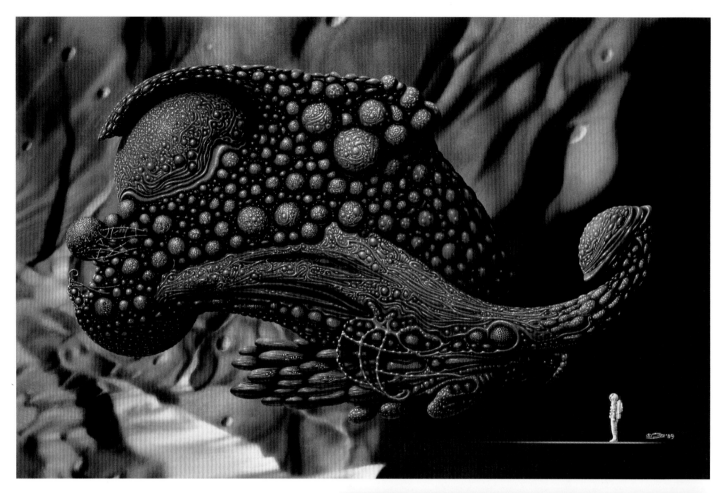

Once upon a time I imagined I might write a book and fully illustrate it. I wrote enough by way of rough text to convince me to stick with what I was best at, namely painting pictures, but we are all allowed one moment of hubris surely? I intended to take the reader on no less a journey than the entire future history of Man right up to his inevitable extinction. 'The Terran Derelict' you have already encountered on your journey through this book—the little goggle-eyed alien in his bubble-ship drifting over the vast ruined hulk of the now extinct 'Cosmic Overlords' (humanity)—was to be the last picture in the book and the first to be completed for some perverse reason on my part.

And here we have in 'Grail Imaging' a supposedly computerised rendering of a ruined alien vessel as discovered on Miranda, one of the moons of Uranus. This was to be part of the opening of my future history. An 'alien autopsy' takes place in 'Dissection of the Miranda Pilot'—the strange insectile pilot occupant found fused in some bio-mechanical way to the interior of the vessel. In 'Muscle-Ship of the Lalandian Hegemony, precision de-warping over Blood Lake, faraway, Deneb System' I'm presupposing a chunk of story line from maybe the halfway point of the narrative but in the end as it never got written at all, the image and its title stand as a cryptic impression of how the book might have developed.

That was then. I'm better now.

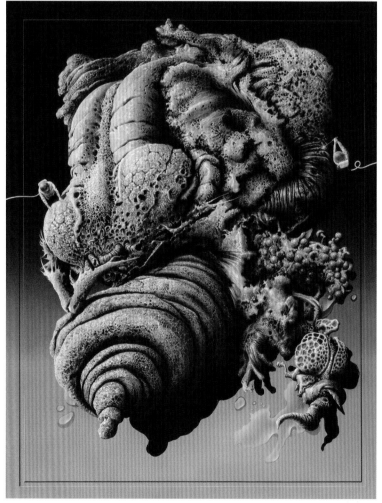

Top: *Grail Imaging* (Personal) Acrylics 1989/90

Right: *Dissection of the Miranda Pilot* (Personal) Acrylics. 1989/90

Opposite: *Muscle-Ship of the Lalandian Hegemony, precision de-warping over Blood Lake, faraway, Deneb System* (Personal) Acrylics. 1989/90

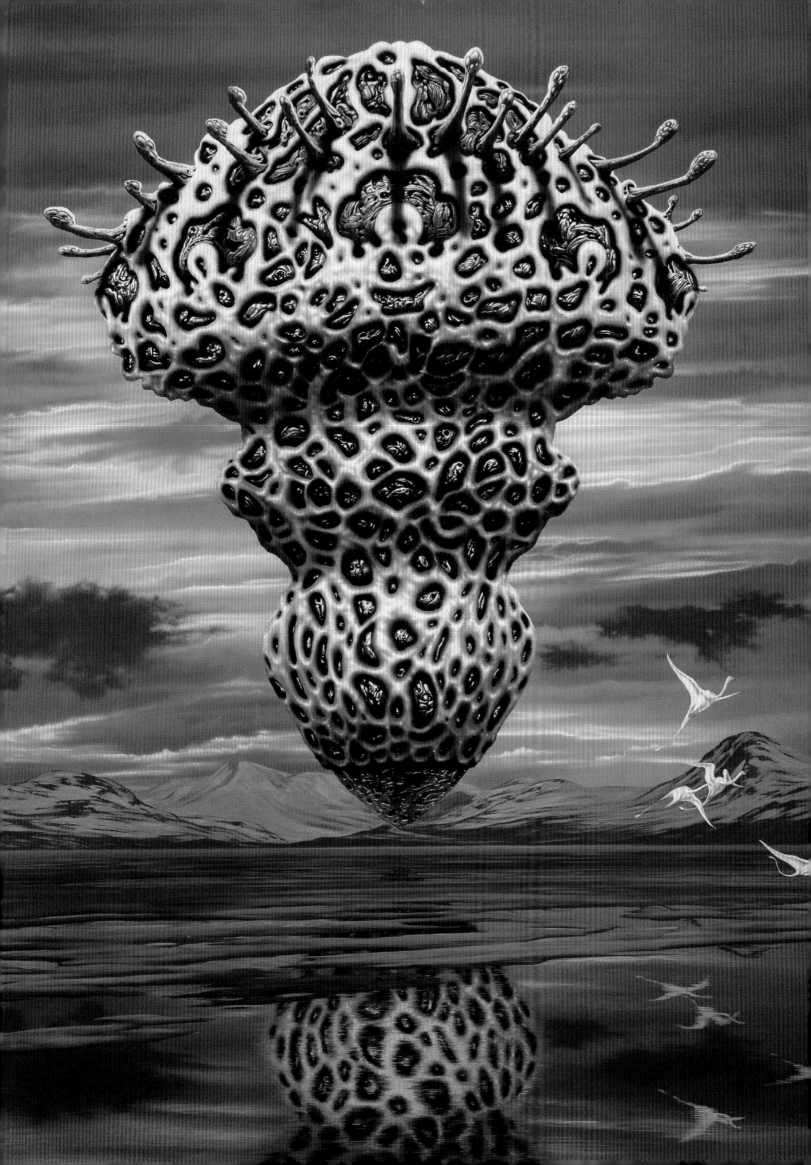

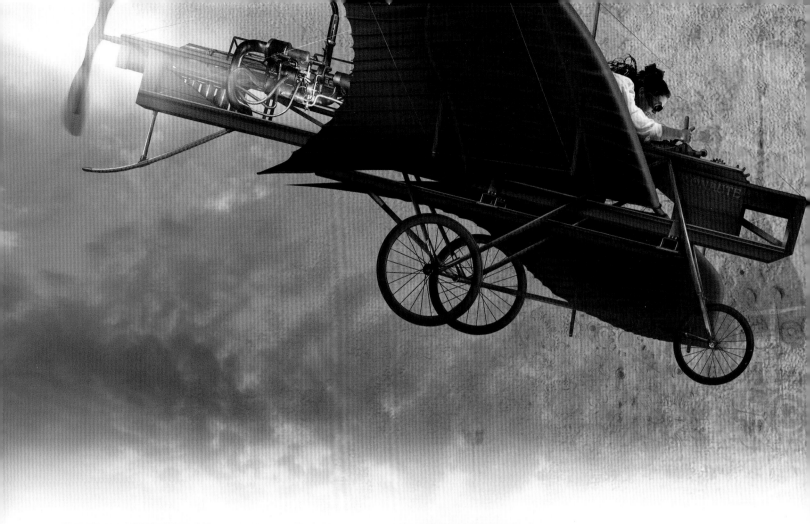

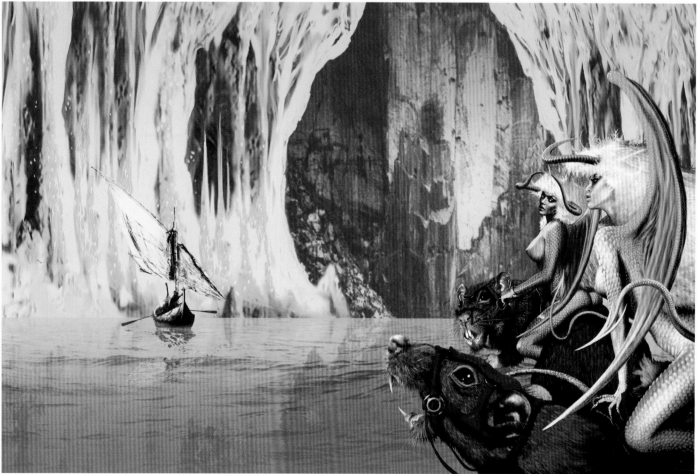

Top: *Steamgothic* (Sean McMullen) Digital. 2012
Above: *Malignos* (Richard Calder) Digital. 2000

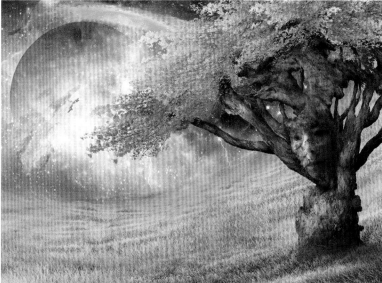

I said to my daughter Gwen, "imagine you're flying an unlikely aerial contraption, a flying death trap from the earliest days of unlikely steam-driven aviation". I took the photos and then built up the 'Aeronaute' in Photoshop. How might a steam-driven airplane of Victorian vintage look? One of my rare excursions into the world of Steampunk.

Then let us journey in *Malignos* to the centre of a perversely, sexily altered Earth to Pandemonium itself. Seductive rat-riding demon girls altered later, on the demand of the publisher, by the addition of Vallejo-esque nipple shields. Here you get the original, uncensored version!

Top: *Karl and the Ogre* (Paul McAuley) Digital. 2013

Above left: *Viator Plus* (Lucius Shepard) Digital. 2009

Above right: *Verthandi's Ring* (Ian McDonald) Digital. 2013
Three illustrations—journeys through the bizarrely bucolic.

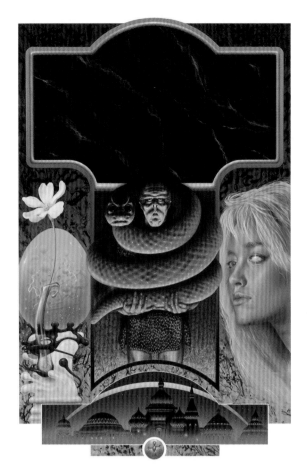

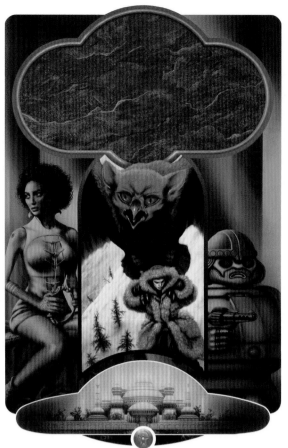

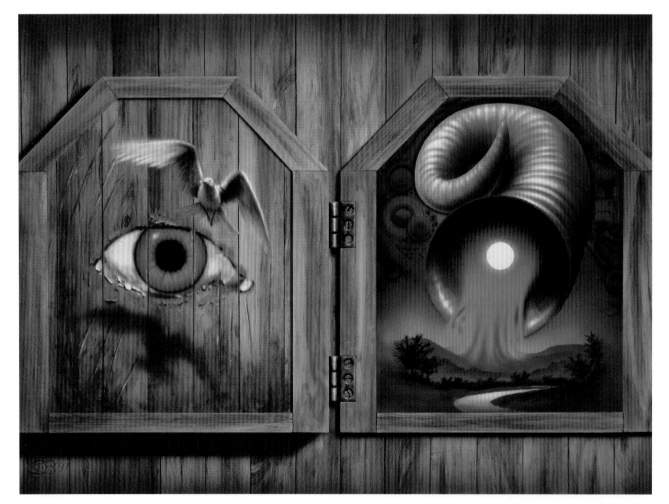

Top Left: *Lucky's Harvest: The First Book of Mana* (Ian Watson) Acrylics. 1993

Top Right: *The Fallen Moon: The Second Book of Mana* (Ian Watson) Acrylics. 1995
A mischievous and highly inventive science fiction retelling of the old Finnish Kalevala myths.

Above: *Quicker Than The Eye* (Ray Bradbury) Acrylics 1997

To achieve a reasonably accurate rendition of the wooden planking I
simply looked down at the floor I was standing on and copied it. More
enchantment from the Master of a genre uniquely his own.

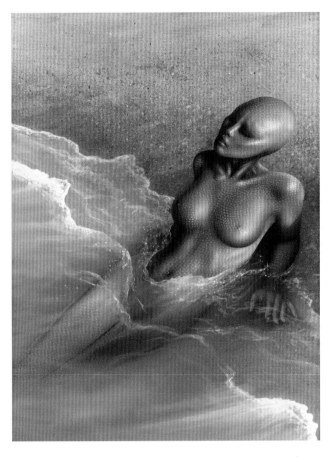

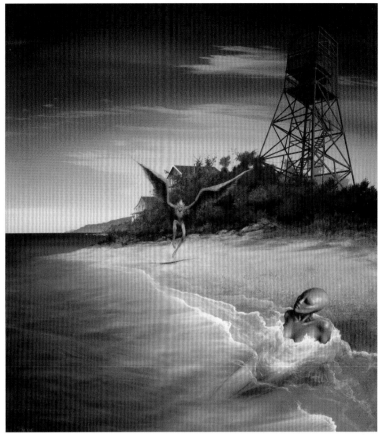

Above left: *Tumbling After—detail of the 'Merm' from the original painting'*

Above Right: *Tumbling After—full painting after 'corrective surgery'* (Paul Witcover) Acrylics. 2004
I just wish I'd done the changes digitally and kept the painting in its original state. That way it might by now have sold to a collector. Because us artists all know what collectors like!

Right: *Son of Man—detail* (Robert Silverberg) Oils. 1978

Next spread: *Homuncularium* (Personal) Acrylics. 2010.
No. 21 in the 'Lost Narratives' series.
'The apprentice feverishly administered the potent mix of refined alien toxins and incantation-altered hormones. All around her, lining shelves—corridors full of shelves—were the failed, formalin-preserved experiments of others, including one or two of her own, earlier, failed efforts. Small mutant corpses in a thousand forms bobbed about lifelessly in their jar-prisons. This homunculus would be different, its short, angry little pseudo-life a testament to her unique talent.'
My youngest daughter, Gwen once again modeling for me.

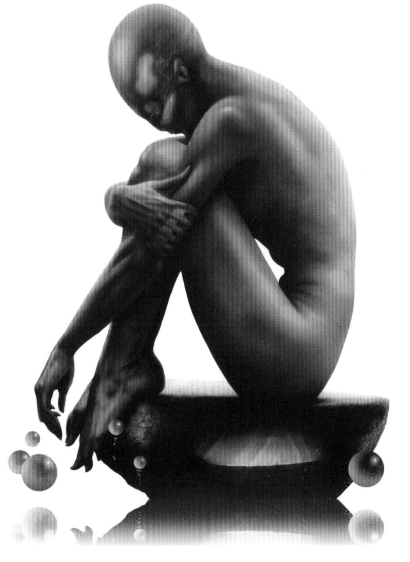

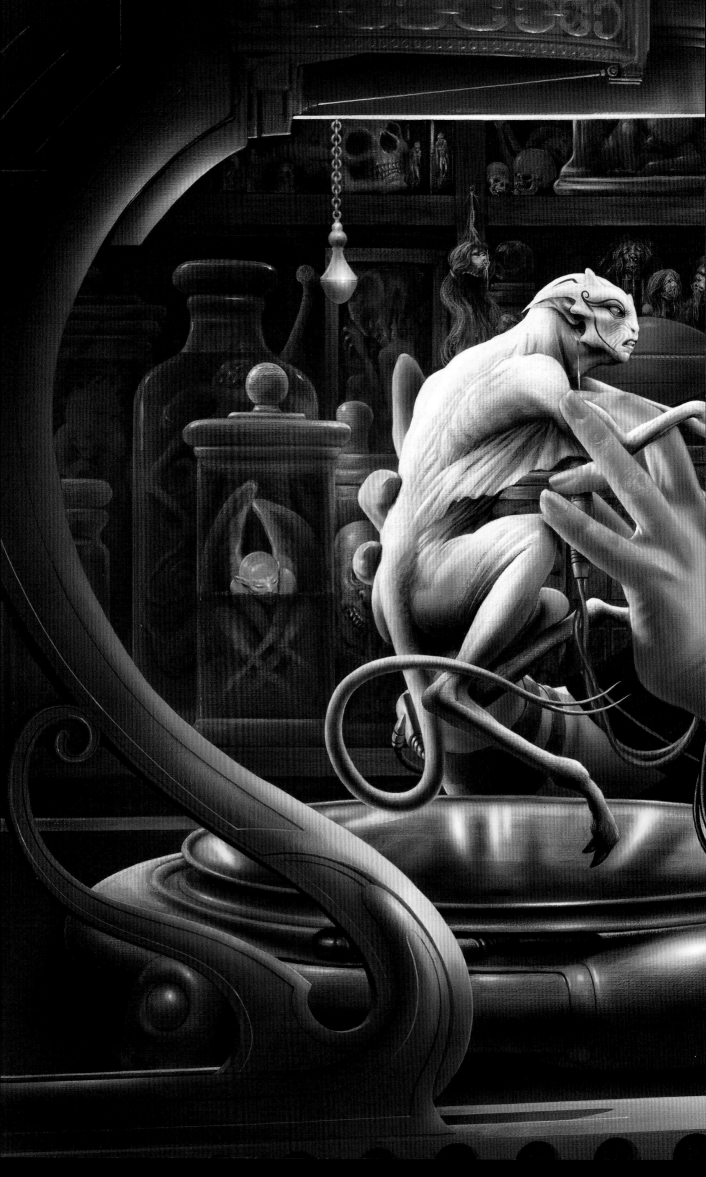

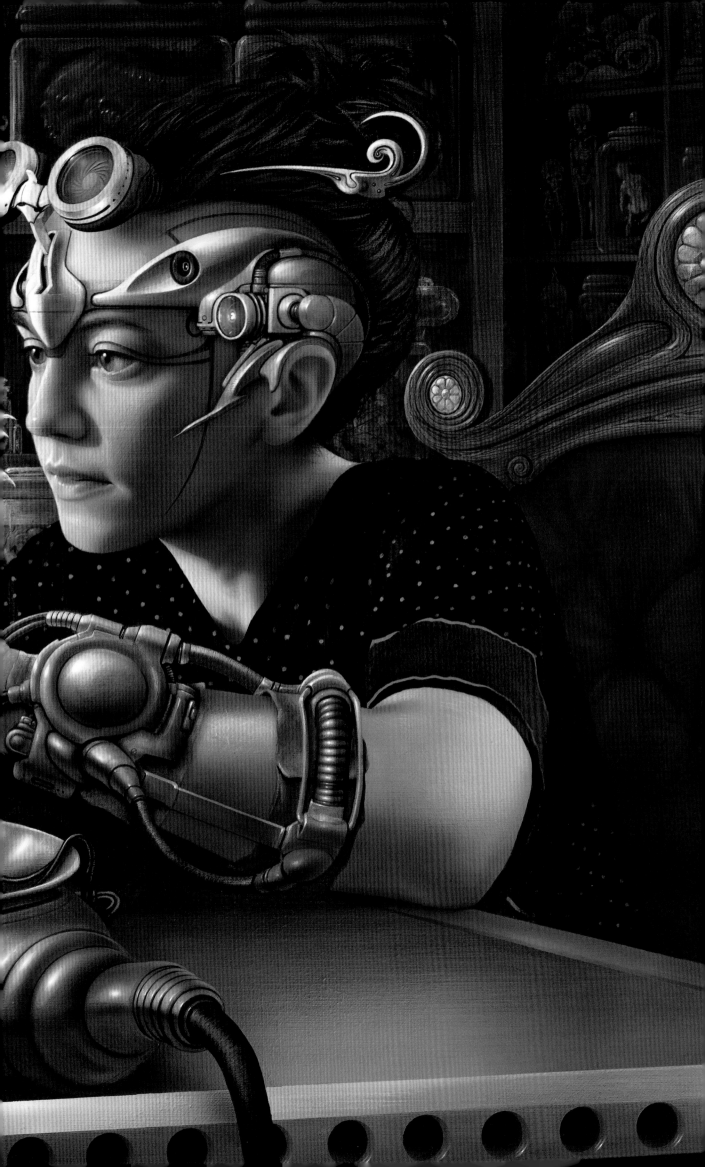

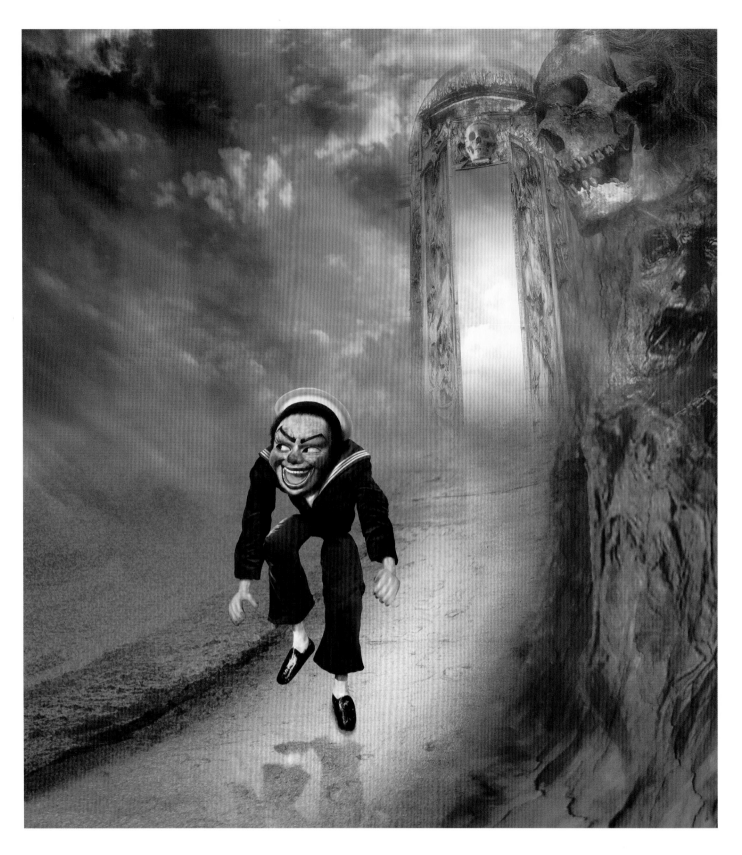

Imagine a 'Jolly Jack Tar', a grinning wooden puppet in a run-down English seaside penny arcade, its lunatic rictus grin painted on to its crude wooden face, the manic recorded laughter when you put your penny in the slot, springing to life, advancing down the promenade towards you and strangling you with the wires that connect its clacking useless limbs. Such is the imagination of Chris Fowler, a gift indeed to the artist in need of sinister new roads to travel along.

It's so long ago now that I can't remember too much about painting the cover art for *Beyond Bedlam*. I know that it was the summer break and I was home from London life. I'd journeyed back down to Wales with a commission in tow—my second ever paid science fiction job. The dining room table of the old family home saw my career begin to take some sort of shape. Struggling with acrylic paint in 1972, I was beginning to understand the dire necessity to go out and buy an airbrush! How I struggled with this!

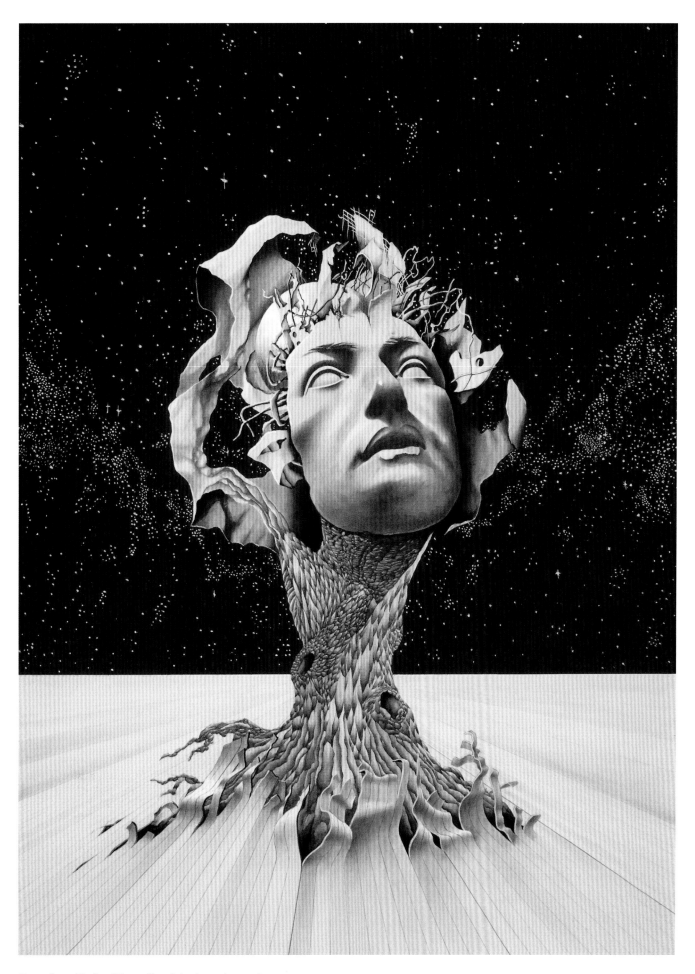

Above: *Beyond Bedlam* (Wyman Guinn) Acrylics and watercolour. 1972
Opposite: *Oh I do Love to be Beside the Seaside* (Chris Fowler) Digital. 2011

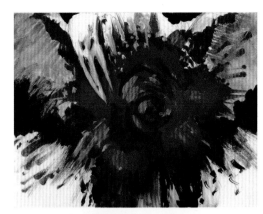

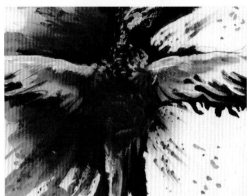

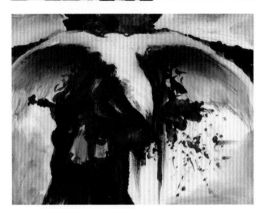

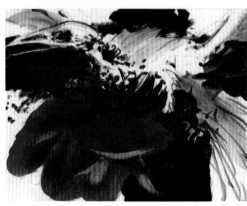

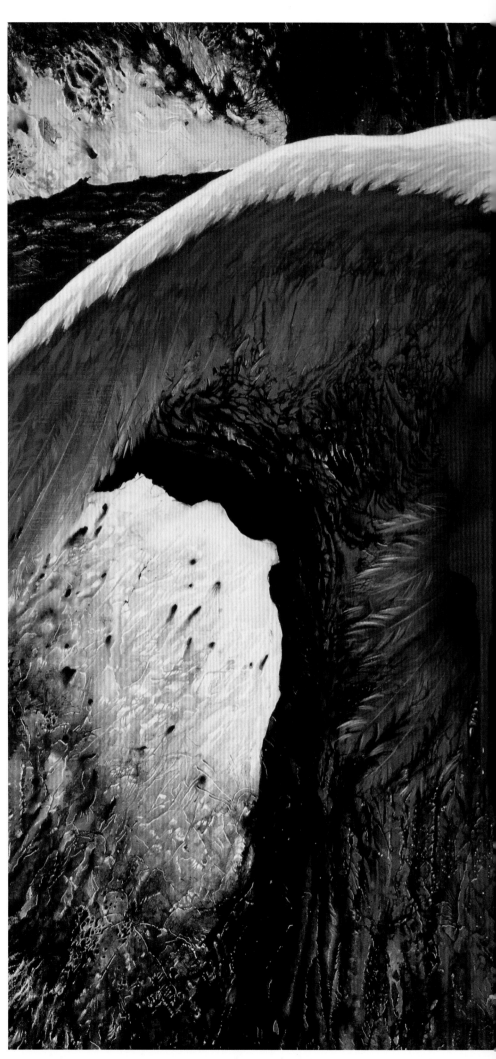

To travel with Garry Kilworth is to travel sometimes to the worlds of the truly strange. A master of the short story. The idea for the 'crucified bird' was Garry's own. It doesn't matter how many times I tell people that simple fact they still go on asking variations on 'were you in a bad place then Jim?' Once someone tried to recommend a good therapist to me on seeing this.

This Spread: *Songbirds of Pain* (Garry Kilworth) Acrylics. 1987

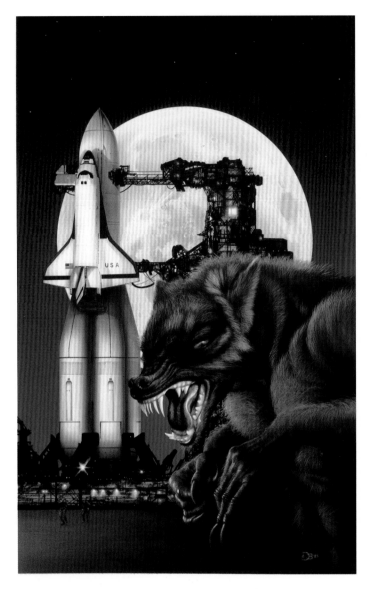
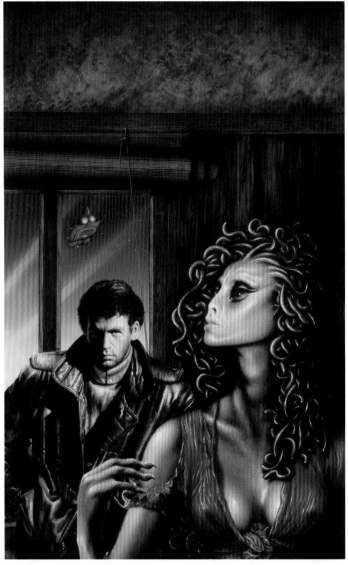

There is a beguiling place where the erotic meets the repellent. It's a fine line to walk. C. L. Moore was an unusual thing back in the 1930s—a woman writer of science fiction stories. *Shambleau* was her first professional sale—essentially a creepy SF retelling of the Medusa myth.

Stheno was the oldest and deadliest of the three Gorgons, the others being Medusa and Euryale. This painting is a study for a larger painting which will feature all three and which I will call 'Stheno and her Sisters'. I wish to voyage more in the worlds of Mythology—an area rich in strange, often dark imagery

Above left: *Moonbane* (Al Sarrantonio) Acrylics. 1989

Above right: *Shambleau* (C. L. Moore) Acrylics. 1982

Opposite: *Stheno* (Personal) Acrylics. 2013

Next Spread: *The Victorian, Act IV: Self-Overcoming* (Len Wein) Acrylics. 2005
A bit more steampunkery from me.

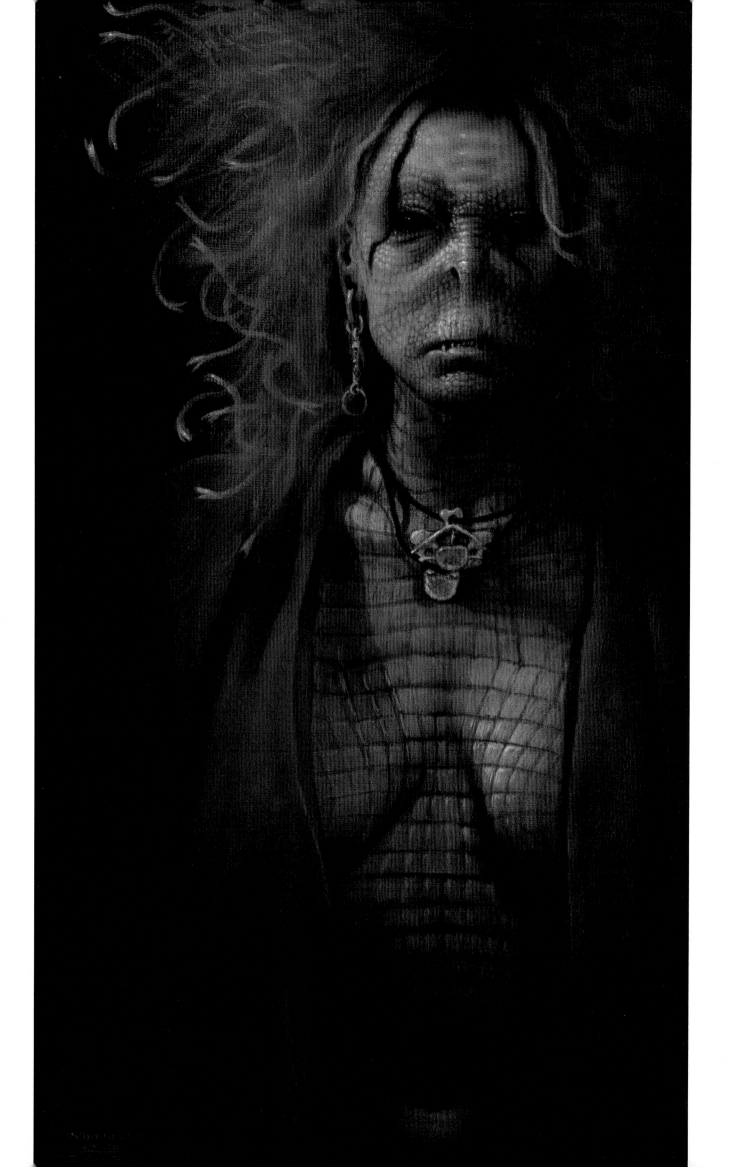

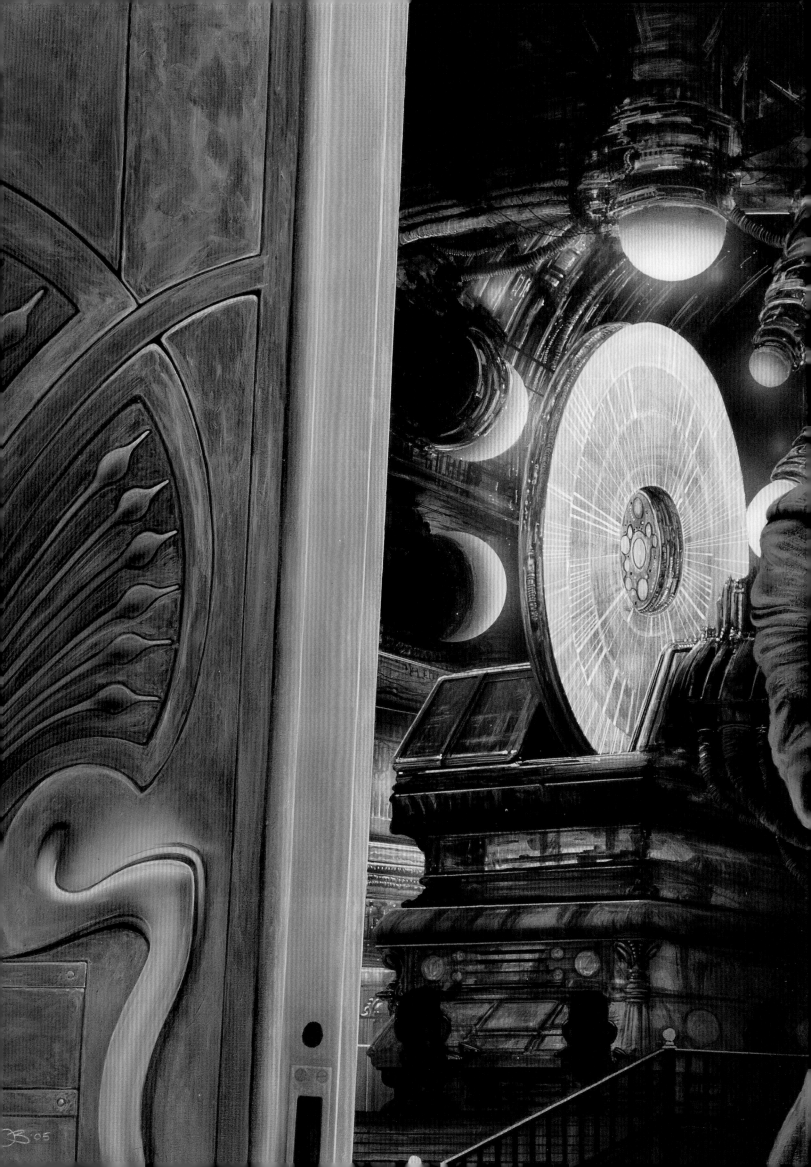

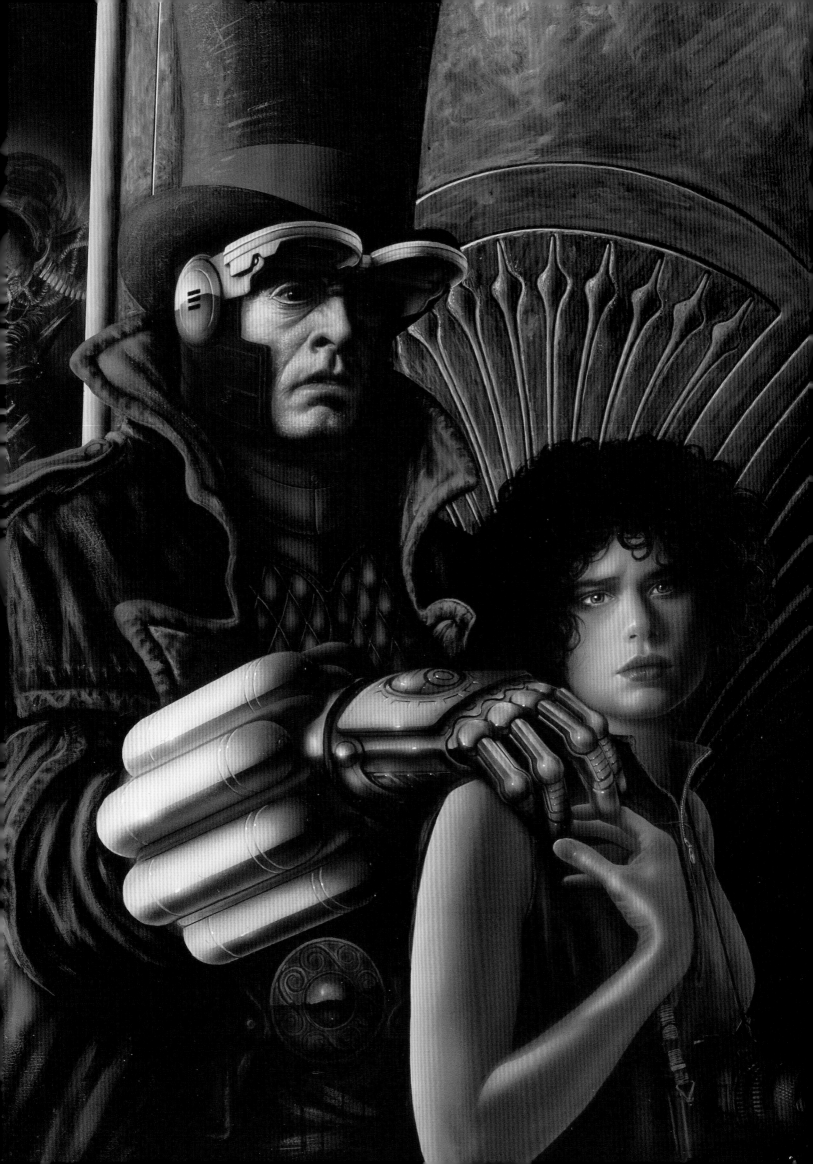

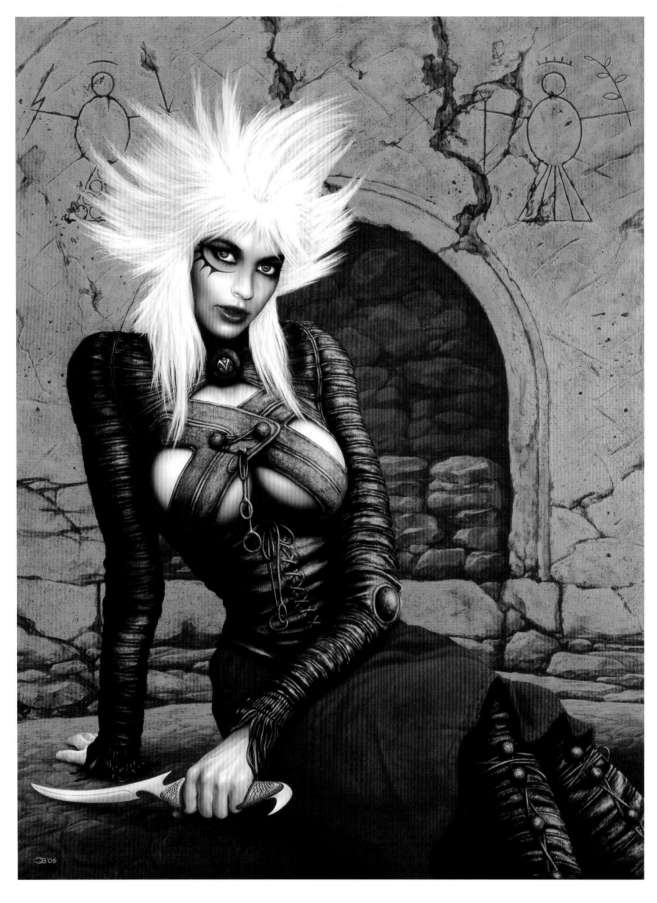

Imagine a strange guild. A guild of young, beautiful assassin women. A guild dedicated to the Finnish goddess of Pain, disease and suffering. Sirpa is such a woman. The myth of Vammatar exists but I invented the guild. On the wall behind her are actual shamanic symbols from Finno-ugrik mythology. Clues for the observer to muse upon. 'The Iceni Girl' is tough and she is beautiful. Her woad face decoration and Celtic styled sword, torc and belt situate her in time and place. In the years to come Colchester, St Albans and Londinium will be razed to the ground as she leads the uprising against the occupying Romans. For she is Boudicca.

Above: *Sirpa of the Guild of Vammatar* (Personal) Acrylics. 2006

Right: *The Iceni Girl* (Personal) Acrylics. 2012

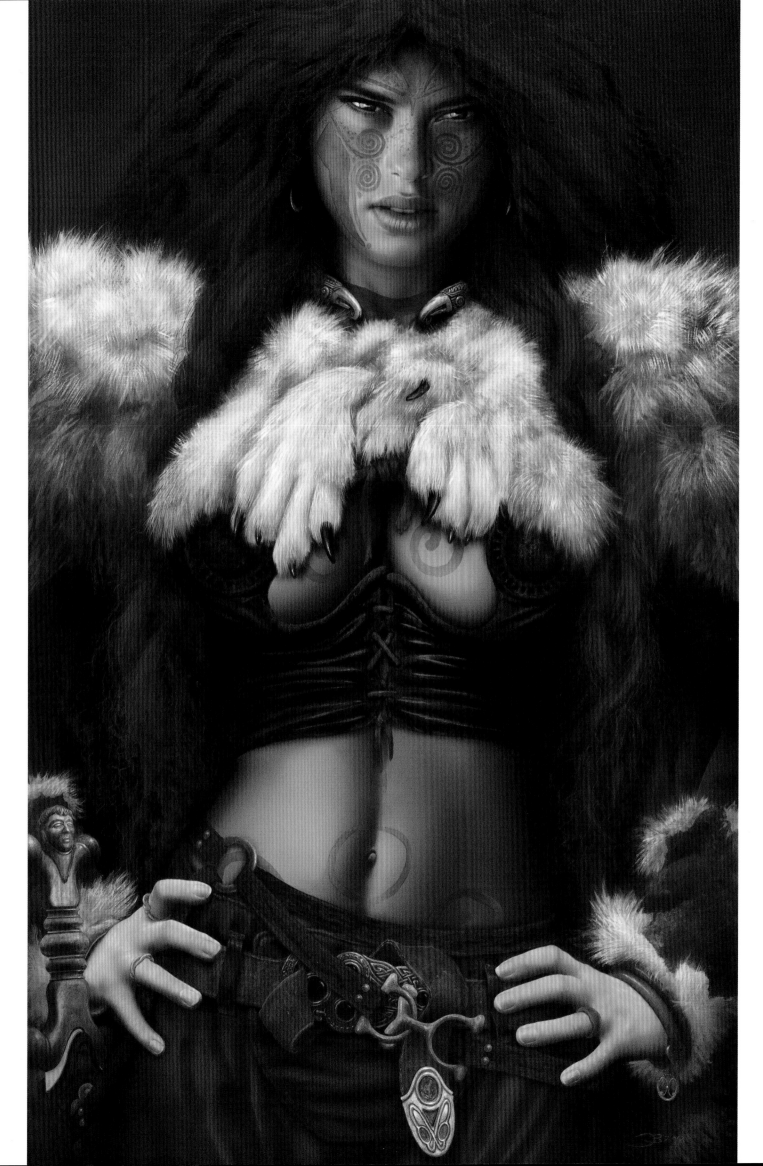

A trio of sketches

Right: *Mercenary* (Personal) Pencil sketch. 2005

Below left: *Ishtar* (Personal) Pencil and digital colour. 2005

Below right: *Threlxepia's Little Sister* (Personal) Pencil and digital colour sketch. 2003

Opposite: *Threlxepia's Little Sister* (Personal) Acrylics. 2003

Following Spread: *The Fetch* (Robert Holdstock) Acrylics 1991
In his mythic fiction, my late and sadly missed friend, Rob Holdstock was able to take one to the strangest and darkest of places in his marvelous books. He had to go no further than the deepest English countryside to experience it. In *The Fetch* his 'mocking cross'—a demonic inversion of 'the true cross'—was a hugely entertaining object to design and paint.

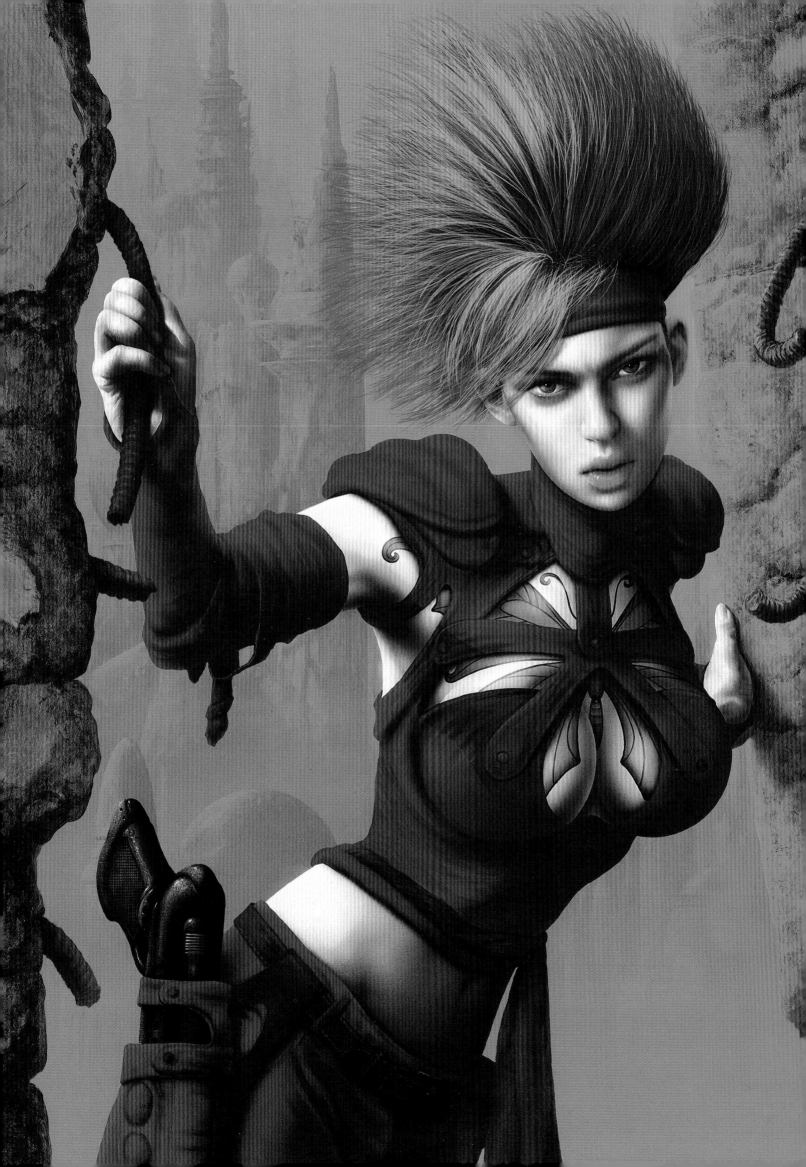

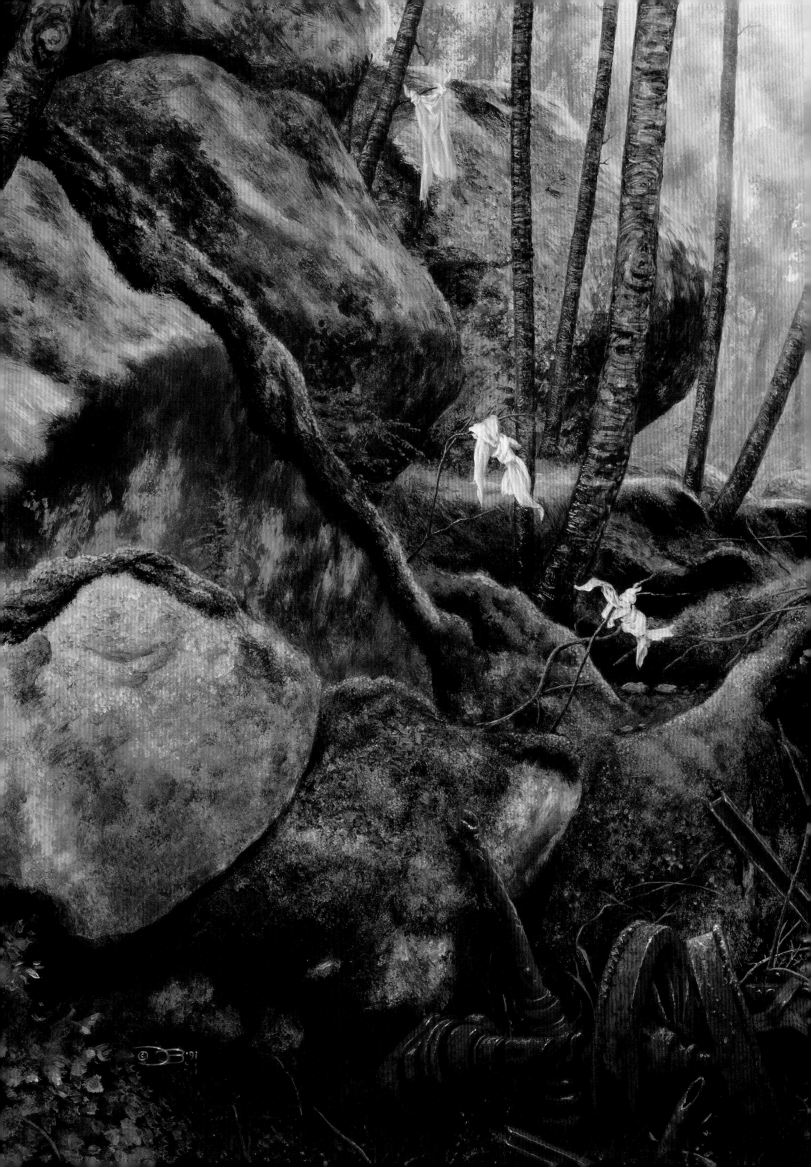

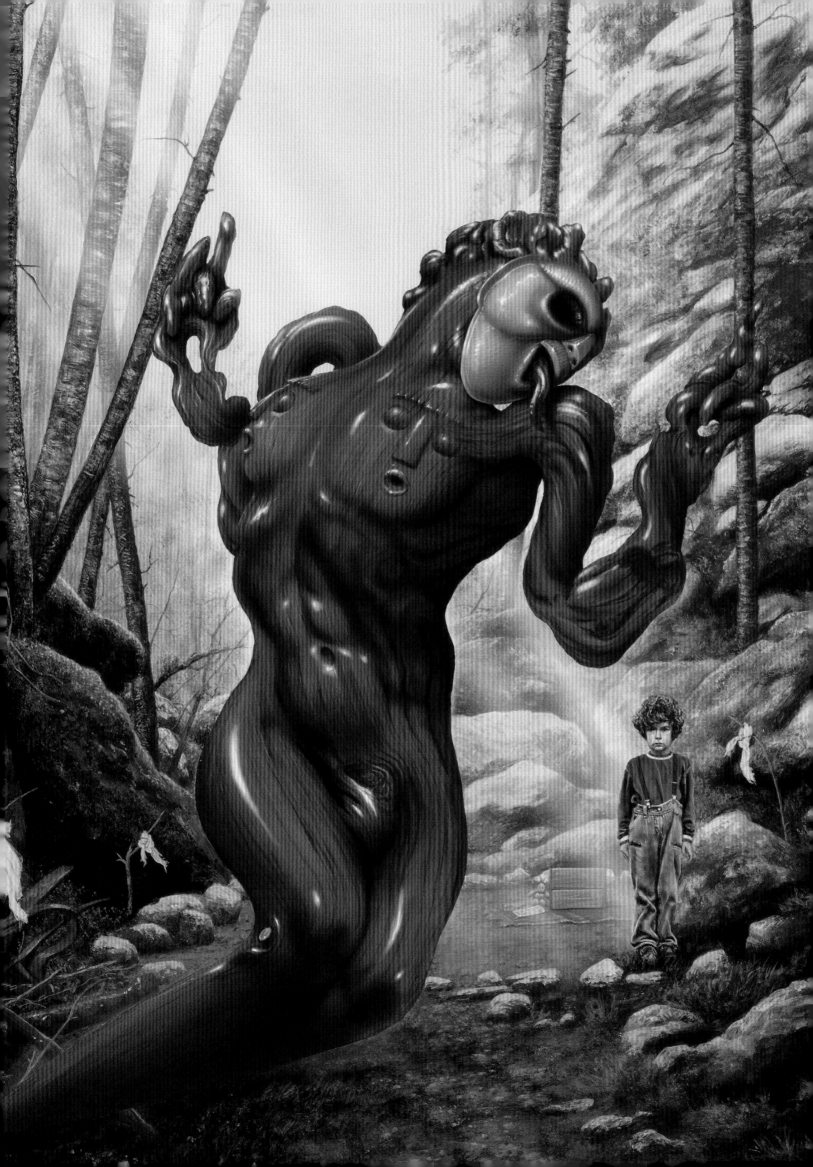

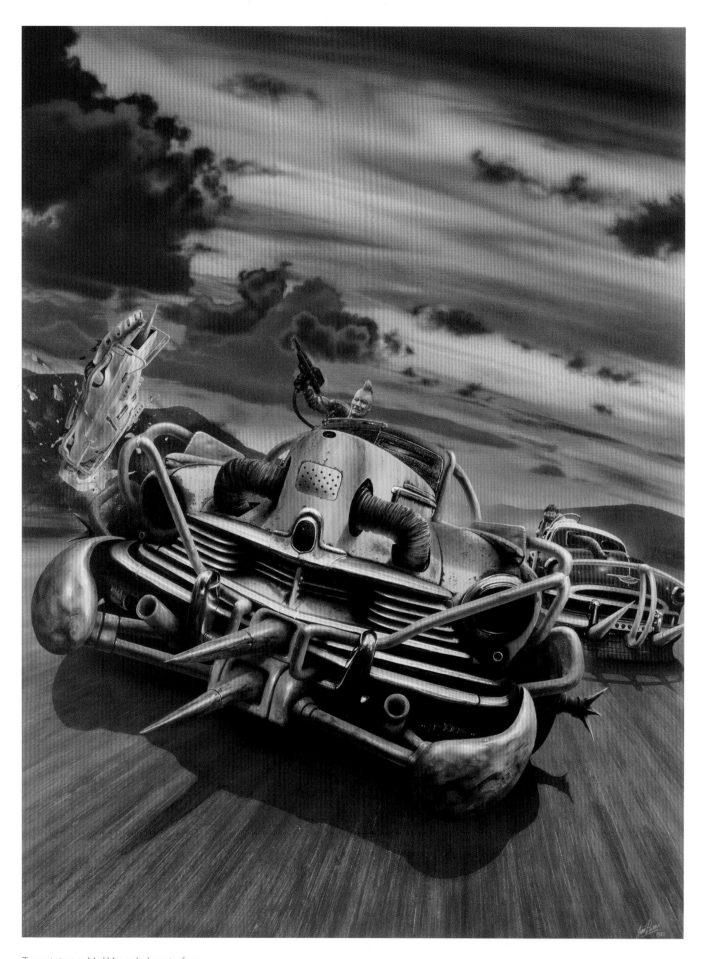

Two variations on Mad Max-style dystopian futures.

Above: *Battle Cars* (Ian Livingstone) Acrylics. 1983

Right: *Freeway Fighter* (Ian Livingstone) Acrylics. 1983

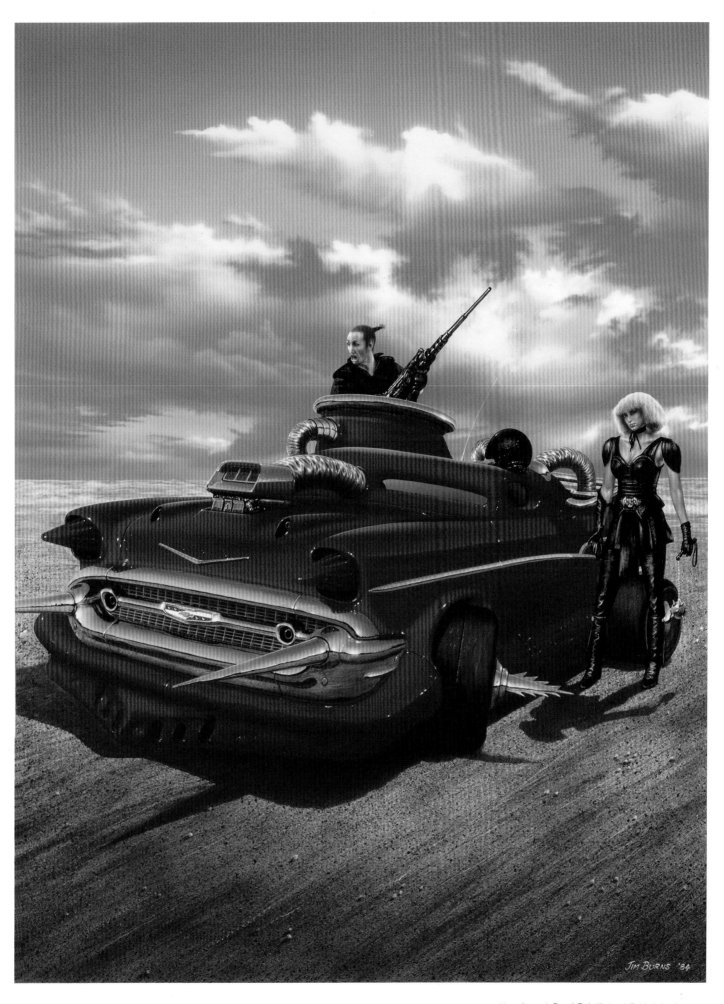

Next Spread: *Dead Girls* (Richard Calder) Acrylics 2014
Primavera Bobinski the engineered 'doll girl' and her partner, Iggy tearing up the Bangkok night sky in L'il Red Rooster. I had read the dark, dark novel of vampiric gynoid dolls—the Lilim—years ago and recently found myself painting the cover for a comic adaptation of it.

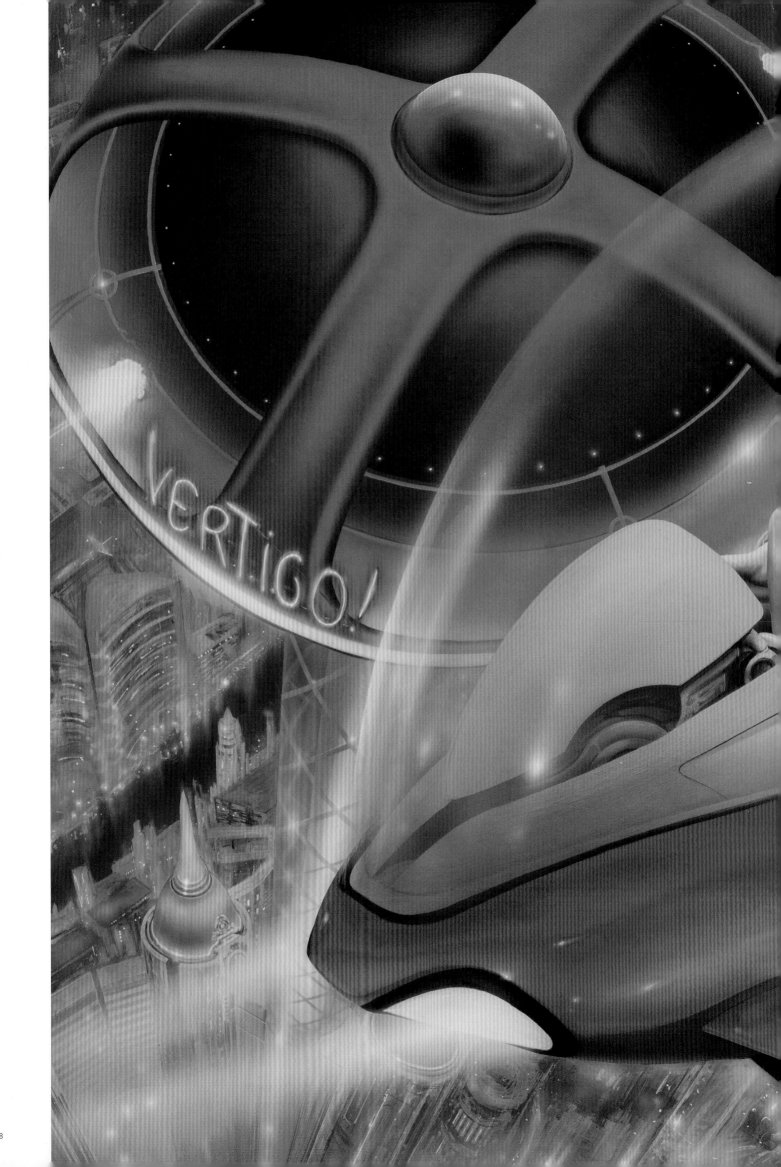

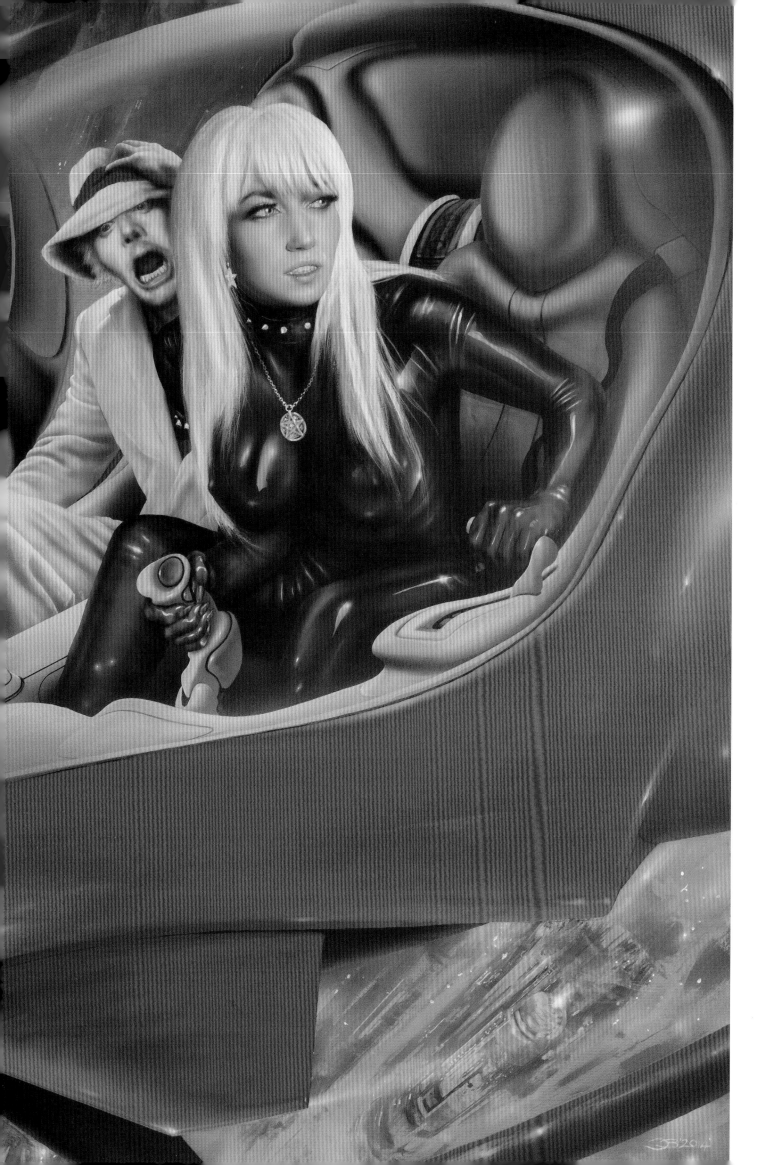

ACKNOWLEDGEMENTS

Without the seemingly limitless energy of my agent, Alison Eldred I rather doubt that *Hyperluminal* would ever have got off the ground. A huge debt of gratitude is owed her—not just for this book but for 40 years of her gently guiding hand and, when needed, more persuasive strategies where this easily distracted artist is concerned! Top agent bar none!

And thanks too to the good folk at Titan Books, in particular my editor, Beth Lewis for the quietly efficient way she has steered the project along and keeping me on track. Also Natalie Clay, my brilliant designer on the book for her enthusiasm for the project and, where possible for accommodating my own ideas without objection. A synergistic partnership indeed.

All my life my imagination has been fed and nurtured by the writers of science fiction. Thank you to them all for the wonderment and awe they have provided— and indeed the career that their work helped stimulate into profitable activity!

Thank you all my fellow artists! who inspire and urge one on to greater heights. I perceive in recent times a steady raising of the bar—the friendliest of competitions!

It's a privilege to count many writers and artists amongst my friends.

Another thank you to the collectors who over the years have acquired pieces of my work. The idea that someone will happily live with and enjoy one's creative efforts on their walls is both immensely satisfying and rather humbling. A big thank you to Jane Frank of Worlds of Wonder—'The Great Enabler' behind many of these sales!

The new enthusiasm I have felt for this field of endeavour is in no small way due to the hard work and dedication to the cause of Patrick and Jeannie Wilshire. Their idea of 'Imaginative Realism' and its promotion through the annual Illuxcon Symposium has given those of us who prefer to paint in the traditional ways a whole new direction in life—inevitably connected (and happily so) to the commercial world most of us have sustained careers in but now with a new sense of gravitas and 'heft' to the genre of fantastical art.

Lastly—of course—my family. The centre of my world.